# TAMING your PHOTO LIBRARY

## with **Adobe Lightroom**

ROB SYLVAN

Adobe

Taming Your Photo Library with Adobe Lightroom
**Rob Sylvan**
Copyright © 2017 by Rob Sylvan
All photography © Rob Sylvan except where noted.

Adobe Press books are published by Peachpit, a division of Pearson Education.
For the latest on Adobe Press books and videos, go to www.adobepress.com.
To report errors, please send a note to errata@peachpit.com.

**Adobe Press Editor:** Nancy Davis
**Development Editor:** Linda Laflamme
**Senior Production Editor:** Tracey Croom
**Copyeditor:** Scout Festa
**Technical Editor:** Rocky Berlier
**Compositor:** Danielle Foster
**Indexer:** James Minkin
**Cover Design:** Chuti Prasertsith
**Interior Design:** Happenstance Type-O-Rama/Danielle Foster
**Cover Image:** Rob Sylvan
**Author Photo:** Rob Sylvan

ISBN 13: 978-0-134-39862-4
ISBN 10: 0-134-39862-9

1  16
Printed and bound in the United States of America

*To everyone at Peachpit Press and Adobe Press, past and present,
who has given me so many opportunities to help others learn.*

# Acknowledgments

My deepest thanks go to Jan Kabili and Victor Gavenda for starting me off on this book project. To Jan for coming up with the original idea for this book, and to Victor for enlisting me to carry the idea through to completion.

I also want to express my gratitude to Nancy Davis, Linda Laflamme, Rocky Berlier, Scout Festa, and Tracey Croom for their assistance, guidance, support, and (near infinite) patience with me throughout this entire process and all that I put them through. Thank you all.

I am grateful for all that I have learned from my friends and colleagues at KelbyOne, from the fantastic instructors at Photoshop World, to all of the members who have sent in Lightroom questions, and to my fellow Help Desk staffers. I am also indebted to my fellow photographers at Stocksy United and at Photofocus.com. You all have taught and inspired me over the years.

I also want to thank my wife, Paloma, for being the love of my life and my number-one supporter during this project; my son, Quinn, for assisting me on many shoots and being the model in many more; and my family, friends, and neighbors for being a part of the book in large and small ways.

Cheers to all who have asked me Lightroom questions over the years!

# Contents at a Glance

Introduction. . . . . . . . . . . . . . . . . . . . . . . . . . . . xv

1 Getting in a Lightroom Frame of Mind. . . . . . . . 1

2 Getting Oriented to the Library
Module and Importing. . . . . . . . . . . . . . . . . . 23

3 File Management, Lightroom Style . . . . . . . . . 49

4 Using Collections for Organization . . . . . . . . 75

5 Using Metadata. . . . . . . . . . . . . . . . . . . . . . 95

6 Care and Maintenance of Your Catalog . . . . . 127

7 Increasing Lightroom Efficiency . . . . . . . . . . 139

8 Common Organizational Workflows. . . . . . . . 167

9 Advanced Workflows. . . . . . . . . . . . . . . . . . 199

10 Integrating with Lightroom Mobile . . . . . . . . 221

Appendix: Troubleshooting 101 . . . . . . . . . . . 241

Index . . . . . . . . . . . . . . . . . . . . . . . . . . . . . 247

# Contents

Introduction. . . . . . . . . . . . . . . . . . . . . . . . . xv

1   Getting in a Lightroom Frame of Mind. . . . . . . 1
    Wrapping Your Head Around Lightroom . . . . . . . . . . . . . .1
        *The Catalog*. . . . . . . . . . . . . . . . . . . . . . . . . .2
        *Your Photos*. . . . . . . . . . . . . . . . . . . . . . . . . .4
    What to Do Before You Start Using Lightroom . . . . . . . . .5
        *Get Your System Ready*. . . . . . . . . . . . . . . . . . . .5
        *Get Your Photos Ready* . . . . . . . . . . . . . . . . . . . .6
    Key Lightroom Files. . . . . . . . . . . . . . . . . . . . . . . .8
        *The Lightroom Application* . . . . . . . . . . . . . . . . . .8
        *Catalog and Preview Caches* . . . . . . . . . . . . . . . . .9
        *Managing the Lightroom Cache Files* . . . . . . . . . . . 11
        *Configure Preferences and Catalog Settings*. . . . . . . 13

2   Getting Oriented to the Library
    Module and Importing. . . . . . . . . . . . . . . . . . 23
    The Library Module's Interface . . . . . . . . . . . . . . . . .24
        *Menu Bar* . . . . . . . . . . . . . . . . . . . . . . . . . .24
        *Identity Plate and Module Picker* . . . . . . . . . . . . .25
        *Left Panel Group*. . . . . . . . . . . . . . . . . . . . . .26
        *Right Panel Group*. . . . . . . . . . . . . . . . . . . . .26
        *Filmstrip* . . . . . . . . . . . . . . . . . . . . . . . . . .26
        *Main Workspace* . . . . . . . . . . . . . . . . . . . . . .27
    Library View Options. . . . . . . . . . . . . . . . . . . . . .28
        *Grid*. . . . . . . . . . . . . . . . . . . . . . . . . . . . .28
        *Loupe* . . . . . . . . . . . . . . . . . . . . . . . . . . .30
        *Compare* . . . . . . . . . . . . . . . . . . . . . . . . . .31
        *Survey*. . . . . . . . . . . . . . . . . . . . . . . . . . .33
        *People*. . . . . . . . . . . . . . . . . . . . . . . . . . .34

Customizing the Interface . . . . . . . . . . . . . . . . . . . . . . . . 34

    *Screen Modes* . . . . . . . . . . . . . . . . . . . . . . . . . . . . . . . *35*

    *Collapsing Panels* . . . . . . . . . . . . . . . . . . . . . . . . . . . . *35*

    *Individual Panels and Solo Mode* . . . . . . . . . . . . . . . . *37*

    *Vanishing Panels* . . . . . . . . . . . . . . . . . . . . . . . . . . . . *37*

    *Lights Out* . . . . . . . . . . . . . . . . . . . . . . . . . . . . . . . . . *38*

Importing Your Photos . . . . . . . . . . . . . . . . . . . . . . . . . 39

    *Choosing a Source* . . . . . . . . . . . . . . . . . . . . . . . . . . 40

    *Choosing a Destination* . . . . . . . . . . . . . . . . . . . . . . . *42*

    *File Handling* . . . . . . . . . . . . . . . . . . . . . . . . . . . . . . *45*

    *File Renaming* . . . . . . . . . . . . . . . . . . . . . . . . . . . . . *46*

    *Apply During Import* . . . . . . . . . . . . . . . . . . . . . . . . . *47*

**3   File Management, Lightroom Style** . . . . . . . . **49**

Understanding the Role of the Folders Panel . . . . . . . . . .49

    *Volume Browser Indicators* . . . . . . . . . . . . . . . . . . . . . *51*

    *Show or Hide a Parent Folder* . . . . . . . . . . . . . . . . . . *52*

    *Find Your Folders and Photos* . . . . . . . . . . . . . . . . . *53*

Create New Folders and Remove Old Ones . . . . . . . . . . . .54

    *Adding New Folders* . . . . . . . . . . . . . . . . . . . . . . . . . .54

    *Renaming Folders* . . . . . . . . . . . . . . . . . . . . . . . . . . . *57*

    *Removing Empty Folders* . . . . . . . . . . . . . . . . . . . . . *58*

Using Lightroom to Delete Photos . . . . . . . . . . . . . . . . . .58

    *Deleting Lots of Photos at Once* . . . . . . . . . . . . . . . . . *59*

    *More Ways to Delete Photos* . . . . . . . . . . . . . . . . . . . 60

    *Moving Photos and Folders* . . . . . . . . . . . . . . . . . . . . *61*

    *Moving Photos Between Folders* . . . . . . . . . . . . . . . . *61*

    *Moving Folders* . . . . . . . . . . . . . . . . . . . . . . . . . . . . *62*

    *Moving Large Groups of Photos Safely* . . . . . . . . . . . *63*

    *Move Shortcut* . . . . . . . . . . . . . . . . . . . . . . . . . . . . . *63*

Using Lightroom to Rename Photos . . . . . . . . . . . . . . . .64

   *Rename a Single Photo.* . . . . . . . . . . . . . . . . . . . . . . .*64*

   *Create and Apply Custom Filename Templates* . . . . . .*65*

Reconnecting Missing Folders and Photos . . . . . . . . . . .68

   *Dealing with an Offline Drive* . . . . . . . . . . . . . . . . . . .*68*

   *Dealing with Deleted Photos.* . . . . . . . . . . . . . . . . . . .*70*

   *Dealing with Folders and Photos Moved*
   *Outside Lightroom* . . . . . . . . . . . . . . . . . . . . . . . . . . .*70*

   *Dealing with Photos Renamed Outside Lightroom* . . . .*73*

**4  Using Collections for Organization** . . . . . . . . **75**

The Case for Collections. . . . . . . . . . . . . . . . . . . . . . . .75

   *The Collections Panel* . . . . . . . . . . . . . . . . . . . . . . . . .*77*

   *The Catalog Panel.* . . . . . . . . . . . . . . . . . . . . . . . . . . .*78*

Collecting Your Photos . . . . . . . . . . . . . . . . . . . . . . . . .79

   *Creating Structure with Collection Sets* . . . . . . . . . . *80*

   *Grouping Photos with Regular Collections* . . . . . . . . .*81*

   *Automating with Smart Collections* . . . . . . . . . . . . . .*83*

Maintaining Collections Over Time. . . . . . . . . . . . . . . .89

   *Moving Things Around* . . . . . . . . . . . . . . . . . . . . . . . .*89*

   *Using a Target Collection* . . . . . . . . . . . . . . . . . . . . .*89*

   *Renaming and Deleting.* . . . . . . . . . . . . . . . . . . . . . . .*91*

**5  Using Metadata** . . . . . . . . . . . . . . . . . . . . . . . **95**

The Metadata Panel . . . . . . . . . . . . . . . . . . . . . . . . . . .96

   *Metadata Panel Views.* . . . . . . . . . . . . . . . . . . . . . . . .*96*

   *Adding Titles, Captions, and More* . . . . . . . . . . . . . . .*98*

   *Applying Metadata to Multiple Photos* . . . . . . . . . . . *101*

Keywords. . . . . . . . . . . . . . . . . . . . . . . . . . . . . . . . . . .103

   *The Keywording Panel.* . . . . . . . . . . . . . . . . . . . . . . .*104*

   *The Keyword List Panel.* . . . . . . . . . . . . . . . . . . . . . .*109*

Finding Faces and Assigning Names. . . . . . . . . . . . . . . 114
 *People View*. . . . . . . . . . . . . . . . . . . . . . . . . . . . . . *114*
 *Assigning Tags* . . . . . . . . . . . . . . . . . . . . . . . . . . . . *115*
 *Drawing Face Regions*. . . . . . . . . . . . . . . . . . . . . . . *117*
 *Moving Forward*. . . . . . . . . . . . . . . . . . . . . . . . . . . *119*
Tying Photos to Locations. . . . . . . . . . . . . . . . . . . . . . . 121
 *Finding Photos with Geolocation Data* . . . . . . . . . . . *121*
 *Manually Placing Photos on Map* . . . . . . . . . . . . . . *122*
 *Working with Tracks* . . . . . . . . . . . . . . . . . . . . . . . *124*

**6 Care and Maintenance of Your Catalog . . . . . 127**
Built-in Backup . . . . . . . . . . . . . . . . . . . . . . . . . . . . . . . 127
 *Catalog Dashboard* . . . . . . . . . . . . . . . . . . . . . . . . . *128*
 *Scheduling and Running the Backup* . . . . . . . . . . . . *128*
 *Testing Integrity and Optimization* . . . . . . . . . . . . . *130*
 *Managing the Backup Copies* . . . . . . . . . . . . . . . . . *131*
 *Restoring from a Backup* . . . . . . . . . . . . . . . . . . . . *132*
How to Move a Catalog. . . . . . . . . . . . . . . . . . . . . . . . . 133
How to Rename a Catalog. . . . . . . . . . . . . . . . . . . . . . . 134
How to Export a Catalog . . . . . . . . . . . . . . . . . . . . . . . . 135

**7 Increasing Lightroom Efficiency . . . . . . . . . . 139**
Presets and Templates . . . . . . . . . . . . . . . . . . . . . . . . . 139
 *Creating Different Types of Presets and Templates*. . .*140*
 *Managing Presets and Templates Over Time* . . . . . . .*156*
Keyboard Shortcuts. . . . . . . . . . . . . . . . . . . . . . . . . . . . 158
 *Discovering Shortcuts*. . . . . . . . . . . . . . . . . . . . . . . *159*
 *Starter Kit* . . . . . . . . . . . . . . . . . . . . . . . . . . . . . . . *161*
Custom Default Settings . . . . . . . . . . . . . . . . . . . . . . . . 161
 *Defaults versus Presets*. . . . . . . . . . . . . . . . . . . . . . *162*
 *Synchronizing Previously Imported Photos* . . . . . . . . *164*
 *Advanced Settings* . . . . . . . . . . . . . . . . . . . . . . . . . *165*

8    Common Organizational Workflows. . . . . . . 167

Importing Photos . . . . . . . . . . . . . . . . . . . . . . 167

   Adding Photos on Your Hard Drive . . . . . . . . . . . . 168

   Copying Photos from a Memory Card. . . . . . . . . . . 170

Evaluating Photos . . . . . . . . . . . . . . . . . . . . . 174

   During Import . . . . . . . . . . . . . . . . . . . . . . . 174

   After Import . . . . . . . . . . . . . . . . . . . . . . . . 176

Applying Keywords . . . . . . . . . . . . . . . . . . . . .180

   Using the Keyword List Panel . . . . . . . . . . . . . . . 181

   Painting Your Photos with Information . . . . . . . . . . 184

Finding Photos . . . . . . . . . . . . . . . . . . . . . . .186

   Using the Library Filter . . . . . . . . . . . . . . . . . .186

   Creating Smart Collections. . . . . . . . . . . . . . . . 189

Exporting Copies for Output . . . . . . . . . . . . . . . . 191

9    Advanced Workflows . . . . . . . . . . . . . . . . . . 199

Using Lightroom with Multiple Computers . . . . . . . . . .199

   Word of Warning . . . . . . . . . . . . . . . . . . . . . 200

   One Drive to Rule Them All. . . . . . . . . . . . . . . . 200

   Keeping It Simple . . . . . . . . . . . . . . . . . . . . .201

   Making It Happen . . . . . . . . . . . . . . . . . . . . .203

   Take Your Presets and Templates Too. . . . . . . . . . .203

Catalog for the Road. . . . . . . . . . . . . . . . . . . .207

   Exporting a Smaller Catalog. . . . . . . . . . . . . . . .207

   Working with the Exported Catalog. . . . . . . . . . . . 209

   Bringing It All Home . . . . . . . . . . . . . . . . . . . .210

   Clean Up . . . . . . . . . . . . . . . . . . . . . . . . . 212

Import Multiple Catalogs into One . . . . . . . . . . . . . 212

   Choose the Master . . . . . . . . . . . . . . . . . . . . 213

Migrating to a New Computer. . . . . . . . . . . . . . . . 213

   Before You Start . . . . . . . . . . . . . . . . . . . . . 214

   Preparing the New Computer . . . . . . . . . . . . . . .214

*Migrating Your Photos*. . . . . . . . . . . . . . . . . . . . . . . . . 214

*Presets and Plug-Ins*. . . . . . . . . . . . . . . . . . . . . . . . . . 216

*Copying the Catalog* . . . . . . . . . . . . . . . . . . . . . . . . . 217

*Transferring to the New Computer* . . . . . . . . . . . . . . 218

*A Word about Publish Services Connections* . . . . . . . 219

*Walk It Through*. . . . . . . . . . . . . . . . . . . . . . . . . . . . 219

**10  Integrating with Lightroom Mobile** . . . . . . . . **221**

What Is Lightroom Mobile?. . . . . . . . . . . . . . . . . . . . .222

Syncing Your Desktop Catalog and Mobile Device . . . . .224

*Lightroom on the Desktop*. . . . . . . . . . . . . . . . . . . .224

*Lightroom on Mobile*. . . . . . . . . . . . . . . . . . . . . . .225

Working with Collections on Your Mobile Device . . . . . .227

*Adding Photos*. . . . . . . . . . . . . . . . . . . . . . . . . . . .227

*Viewing Photos* . . . . . . . . . . . . . . . . . . . . . . . . . . .229

*Exporting Photos*. . . . . . . . . . . . . . . . . . . . . . . . . .233

*Lightroom Web* . . . . . . . . . . . . . . . . . . . . . . . . . . .234

*Applying Ratings and Flags on the Go* . . . . . . . . . . .237

**Appendix: Troubleshooting 101** . . . . . . . . . . . **241**

Time for a Do-Over . . . . . . . . . . . . . . . . . . . . . . . . . . 241

Resetting the Preference File . . . . . . . . . . . . . . . . . . .242

Creating a New Catalog. . . . . . . . . . . . . . . . . . . . . . .243

Uninstalling and Reinstalling Lightroom . . . . . . . . . . . .244

Finding Outside Help. . . . . . . . . . . . . . . . . . . . . . . . .245

**Index** . . . . . . . . . . . . . . . . . . . . . . . . . . . **247**

# Introduction

Thanks for your interest in this book. You should know right away that this is not a book about how to use the Develop module to make your photos look better, as there are many good books and videos that do that already. You might even want to check out my video *Adobe Photoshop Lightroom CC (2015 release)/Lightroom 6 Learn by Video*, which is 10 hours of content about all aspects of Lightroom.

So, what is this book? In a sense, it's an answer to the many, many questions I've been asked since I started helping people learn about Lightroom and solve Lightroom-related problems, back in 2007, when Lightroom 1.0 came out. I've learned a lot from that experience, and my goal for this book is to pass along some of the key knowledge I've acquired to you, the reader, so that you may benefit from the collective experience of us all.

In that time, I've seen the same questions asked, the same problems encountered, and the same misunderstandings slow people down over and over again. I've designed this book to help you build a solid foundation for understanding the way Lightroom works, which I believe is the key to working smarter and faster and avoiding the pitfalls that so many encounter. I've also focused on teaching you about the most important (and often least intuitive) tools, techniques, functions, and tips you need to know to stay in control of your Lightroom library over time.

You don't need to read this book in its entirety or in any particular order, but I do recommend starting with Chapter 1 to get off on the right foot. From there, use the book as a reference and resource to help you with the areas that are most concerning to you.

On a final note, I wrote Chapter 8, on common workflows, as a way for you to see how many of the aspects of the other chapters work in a real-world context. The workflow steps I describe are not the only way to perform a given task (as there are usually many roads to the same destination) but rather the steps that I felt would best help you understand how something can be done and from there, as you gain experience, you can customize to best fit your needs and style. I wish you all the best as you learn how to get the most out of Lightroom and stay in the driver's seat throughout your journey.

# 1

# GETTING IN A LIGHTROOM FRAME OF MIND

Lightroom is built upon a database. Inside this database, most commonly referred to as the *catalog*, is all the data about your photos. This includes all the metadata created by the camera at the time the photo is taken (shutter speed, f-stop, ISO, and more), as well as all the data you add in Lightroom (such as keywords, IPTC data, and ratings) and all the adjustments you make in the Develop module. Understanding the relationship between this catalog of data and your photos is the key to unlocking and mastering the power of Lightroom to manage and organize your photos.

## Wrapping Your Head Around Lightroom

One of Lightroom's greatest strengths is that it is actually very easy to start using. The flipside of this strength is Lightroom's greatest weakness: Lightroom is very easy to start using before you understand how it works, before you understand the relationship between the Lightroom catalog and your photos. I say this because I've seen it happen all too often. Week after week, I teach people about the Lightroom fundamentals while at the same time helping them unravel the file management mess that has resulted from that lack of understanding. This mess most commonly grows from people not knowing where all of their photos are located, not knowing where the Lightroom catalog is located, finding question marks on folders in Lightroom's Folders panel, and knowing that photos are still on their hard drives despite Lightroom insisting that those same photos are missing or offline. If you're reading this book, either you've been there or you really want to avoid ending up there.

Let's take a step back and gain a big-picture view of the Lightroom model to give you a firmer foundation for moving forward with less frustration and much more confidence.

## The Catalog

In fact, let's take a step even farther back to the days of library card catalogs, those hulking masses of wooden drawers and cards that were once the height of information storage and organization (**Figure 1.1**). Although most libraries have replaced them with databases housed in sleek banks of computers, card catalogs still have a lot to offer when it comes to understanding Lightroom's catalog.

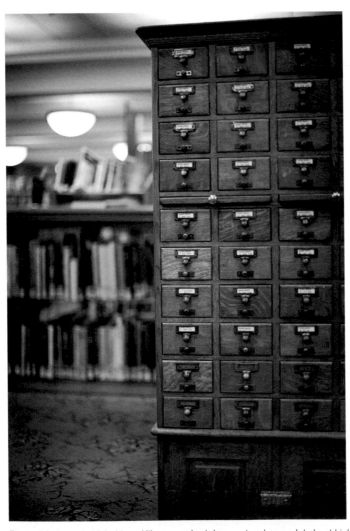

**Figure 1.1**  A good old-fashioned library card catalog can teach you a lot about Lightroom.

Traditional card catalogs contained rows of wooden drawers arranged in alphabetical order by author, and each drawer was filled with paper cards (also in alphabetical order) that contained an author's name, names of the books he or she had written, the dates of their publication, page counts, and so on, as well as where in the library you needed to go to actually get your hands on the book. You can think of the information each card held as the *metadata* for each book. Even small children understood that the real things—the actual books—were stored on shelves all around the library. Lightroom uses a very similar model, although it is not as easy to see and consumes a lot less space.

When you hear someone refer to your Lightroom catalog, conjure up an image of that library card catalog full of drawers and cards. Stored within the Lightroom catalog is a database record for every individual photo you have chosen to include in, or *imported* into, your Lightroom catalog. These records are like those paper cards for each book in the library; each contains all the available information about each photo taken from the photo's own metadata, plus anything you may have added via Lightroom's Import window (such as keywords or your copyright info). As you work with your photos, Lightroom continually writes to that catalog record all the new metadata you add, Develop settings you adjust, virtual copies you create, and so on. There is no Save menu inside Lightroom, because everything you do is saved automatically in the catalog as you make the changes. The record also contains the exact location of where that photo is stored on your hard drive, just as the card tells you where to find the actual book on the library shelves.

The Lightroom catalog, like its library ancestor, is just a container of records about all the photos you have imported. All your actual photos are stored in the various folders you create on your hard drive; think of your folders as the bookshelves in the library. When you want to do something with a photo—such as work with it in the Develop module, print it on your desktop printer, or save a copy to deliver to someone (in Lightroom lingo, that would be *exporting* it)—Lightroom pulls up the record for that photo, gives you access to all the information contained in the record, reaches across the virtual library to grab the image data off the virtual shelf, and processes it based on the instructions you provide in whatever module you are working.

Now, a big difference between Lightroom and a library card catalog is that you can't read a book by looking inside the card catalog, but you can see all your photos when you open a Lightroom catalog. This is where I think most of the confusion about Lightroom stems from. When you see thumbnails of your photos in the Library module, you are seeing *previews* that Lightroom has created and stored in a special cache file alongside the catalog file. This can give the impression that your photos are somehow

stored inside the catalog, but it is critical that you understand that your actual photos still reside only in the folders you create and designate on your computer's hard drives. For now, imagine that someone taped a tiny picture of a book's cover to its paper card; the book is still on the shelf, but now a thumbnail preview is attached to its record. Later in this chapter, we'll take a much closer look at all the files Lightroom uses to display what you are seeing.

## Your Photos

So if photos are stored in folders on your hard drive and Lightroom only keeps track of those locations in the catalog, how did the photos get to those folders originally? The answer is simple: You saved your photos into those folders before you started using Lightroom, or they were directed to those folders by you after you started using Lightroom. The key point is that you were in the driver's seat (whether you were fully aware of it or not) when the photos were placed in those folders.

Earlier I said that Lightroom is easy to start using and that this is where some people get off on the wrong foot. In their excitement to get started, people frequently install Lightroom, launch the program, and pop a memory card in the card reader. When they immediately encounter the Lightroom Import screen (**Figure 1.2**), they simply click the Import button at the bottom without looking too closely at what they are telling Lightroom to do.

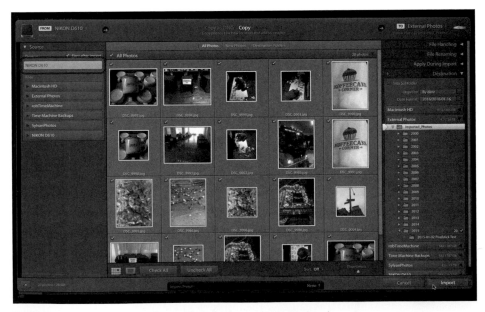

**Figure 1.2** The Import screen settings control where your photos are stored.

Eager to get to the sexy processing part of the program, people often glaze over the mundane housekeeping chores at the start. Unfortunately, the mundane housekeeping is critical to your long-term success as a Lightroom user. When importing photos and instructing Lightroom to copy or move them to a new location, pay close attention to the settings in the Import screen's Destination panel. The settings you choose here determine where your photos go. Lightroom only does what it is told to do, so make sure you know what you are telling it each time.

The rest of this chapter is devoted to diving deeper into what makes Lightroom tick and into those housekeeping chores. I know I said they were mundane, and, yes, the discussion can get technical and even boring. Resist the urge to skip ahead; that's what gets people into trouble. Sticking with it to really understand how these pieces work together will save you hours of wasted time and frustration down the road. Once you come to terms with where these important files are stored, how they work together when you launch Lightroom, and your own very important role in making the important decisions that affect everything, you will be a much happier Lightroom user.

# What to Do Before You Start Using Lightroom

Lightroom is not a magic wand that you can wave to solve all your organizational problems. It is just a tool that, when used the right way, can make those critical organizational and maintenance tasks more efficient over time. Lightroom doesn't work in a vacuum, though, and there are things you can do outside Lightroom to get started off right and keep things running smoothly.

## Get Your System Ready

Nothing has a bigger impact on Lightroom performance than your own system. Here are two things you can do for free.

### Free Up Space on Your Startup Drive

Your computer needs a certain amount of free space to run smoothly. A good guideline is to keep at least 20 percent of your startup drive free and clear of data at all times (granted, the larger your startup drive the more flexibility you have). Your operating system and applications need the elbowroom to operate. Running out of space can

**NOTE** When moving photos to another drive, do so from inside Lightroom to maintain the connection between the catalog and your photos. We'll cover how to do this in Chapter 3, so hold off on that for now.

seriously affect performance. Set aside some time to uninstall unused applications, delete unused files, empty your Recycle Bin or Trash, and move data to another internal drive or to an external drive. It's no more fun than emptying your real trash can, but it's just as worthwhile and necessary.

## Run Your System's Disk Maintenance Functions

**TIP** Adobe offers an excellent resource for learning about hardware choices that will help Lightroom run optimally. For more information, see optimizelr .robsylvan.com.

Which disk maintenance functions you need to run depends on your operating system. Windows offers two utilities that can help keep your system running in optimal condition: Error-Checking and Disk Defragmentation. To find these, double-click My Computer, right-click the C drive, choose Properties, and go to the Tools tab. Run the Error-Checking utility first, reboot, and then come back and defragment your disk, if necessary. (If the utility shows that your drive is not fragmented, you can skip this step.) These operations can take some time to complete, so you might consider running them overnight.

On a Mac, you have Disk Utility, which resides in the Utilities subfolder of the Applications folder. After you launch Disk Utility, select your disk, click the First Aid tab, and then click the Repair Disk Permissions button. It's a good idea to run Disk Utility before and after you install any application, as a regular part of your workflow.

# Get Your Photos Ready

If you have not yet imported a single photo into Lightroom, this section is for you. Even before you launch the program, you can do a few things with your photos that will help you (and Lightroom) later.

## Pre-Lightroom

**WARNING** Don't move your photos outside Lightroom if you have already imported them into the program. If you move imported photos outside Lightroom, you break the connection between the photos and the catalog and create a new problem for yourself. Don't do that.

If you're brand new to Lightroom, you may find it more efficient to organize your photos into a logical folder structure *before* you run those photos through the import process. It is not that you can't create and organize folders in Lightroom later—you sure can (and you will). But your system browser is probably more comfortable and faster for you to use. Instead of trying to learn Lightroom's controls at the same time, you can focus solely on consolidating all photo folders into one location, renaming folders in ways that make more sense, deleting all the duplicate images, and really wrapping your arms around your existing photo collection.

## Consider the Future

I do not believe that there is one right way to organize your photos. There are as many different ways to approach photo organization as there are different ways to approach photography. Just as with photography, however, sticking to a couple of core concepts will help you. Specifically, the organizational scheme you choose must:

▶ Make sense to your brain

▶ Be able to scale into the future

For my brain, keeping the folder structure based on a combination of dates and descriptive words keeps things simple—plus, this approach scales nicely into the future. For example, on each hard drive I use to store photos, I create a parent folder at the top level and name it Imported Photos. Within that folder is a date-based folder structure organized by year. Within each year folder are subfolders named with the date of, and a descriptive phrase for, each shoot. The descriptions give me a clue about the shoot's subject or location (**Figure 1.3**).

**Figure 1.3** A date-based folder structure like this one scales easily into the future.

Keeping all photo folders in a single top-level parent folder makes it much easier to move them to a new drive, in the not-too-distant future, when you start to fill up your current drive—or if you have to restore from a backup after a disaster. This is not to say that you have to keep them all in a single folder, but just trust me that you will thank me for this later.

In my years of using Lightroom, there have been times when my photos were stored across multiple drives (internal and external) and other times when I needed only one. As I write, I have my entire photo library stored on a single 4 TB external drive. Lightroom doesn't care how many drives you use. It just has to make sense to you and fit your needs.

Lightroom itself defaults to a date-based folder structure that uses the capture time embedded in each photo, so it is easy to automate the creation of that folder structure into the future as part of the Import process. If you prefer, however, you can disable that date-based option and manually create folders based on event, location, subject, or whatever makes sense to your shooting style. (We'll cover all the Import options later on.)

Whatever organizational approach you choose (try the single parent folder; you'll thank me later), take time now to think it through and formulate a plan. When it comes time to meet the Import dialog box, you'll know what you want to do, and your existing photo library will be ready to be imported.

# Key Lightroom Files

The catalog is where all the information about your photos is stored, but there are other files that Lightroom uses to display what you see when you launch the program. In addition to the catalog, these files include the following:

▶ Application (Lightroom itself)

▶ Preview caches

▶ Preferences file

▶ Presets, templates, and (optionally) plug-ins

## The Lightroom Application

**NOTE** Lightroom is nearly identical on Windows and Mac, but there are differences in a few menus, keyboard shortcuts, and file locations because of differences in the operating systems. I will call these out as we come to them and even show screen captures from both operating systems when necessary.

I recommend installing the Lightroom program in its default location (Program Files/Adobe on a Windows system, and the Applications folder on a Mac), which if you just clicked all the Next buttons during installation is precisely where it is located. Installing Lightroom anywhere else can lead to problems, so stick to the defaults as the installer walks you through the process. If you are concerned about space on your startup drive, there are other things you can do to reduce Lightroom's footprint; I cover them later.

## Catalog and Preview Caches

When you open Lightroom, you are doing two things:

▶ Launching the program

▶ Opening a Lightroom catalog

This is very different from how many other programs operate. For example, you can open Photoshop without opening an image, but it is impossible to open Lightroom without also opening a catalog. Your Lightroom catalog can be located on any drive on your computer, but by default it will be found in My Documents/Pictures/Lightroom on Windows systems and in Pictures/Lightroom on a Mac.

Inside this Lightroom folder you will find your Lightroom catalog, which has the *.lrcat* file extension. As soon as you start importing photos, the catalog will be joined by its companion preview cache, which has the *.lrdata* file extension (**Figure 1.4**). The .lrcat file holds all the data about your photos as well as all the work you do inside Lightroom. The .lrdata file holds all the previews of your imported photos.

**NOTE** Lightroom cannot open a catalog over a network, so technically you can put a Lightroom catalog only on an internal or local external drive.

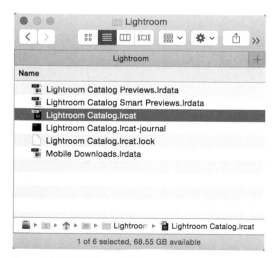

**Figure 1.4** The Lightroom folder contains the catalog and its associated cache files.

As you can see in Figure 1.4, there are actually a few different types of cache files, including the following:

▶ **Lightroom Catalog Previews.lrdata:** This stores the previews you see in the Library, Slideshow, Print, Web, and Map modules. There are multiple versions of these previews in different sizes (from Filmstrip size up to full 1:1 previews), which can make this preview cache quite large over time.

▶ **Lightroom Catalog Smart Previews.lrdata:** This preview cache holds any Smart Previews you create. The size of this cache depends entirely on how many Smart Previews you have rendered; if you don't use any, you won't see this file at all. (More on Smart Previews shortly.)

▶ **Mobile Downloads.lrdata:** If you are a Creative Cloud subscriber and you also use the Lightroom Mobile app for iOS or Android, then you may have a Mobile Downloads .lrdata file. This is where Lightroom stores photos that are synced from your mobile device and downloaded to your computer.

When you have your catalog open in Lightroom, you will also see Lightroom Catalog. lrcat.lock, which helps prevent other programs and users from opening the catalog, and Lightroom Catalog.lrcat-journal, which helps preserve data in case of a computer crash. As soon as the catalog is closed out of Lightroom, those two helper files automatically disappear. You don't have to do anything with those files, and if you never open the folder containing the catalog when the catalog is open in Lightroom, you'd never know they're there.

## Smart Previews

In Lightroom 5, Adobe introduced a type of preview file, called a Smart Preview, that provides additional ways to work with offline photos. As mentioned, Lightroom stores the path to each imported photo in the catalog, and Lightroom needs to be able to access photos for certain key functions, such as editing in the Develop module or exporting copies for output.

If you store all your photos on an internal drive, then you'll always be able to access them inside Lightroom, but many people don't have room for their entire library on their internal drive, so they use external and network drives to store their photos. External drives are great, but they may not always be attached to your computer, and when those drives are offline, your photos are also offline, and that can severely limit the work you can do inside Lightroom.

To address this dilemma, Adobe created the Smart Preview, which is a special type of preview file that contains the important data Lightroom needs for editing purposes in a compressed package, allowing you to do more in Lightroom when the source photos are offline for any reason. Chapter 9 explores how to use Smart Previews in an offline workflow. For now, you just need to be aware of the basics.

## How Many Catalogs?

The simple answer to this question is that you need just one—one catalog to rule them all! Think back to the example of the traditional card catalog: It makes sense to have a single, central card catalog to house all the data about all the books in the library. The books can be spread across an infinite number of shelves in various rooms and on different floors of the building, but it makes your life much simpler to have a single catalog to open when you want to find a book. How much more difficult would it be to find a book if there were separate card catalogs for each year that books were published? Or if there were one card catalog for books on people, another card catalog for books on outdoor photos, and another for books on cats? Where would you look for a book about people with outdoor cats? If you are just getting started with Lightroom, having a single catalog will make your life and many tasks much simpler.

The purpose of the catalog is to keep track of all your photos in one place. If you have multiple catalogs, then you need an external system for knowing which catalog is managing which photos. Of course, there are good and logical reasons for why someone might have multiple Lightroom catalogs. For example, a professional photographer might want to devote one catalog to family photos and another to client photos. We'll look at how to deal with multiple catalogs and even how to merge them into one in Chapter 9.

## Managing the Lightroom Cache Files

Now that you know a bit more about the various files that make Lightroom tick, let's look at ways you can keep those files in check. Lightroom provides a few configuration settings to help you manage the size and growth of the main preview cache. Go to Edit > Catalog Settings (or Lightroom > Catalog Settings on a Mac), and click the File Handling tab to access the File Handling panel (**Figure 1.5**). At the top of the panel's Preview Cache section, you can see the preview cache's current size, and the size of the Smart Preview cache is displayed in the Smart Previews section. This is useful for tracking how large those caches are getting. My preview cache is at 54 GB, and that is for a catalog managing more than 130,000 photos. The smaller your catalog, the smaller that cache will be.

If your cache file size is growing too large, you can take control in the File Handling panel. Three settings here have an impact on the size of the preview cache: Standard Preview Size, which controls preview pixel dimensions; Preview Quality, which determines the amount of JPEG compression applied to previews; and Automatically Discard 1:1 Previews, which specifies how long to keep 1:1 (full-sized) previews before deleting them.

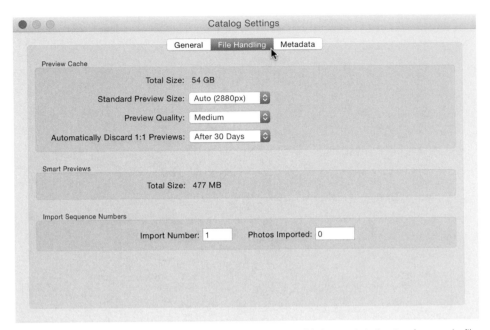

**Figure 1.5** The File Handling panel of the Catalog Settings dialog box will help you rein in the size of your cache file.

Standard-size previews are the thumbnails you see in Grid view, the Fit Screen previews in Loupe view, and the previews displayed in slideshows, print layouts, and web gallery layouts. Ideally, you would set Standard Preview Size to about the same width dimension as your monitor's resolution to control the maximum pixel width of the preview files. On my MacBook Pro, with its display of 2880x1800, for example, I have my previews set to 2880. My Windows desktop runs a display resolution of 1920x1200, so for it I set Standard Preview Size to 2048. The smaller the pixel dimensions, the less cache space they require. New to Lightroom CC 2015/Lightroom 6 is an Auto option for Standard Preview Size, which is set by default and which is perfectly fine if you want to just set it and forget it.

For the Preview Quality setting, the default of Medium is usually fine. Think of this as the amount of JPEG compression applied to the previews. More compression means a smaller file size but has a larger impact on quality. Medium is a good compromise between file size and quality. If space is not an issue or if you notice artifacts in your previews, change this setting to High.

The last setting to consider is a schedule for discarding 1:1 previews. Viewed in the Library module, a 1:1 preview is essentially a full-size (a 1:1 ratio, or 100%) JPEG copy of your source photo. After a while, these can really take up a lot of space! The purpose of any cache is to speed up viewing time by keeping a copy at the ready

whenever you need it. However, Lightroom will always render new 1:1 previews as needed. If space is tight, change the Automatically Discard 1:1 Previews setting to After One Week to dampen the growth of the preview cache.

## A Clean Slate

If your preview cache is unmanageably large and ordinary housekeeping chores don't improve matters, you can simply delete it (the .lrdata file) and then let Lightroom re-render a fresh cache. The upside of this approach is that it gets rid of a lot of previews of deleted files, reclaims wasted space, and allows Lightroom to start fresh. The downside is that it slows performance while new previews are being rendered. Plus, if you have any photos stored offline (such as on disconnected external drives), those previews won't be rendered until those files are back online. Remember that the preview cache is important but not required for backup. You don't need to delete it under normal operation, but it is not the end of the world if you do.

OK, now that you have your Lightroom catalog and preview cache under control, let's look at a few things you can do to optimize overall performance.

## Configure Preferences and Catalog Settings

The preferences file is where all program-wide settings are configured and stored. Although where and how you access this file and the configuration settings it holds depends on your operating system, the important settings themselves are common across all versions.

### Windows System Access

To access the configuration settings on a Windows system, choose Edit > Preferences. The actual preferences file is stored here:

Users/[username]/AppData/Roaming/Adobe/Lightroom/Preferences Lightroom [version number] Preferences.agprefs

Be aware, however, that sometimes Windows likes to hide folders from you for your own protection. If you can't see the Preferences folder, you can use a shortcut to it: Open Lightroom, choose Edit > Preferences > Presets, and click the Show Lightroom Presets Folder button. This will open Windows Explorer to the Lightroom folder that holds the Preferences folder.

## Mac Access

On a Mac, you can access the configuration settings by choosing Lightroom > Preferences. The preferences file is stored here:

[username] /Library/Preferences/com.adobe.Lightroom [version number] .plist

With recent versions of the operating system, Apple has made it harder to find the Library folder. Open a new Finder window, choose the Go menu, and then hold down the Option key to reveal the Library option in the list. Choose Library and proceed to the Preferences folder.

## Key Preferences Settings

Lightroom is very good at doing exactly what it is told, but unfortunately, a lot of people don't realize just what they are telling Lightroom to do. By relying on the default preferences settings, you (and your photos) are basically just going along for the ride. To get in the driver's seat and make decisions about what Lightroom does or does not do, start with customizing the preferences. To help you, the next sections highlight the settings that every Lightroom user needs to understand, starting with the General tab.

## General Preferences

Possibly the most important Preferences setting, not only in the General tab but of all, is "When starting up use this catalog," in the Default Catalog section (**Figure 1.6**). Adobe sets this to "Load most recent catalog." In theory, if you have only a single catalog, this setting works just fine because you only ever open one catalog and it is always the same catalog. In reality, I can't tell you how many times the unspecific nature of this default has caused huge headaches for people.

It always starts off innocently: Curious, you decide to look in the Lightroom catalog backup folder, where all the backup copies of the Lightroom catalogs are stored. You open one of the catalog backup copies (just to see what happens) and then watch as it harmlessly opens into Lightroom. Curiosity satisfied, you quit Lightroom. When you next launch Lightroom to get back to work, the program simply does what it is told and opens the most recent catalog upon startup, which of course was that old backup copy. Because the backup copy is an exact duplicate of the working catalog, it is easy to miss the fact that you are looking at the backup, so you go to work importing new photos and editing existing ones. From this point forward, until you realize something went wrong, that old backup copy has become the new working catalog and your original working catalog is just left sitting unused. While not impossible to untangle, it is a real time waster and an all-around frustrating process.

**NOTE** On both operating systems, a list of recently opened catalogs resides in a separate Startup preferences file that is stored in your Presets/Preferences folder. This is kept separate from the other user preferences so that you can trash your user preferences without losing the list of recently opened catalogs. (See the appendix for more information.)

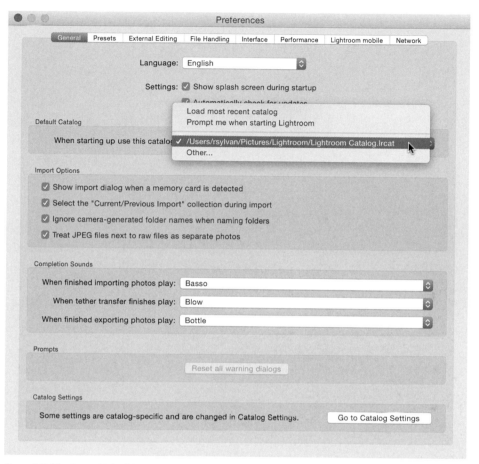

**Figure 1.6** The General tab of the Preferences dialog box contains one of your most important settings.

Avoiding this headache is easy. Change the "When starting up use this catalog" setting to specify the name of the catalog you always want to open. If you have multiple catalogs, choose "Prompt me when starting Lightroom." Either way, you are in control of deciding specifically which catalog you want to open every time you launch Lightroom.

If you shoot Raw+JPEG, I also recommend turning on "Treat JPEG files next to raw files as separate photos." When this preference is selected, Lightroom shows both versions of the photo side by side in the catalog. When it's unselected (the default), you see only the raw versions, which I think defeats the purpose of shooting Raw+JPEG to begin with. If you shoot only Raw files, the setting doesn't matter. No matter what you shoot, the rest of the settings in the General tab are up to personal preference.

## Presets Preferences

The next tab to investigate is the Presets tab (**Figure 1.7**). The choices in the Default Develop Settings section are largely a matter of personal preference. Lightroom allows you to customize your default Develop settings (which is a real time-saver that lets you apply your preferred Develop settings to all newly imported photos automatically). Using the options on the Presets tab of the Preferences dialog box, you can, by selecting the respective boxes in this section, tie those customized settings to specific camera serial numbers (which could be helpful when you're shooting with multiple bodies of the same camera model) and to specific ISO settings. (You'll learn more about these settings in Chapter 7.)

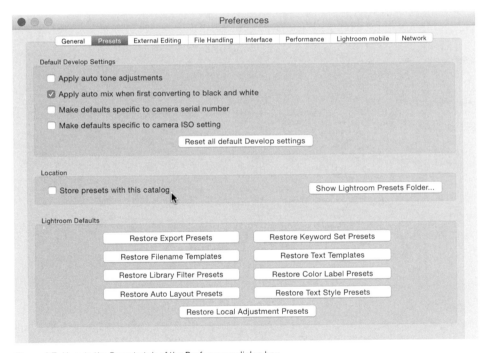

**Figure 1.7**  Here is the Presets tab of the Preferences dialog box.

The biggest trouble spot of the Presets panel is the "Store presets with this catalog" setting in the Location section. When it is unselected (the default), your custom presets and templates are kept in a central location and are available to all your catalogs, even across different versions of Lightroom (which I find most helpful). When you turn on the setting, Lightroom creates a subfolder named Lightroom Settings in the same folder as your current catalog file, and your catalog will refer only to that folder for all presets and

templates. The new Lightroom Settings folder will contain only the default presets and templates; Lightroom does not copy any custom presets or templates to it from the original central folder. If you've turned on "Store presets with this catalog" and then wondered why you could no longer access your custom presets from the Develop module, now you know. Of course, you can manually copy custom presets to their respective folders in the Lightroom Settings folder, but I suggest just leaving the setting off so that you are always accessing the same centrally stored collection of presets.

## External Editing Preferences

OK, let's take a look at the External Editing panel (**Figure 1.8**). External editors are any other image editing program that Lightroom can pass a photo to for additional editing.

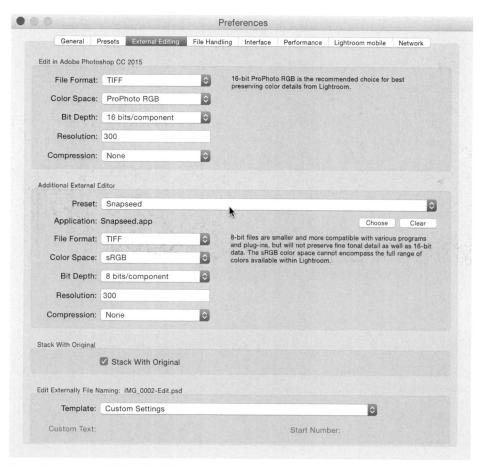

**Figure 1.8**  The External Editing tab of the Preferences dialog box helps Lightroom work seamlessly with other image editing programs.

The most common external editor is Adobe Photoshop, but there are a growing number of image editors from such companies as Nik, Topaz, ON1, and so on. By default, Lightroom designates the most recent version of Photoshop (or Photoshop Elements, if Photoshop is not installed) as the primary external editor (which appears at the top). Lightroom then uses the File Format, Color Space, Bit Depth, and Resolution settings when it creates copies to send to Photoshop (with Lightroom adjustments) for additional editing. I suggest sticking to the defaults for these. There is room for personal preference; mine is that if you shoot in the Raw format, you should edit copies in 16-bit and the ProPhoto RGB color space to get the most out of all that data you captured. If you use Photoshop Elements or would just rather work with 8-bit files, then change the Bit Depth setting accordingly and set Color Space to Adobe RGB.

**NOTE** Some editing applications designed to work with Lightroom, such as the Nik Collection from Google and ON1 Photo 10 from ON1, create their own links into Lightroom when you install them, so there's no need to manually configure them in Preferences.

Most of the questions I hear about this panel are about the Additional External Editor section. Its purpose is to allow you to seamlessly send copies from Lightroom to other image editors. For example, I have the desktop version of the Snapseed app from Nik on both my Windows and Mac computers, so I configured Snapseed to be an additional external editor, and now I can "round-trip" files from Lightroom to Snapseed just like I do to Photoshop. To set your own external editor, click the Choose button, navigate to the external editor, and select it in the resulting browser window. After you set the File Format, Color Space, Bit Depth, Resolution, and Compression parameters, you can save all the additional editor settings as a preset by clicking the Preset drop-down menu and choosing "Save Current Settings as New Preset" (**Figure 1.9**). You can configure presets for multiple editors and then easily switch between as many external applications as you like based on what apps you have installed.

**Figure 1.9**  Save a new additional external editor as a preset.

## File Handling Preferences

The default settings for the File Handling panel (**Figure 1.10**) are spot on for most users. To improve performance, however, you may wish to customize the Camera Raw Cache Settings section. The role of the Camera Raw cache is to speed up performance by storing the base rendering of the Raw photos you're currently working on in Develop, enabling Lightroom to update what you are seeing faster. By default, this cache is set to only 1 GB, which is pretty tiny. You can increase to a maximum of 200 GB, but that is overkill. If you have enough free drive space, try something in the 5 to 10 GB range to see if that has a positive impact on your workflow. If you have multiple internal drives, then you can also click the Choose button and relocate the cache to a faster drive or to a drive with more free space.

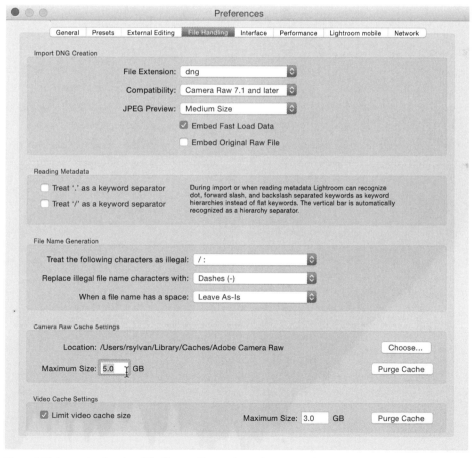

**Figure 1.10** Increasing the size of the Camera Raw cache can improve performance.

## Performance Preferences

Although most of the remaining panels are self-explanatory and work well with the defaults, the Performance panel (**Figure 1.11**) is a source of trouble for some Lightroom users. The Performance panel was introduced in Lightroom CC 2015/6, the first version that was able to leverage the power of your computer's graphics processor (GPU) in the Develop module. This is good news for most Lightroom users, especially for those with newer machines and powerful GPUs. However, it has created some problems for users with less capable GPUs or out-of-date drivers. If you are experiencing any problems, such as crashing, slow performance, or general weirdness in the Develop module, try turning off the Use Graphics Processor box and see if that helps. In addition, make sure your graphics card's driver is up to date (Windows users may need to check the website of the GPU maker for an update).

**Figure 1.11** Using the graphics processor is great when it works but can be a problem when it doesn't.

Now that you have a much firmer understanding of how Lightroom works and its relationship to your photos, you're ready to delve into the import process and get fully oriented to the Library module, which is the subject of the next chapter.

# 2

# GETTING ORIENTED TO THE LIBRARY MODULE AND IMPORTING

When you open Lightroom, remember that you are really opening a catalog file. When you subsequently work with your images, you are accessing and changing the data contained within that catalog. Lightroom's import process is the gateway your photos must pass through to be recognized by the catalog. Think of it like a cocktail party: Your photos are introduced to the catalog first, just like you would be introduced to the party's host when you arrive, and then everyone goes on to have a good time later.

During the import process, Lightroom creates a new database entry for every photo and fills that entry with the information contained in each photo's metadata, as well as with each photo's filename and storage location on one of your disk drives. That is the sole purpose of importing. Once Lightroom has been introduced to each photo, you can go on to access those photos inside each of Lightroom's seven different modules, including the all-important Library module.

Before we can get into the ins and outs of the import process, however, you need to have a good understanding of the role of the Library module. The Library module is really the hub of your Lightroom experience and where you complete the file management tasks that compose a lot of your post-processing workflow—making selects, deleting rejects, batch processing, applying keywords, organizing into collections, renaming, applying metadata, and so on. It is from the Library module that you'll launch the Import screen, and it is to the Library module you will return after the

importing is done. Once you get oriented to the Library module, the different ways it can be used to view your photos, and how you can customize the interface to suit your workflow, we'll dive into the import process itself.

# The Library Module's Interface

A few core interface elements and behaviors are consistent across all of the modules in Lightroom. Although this book is primarily focused on tasks related to the Library module, this tour of that module's interface covers features that apply in other modules too (**Figure 2.1**).

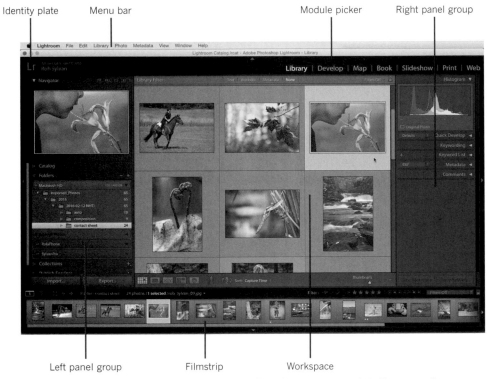

Identity plate    Menu bar    Module picker    Right panel group

Left panel group    Filmstrip    Workspace

**Figure 2.1** The Library module contains all the tools you'll need to manage your photo library over time.

## Menu Bar

Across the very top of the screen in all modules is the main menu bar, which is where you can dive into the various commands that are related to the module you are in and to Lightroom as a whole. This is also where you see one of the few differences between

how Lightroom appears on a Mac versus on Windows. On a Mac, there is a Lightroom menu, which the Windows version lacks. When you run Lightroom on a Windows system, the Edit menu contains most of the commands that appear under the Mac's Lightroom menu. I'll highlight this anytime such differences occur. Additionally, each system's interface has unique buttons for closing the current window, minimizing the window, or zooming the window. The Mac version uses red, yellow, and green buttons, respectively, on the top left of the interface (**Figure 2.2**), whereas the Windows version uses three buttons on the top right of the interface (**Figure 2.3**).

**Figure 2.2** Here are the close, minimize, and zoom buttons on a Mac.

**Figure 2.3** These are the minimize, maximize, and close buttons on Windows.

I draw your attention to these minor differences because they are the source of some of the most common questions I hear. Some Lightroom users are not familiar with the other operating system, and they get thrown off when they see the alternate controls depicted in books and videos. Those buttons are also hidden in Full Screen mode (which we'll cover in just a bit), and that causes a bit of confusion too. I use Lightroom in Full Screen mode 99 percent of the time, so you won't see the window sizing controls much in this book.

## Identity Plate and Module Picker

At the top of the Lightroom interface itself are the identity plate (on the left) and the Module Picker (on the right). By default, the identity plate shows the version of Lightroom you are using, and it may also display progress meters or other information when Lightroom is performing some task (**Figure 2.4**).

**Figure 2.4** In this case, an export is in process.

The Module Picker is just a series of labels that act as buttons to navigate between Lightroom's modules. The highlighted label indicates which module you are in.

## Left Panel Group

On the left side of the interface, you'll typically find the panels that give you access to your photos (the Catalog, Folders, Collections, and Publish Services panels in this module) or display the active or most selected photo (Navigator). The chapters that follow take a much closer look at the Folders and Collections panels. At the bottom of the left panel group, take particular notice of the Import and Export buttons, which launch the Import screen and the Export screen, respectively.

## Right Panel Group

On the right side of the interface are the panels that relate to the tools and purpose of the module in which you are currently working. In the Library module, you'll find the Histogram, Quick Develop, Keywording, Keyword List, Metadata, and Comments panels on the right, but each module displays a unique set of panels. At the bottom of the right panel group are the Sync Metadata and Sync Settings buttons, which help you quickly apply metadata and develop settings from one photo to many others. You'll learn to use many of these panels and functions in later chapters.

## Filmstrip

Along the bottom of the interface is the Filmstrip, which displays all the photos in the current view, whether you're viewing a folder, a collection, search results, or your entire library. The Filmstrip is consistent throughout all modules, just like the identity plate and Module Picker at the top. You can use it to select individual or multiple photos, as well as see at a glance how many photos are selected and the source you are currently viewing (**Figure 2.5**).

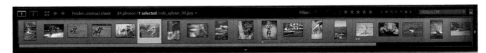

**Figure 2.5**  The current view is a folder named contact sheet, containing 24 photos. One photo is selected: rob_sylvan_09.jpg.

That path is also a clickable link to other quick routes to your photos (**Figure 2.6**).

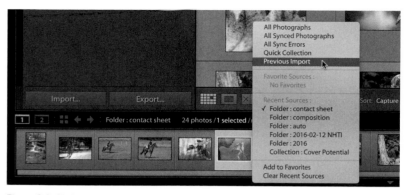

**Figure 2.6** Clicking the path in the Filmstrip opens a context menu that provides easy access to recently visited sources, the previous import, the entire library, and more.

## Main Workspace

In the center of it all is the main workspace where your photos are displayed. For example, Figure 2.1 uses Grid view (more on the other views coming up). When in Grid view, Lightroom displays a bar across the top of the thumbnails: the Library Filter bar, which can be used to control which photos are visible based on your filter settings (**Figure 2.7**); you'll put the Library Filter bar to use in Chapter 8.

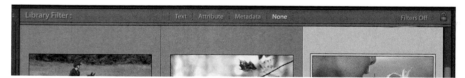

**Figure 2.7** The Library Filter bar is a powerful tool for displaying only photos that match specific criteria.

At the bottom of the workspace is the toolbar, which displays a set of tools relevant to the module you are in at the time (**Figure 2.8**). You can configure which tools are displayed by clicking the disclosure triangle on the far right of the toolbar. The toolbar is notorious for disappearing without users knowing, so keep in mind that pressing the T key shows and hides the toolbar if you need to bring it back or hide it.

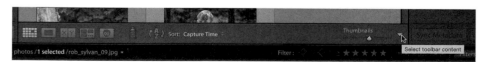

**Figure 2.8** The contents of the toolbar change as you change modules.

Now that you're familiar with the module in which we'll be spending most of our time, take a closer look at the options for viewing your photos in the Library module.

# Library View Options

The most popular way to view your photos in the Library module is Grid view, shown in the last section, but Lightroom offers four other view options:

▶ Loupe view

▶ Compare view

▶ Survey view

▶ People view

You can switch between each view by using the view buttons on the toolbar (**Figure 2.9**), but learning the keyboard shortcuts is much faster. If you hover your cursor over each button, you'll see the name of the view and its shortcut in a tool tip. Each view is displayed within the main workspace.

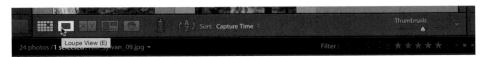

**Figure 2.9**  Learning the shortcuts for each Library view is a real time-saver.

## Grid

When you need to see your photos as a series of thumbnails, Grid view is the place to go. Grid view is great anytime you need to do something to or with multiple photos at once, such as selecting multiple photos to export as copies, to move to a new folder, to apply the same keywords to, to apply the same preset to, and so on.

The toolbar offers a slider for increasing or decreasing the size of the thumbnails, but here again, the + and − keys on your keyboard are a faster way to do the same job.

You can configure what information (if any) is displayed on the thumbnails by choosing View > View Options and configuring the Grid View tab of the Library View Options dialog box (**Figure 2.10**). You can cycle through each Grid view style by pressing the J key.

Here are a few more tips for working in Grid view:

▶ To select all photos in Grid view, press Ctrl+A (Mac: Command+A).

▶ To select a contiguous group of photos, select the first photo and, while holding the Shift key, select the last.

▶ To select a non-contiguous batch of photos, hold the Ctrl key (Mac: Command key) while you click each thumbnail.

▶ To change the way the thumbnails are sorted, use the Sort menu in the toolbar or choose the View > Sort menu.

These tips work in the Filmstrip as well.

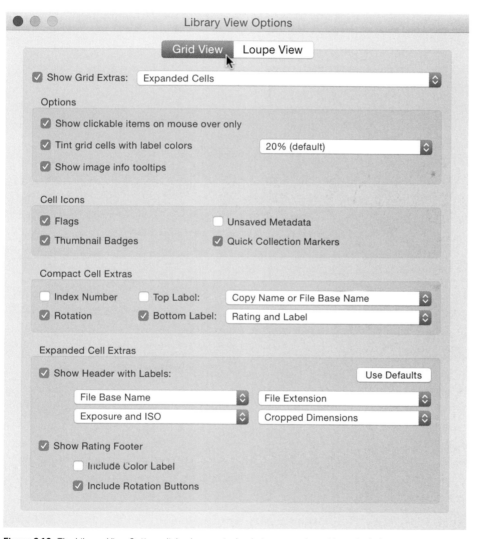

**Figure 2.10**  The Library View Options dialog box controls what you see alongside each photo.

## Loupe

Thumbnails are useful for a lot of jobs, but sometimes you just need to see a large version of a single photo, and that is where Loupe view comes in handy (**Figure 2.11**). To switch to Loupe view, you can use the button in the toolbar or press the keyboard shortcut (E). In addition, if you are in Grid view, you can double-click any thumbnail to switch to viewing that photo in Loupe view. When you're in Loupe view, any work you do is applied to the active photo only, even if you have multiple photos selected in the Filmstrip.

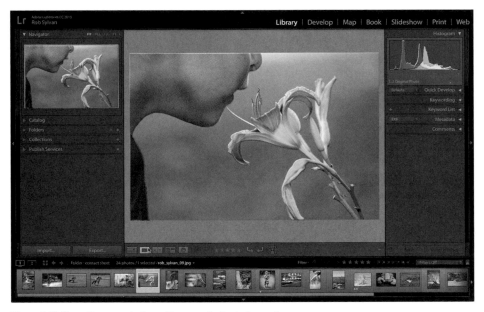

**Figure 2.11** Sometimes you just need to see a single photo up close.

Once in Loupe view, you can click the photo to zoom in and examine it up close. While zoomed in, you can drag to pan around within the photo. The Navigator panel has a role here too. Notice that while you're zoomed in to a photo, a white rectangle appears in the Navigator, indicating the zoomed area you see in the workspace (**Figure 2.12**). Drag that white rectangle in the Navigator to pan around the photo. Along the top of the Navigator panel, you can set the zoom level, from Fit (fits the entire photo in view) to Fill (fills the workspace with the photo) to 1:1 (zoomed to 100%) to 3:1 (300%), or click the double-headed arrow to choose another level (it goes up to 11!).

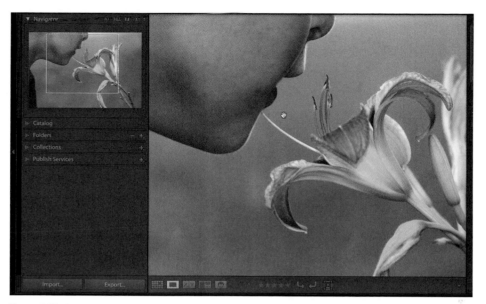

**Figure 2.12**  The Navigator panel allows you to interact with the photo and set the zoom level.

Loupe view has its own way to display information about your photos, which is controlled by the same Library View Options dialog box that Grid view uses (Figure 2.10)—except you click over to the Loupe View tab. The information is displayed as an overlay on your photos, which you can cycle by pressing the I key.

## Compare

Sometimes viewing a single photo is not enough to help you make a decision, and this is when Compare view comes into play. Imagine you have a series of similar images and you want to compare one against the other to determine which was the best of the bunch. I usually start by making my selection in Grid view and then press the C key to enter Compare view, but you can also make your selections from the Filmstrip after you are in Compare view.

Compare view provides a side-by-side view of the two most recently selected photos. The active photo is on the left (referred to as the *select* and indicated by a white diamond on its Filmstrip thumbnail), and the photo you selected previously (referred to as the candidate and indicated by a black diamond on its Filmstrip thumbnail) is on the right (**Figure 2.13**).

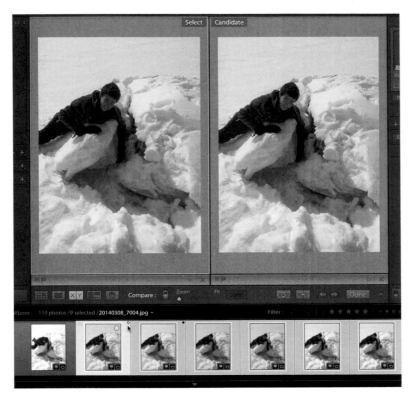

**Figure 2.13** Compare view allows you to examine two photos side by side.

By default, the zoom level of the select and candidate are locked together; if you zoom in to one, you zoom to the same point in the other as well, which is great for comparing at a 1:1 ratio. You can unlink that focus by clicking the lock icon on the toolbar. When working unlinked, you can click the Sync button on the toolbar to bring the other photos to the same level.

If you select more than two images to compare, use the arrow keys on your keyboard to scroll through the selected candidates one by one. If you find a better version of a photo and want to make it the new select, click the Make Select button in the toolbar to upgrade the current candidate to the select and demote the current select down to candidate (**Figure 2.14**).

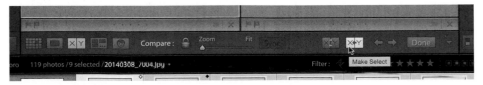

**Figure 2.14** The buttons on the toolbar change to provide the right tools for the view you are in.

## Survey

When you want to view multiple photos at the same time and then refine your selection, head over to Survey view by pressing the N key (as in refi*N*e). I usually make my initial selection of photos in Grid view and then jump over to Survey. Lightroom fits each selected photo into the main content area by dynamically resizing the thumbnails to fill the available space, making them smaller or larger as more photos are added to or removed from the selection. For this reason, Survey view works best with a relatively small number of selected photos (**Figure 2.15**).

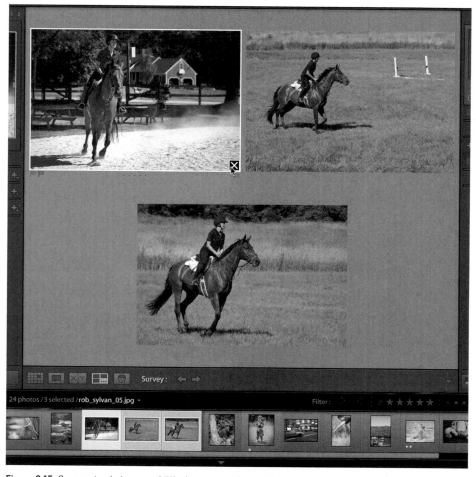

**Figure 2.15** Survey view helps you whittle down your selection to the ones you want.

The key function of this view is the ability to narrow down your selection choices by simply removing photos from the view without worrying about removing the photos from the folder or collection. Just click the X under any photo to remove it from view. Lightroom will continue to dynamically resize the remaining photos to fill the screen.

## People

People view was added to Lightroom CC 2015/Lightroom 6 as part of its new facial recognition function for helping you find and tag the people photos in your library. Chapter 8 covers how to use facial recognition, but for now, just know that this view is where you will perform the task of assigning names to the faces Lightroom finds (**Figure 2.16**).

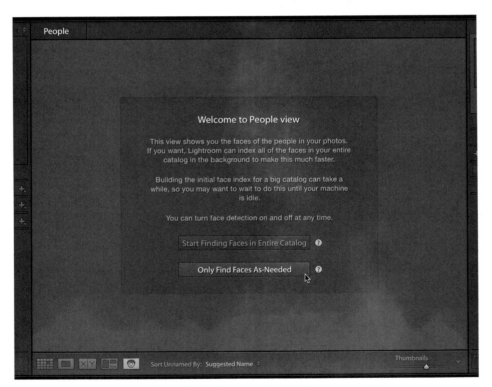

**Figure 2.16**   People view is for finding and assigning person tags to the faces in your catalog.

# Customizing the Interface

Lightroom's interface can be customized to maximize the space devoted to your photos, to make your workflow more efficient, and to hide the parts you just don't use very often.

## Screen Modes

You have the ability to switch between a few different screen modes. The modes are listed under Window > Screen Mode, along with their respective keyboard shortcuts. You can cycle through them one at a time by pressing Shift+F. Remember, too, that you can still access the menu bar while in Full Screen mode. Just move your cursor to the very top of the screen, and the menu bar will pop down automatically (**Figure 2.17**).

**TIP** Full Screen Preview (press F) takes the selected photo to full screen, and it is handy when you want to clear all the clutter and see nothing but your photo filling the screen. Press F again to return to the full workspace.

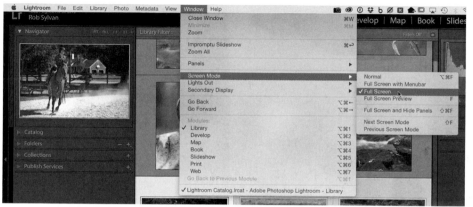

Figure 2.17  You can still access the menu bar in Full Screen mode.

## Collapsing Panels

As mentioned, four main panels—the Module Picker, left panel group, right panel group, and Filmstrip—appear in all Lightroom modules. They can be manipulated as needed to allow you to control the size of the main workspace, where your photos appear, as well as to reveal only the set of tools required for the task at hand.

You can collapse any panel completely by clicking its outside edge; you don't need to click the arrow on the outside edge. If you right-click the outside edge, however, you'll get a context menu that gives you a greater level of control (**Figure 2.18**).

I find the default option of Auto Hide & Show a little annoying, as it automatically shows the panel if your cursor gets too close to the edge, which happens too often for my taste. I prefer to set each panel to Auto Hide. When you choose Auto Hide, the panel automatically collapses, and it won't expand again until you manually click that panel's outside edge. The panel will then appear at a low opacity and allow you to access everything inside it. As soon as you move your cursor off the panel, it automatically hides again. This really helps me maximize the space devoted to my photos.

**Figure 2.18** The context menu for the outside panels gives you additional options for showing and hiding the panel.

**TIP** If you need to refresh your memory on shortcuts, choose Help > Library Module Shortcuts to display all shortcuts onscreen. Note that the option name changes depending on the module you are in.

Of course, as with most things in Lightroom, there's more than one way to get the job done. There are keyboard shortcuts for hiding and showing each panel group, and they're all listed in the Window > Panels menu.

While you may most often want to collapse panels to get them out of the way, you can also drag the left or right panel's inside edge inward to make it wider. I often make the right panel group in the Develop module wider to get a finer level of control on the sliders. Similarly, you can make the Filmstrip taller or shorter by dragging its top edge up or down, respectively. Note that if you make the Filmstrip too small, the icons that appear on the thumbnails will go away.

Now that you have a handle on how to manage the larger panels, take a look at what you can do with the smaller panels contained within the left and right panel groups.

## Individual Panels and Solo Mode

To cut down on the amount of scrolling you do in a day, as well as to reveal only the tools you need for a given job, you can expand or collapse an individual panel by clicking its header (not just the disclosure triangle). As an alternative, Ctrl-click (Mac: Command-click) any panel header to expand or collapse all the panels on that side at once.

A really neat trick is to Alt-click (Mac: Option-click) any panel header to engage what is called Solo mode (**Figure 2.19**). With Solo mode enabled, you're restricted to opening a single panel at a time within the larger panel group. This makes it very easy to switch between panels with a minimum of scrolling (if any). As soon as you expand a new panel, the last one you were using automatically collapses.

**Figure 2.19** When Solo mode is engaged, the disclosure triangles on the panel header are filled with a dot pattern. When Solo mode is off, the triangles are solid.

Alt-click (Mac: Option-click) any panel header a second time to disengage Solo mode in that group. Note that although the Navigator, Histogram, and Preview panels within the various modules can be collapsed or expanded individually, they are not included in Solo mode or in the Expand All/Hide All commands.

## Vanishing Panels

One panel option that most people seem to find by accident is the ability to completely remove a given panel from the panel group so that you no longer even see its header label. If you right-click any panel header—except the ones excluded from Solo mode—you can simply deselect any panel from the context menu that appears, and it will disappear from the group (**Figure 2.20**). Just re-select that panel in the menu to bring it back. You can also restore panels from the Window > Panels menu.

**Figure 2.20** The context menu for each panel allows you to hide the panel from the group.

## Lights Out

One last trick up the interface's sleeve is Lights Out mode. Lights Out comes in three flavors: Lights On, Lights Dim, and Lights Off. Lights On is the default and what you'll use all the time. Press the L key once to transition to Lights Dim, where the selected photos remain at full brightness but the interface dims. Press the L key again to transition to Lights Off, where the interface fades to black completely.

I love using Lights Off in conjunction with the Crop tool to get a real-time preview of the final crop. On the Interface tab of the Preferences dialog box, you can set the dim level and even change the Lights Out color from its default of black if you wish. Press L one last time to turn the lights back on.

Now that you've got a good handle on the role of the Library module, let's turn our attention to the import process itself.

# Importing Your Photos

Because the import process is the gateway through which all photos (and videos) must pass, Lightroom enables you to accomplish a few jobs via the Import dialog box as a way to save you time and effort. After all, one of the driving forces behind Lightroom's creation was to make a photographer's workflow more efficient.

To launch the Import screen, click the Import button at the bottom of the left panel group (**Figure 2.21**) or choose "Import photos and videos" under the File menu. Aside from creating a database record in the catalog for each imported photo, from the Import screen you can:

▶ Copy or move photos to a new destination on disk.

▶ Copy and convert copies of the source raw photos to DNG format.

▶ Rename copied or moved photos.

▶ Copy photos to a second location as a backup of the memory card.

▶ Add common keywords to all imported photos.

▶ Apply develop settings to all imported photos.

▶ Add common metadata to all imported photos.

And that's not all! These are the most common tasks you'll perform on a regular basis, but you can do a few other things, as you'll learn in Chapter 8, which goes step by step through the import process in the context of a workflow. For now, however, I just want you to get oriented to the import options.

**Figure 2.21** Click the Import button to launch the Import screen.

The way that these tasks get accomplished is through the settings and options on the Import screen (**Figure 2.22** on the next page). There are so many options that some people think of it as a module unto itself!

Choose source          Choose what happens          Choose destination

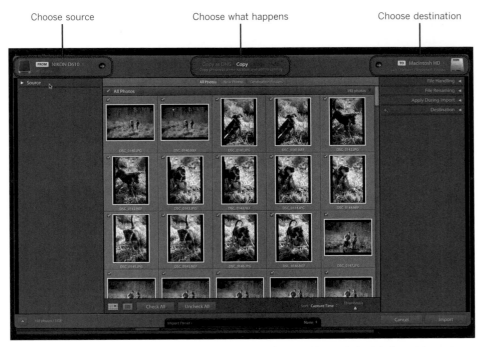

**Figure 2.22** The Import screen contains all the tools you'll need to import your photos into the catalog and perform a number of other tasks.

Like most things in Lightroom, the screen should be read from left to right and from top to bottom. Along the top you can see the basics of the import workflow, which starts with selecting the source for the photos (such as a memory card), followed by the action you want to take (copy, move, or add), and finally whether the photos are going to a new destination. That's it in a nutshell. The panels on the left and right sides of the screen provide additional options you can choose to configure for each batch of photos you introduce to the catalog. All the photos contained in the selected source appear in the center area of the screen. Take a closer look at the options.

## Choosing a Source

The location of the source photos is the primary factor in determining whether the import process will include copying or moving photos to a new location or whether it will just leave them where they currently reside. If you are importing photos from a memory card, then you have to choose to copy the source photos to your hard drive or copy and convert the copies to DNG.

Lightroom will not give you the option to move photos from a memory card. This is done for safety. If something were to go wrong during a move operation (such as a

power failure or accidentally unplugging the card reader by kicking its cord), you could lose data. By using a copy operation, you know that your source files are safe even if something goes wrong with the copy.

If you are importing photos that are already on your hard drive, then you have the option to just leave them where they are and add the data to the catalog, or if you wish, you can copy or move them to a new location. The choice is up to you for how you want to organize your photos on disk.

In the Source panel in **Figure 2.23**, for example, you can see under Devices a memory card named Nikon D610, and below that, in the Files section, other drives are listed (including the memory card since it is essentially just another removable drive).

**Figure 2.23** The source of the photos determines which options are available.

If I wished to select the photos on the memory card for import, I would select the memory card under Devices, which enables the "Eject after import" option in the Source panel and disables the Move and Add options at the top of the screen (**Figure 2.24**).

**Figure 2.24** The availability of the Copy, Move, and Add options varies with the selected source.

The Copy option is selected by default, but I could also choose "Copy as DNG," which means that Lightroom would copy the photos from the memory card to my chosen destination, and once that was done, it would proceed to convert any raw photos to Adobe's DNG file format. There are pros and cons to DNG, but in the end it is a personal choice. Keep in mind that you can always convert to DNG after import (under the Library menu), so you can take your time with this decision.

When you select a folder on your internal hard drive as the source, the process is a little different. In **Figure 2.25**, I selected a folder on my Desktop as the source and a few things changed. First, notice that there is now an Include Subfolders checkbox in the Source panel, which allows you to select just a top-level folder and include all the photos contained within its subfolders. This is really helpful when you are first importing your entire existing library. Second, the option on the top switched from Copy to Add. The Add option tells Lightroom to simply record the photos at their current location and not to move or copy them to a new destination. This is reinforced by the fact that the Destination panel vanishes from the interface completely.

**Figure 2.25**  Choosing a local folder opens up new import options.

You could still choose the Copy or Move option if you wanted to, but my recommendation is to manually copy or move the photos to a final destination of your choosing before getting to this step. If you're new to Lightroom, it will be a lot easier to copy and move files in the file browser you already know than to configure Lightroom to do it. Then, you can choose Add and know that the photos are already organized and located exactly where you want them.

## Choosing a Destination

When you are not using the Add option—which, after you get your existing library imported into Lightroom, will be what you use most when importing new photos from your camera—the most important decision you need to make is where to tell

Lightroom to put your new photos. This choice is configured in the Destination panel on the right side of the screen (**Figure 2.26**).

I wish the Destination panel were at the top of the right side because it is so important and so many people miss it when they get started, so I'm showing it to you first. I switched my source back to my memory card and chose the Copy option at the top. That means I want Lightroom to copy the photos from my memory card to a destination I choose here in this panel. As I mentioned, Lightroom uses a date-based folder structure by default, and that is entirely controlled by the Organize drop-down menu at the top of the Destination panel (**Figure 2.27**).

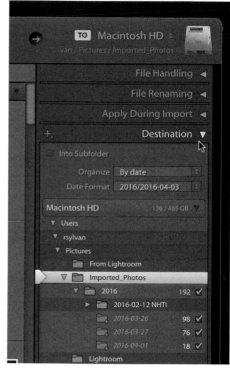

**Figure 2.26** The Destination panel controls where your photos are placed as part of the import process.

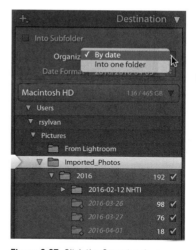

**Figure 2.27** Click the Organize drop-down menu to choose the structure that works for you.

When "By date" is selected, the Date Format menu right below it controls the way the date-based folders are created. Lightroom uses the date (and time) from each photo to create the folders, but the Date Format menu lets you control how you want those folders to look on your drive. For example, in **Figure 2.28** I selected the 2016/2016-04-03 option. Those dates are derived from the photos selected in the source, but that

structure translates to a parent folder for the year, and within that, a subfolder based on the day each photo was shot. If my memory card contained photos from multiple days (and it does), then Lightroom would create a subfolder for each day. There is no right or wrong choice, as long as it makes sense for your folder structure.

What if you don't want to use dates? Go to the Organize drop-down menu and choose "Into one folder" instead. Once that choice is made, the Date Format menu disappears, and Lightroom will simply copy all photos to the folder you select down below. OK, what if you want to create a new folder for a specific batch of photos? That's what the Into Subfolder checkbox at the top is for. Let's say I wanted to create a folder named "Hike to the Pond" for all the photos on this memory card and have that folder be inside my Imported_Photos parent folder. First, I would select the parent folder, then select Into Subfolder to access a field in which to enter a name for the subfolder, and then type the desired name (**Figure 2.29**).

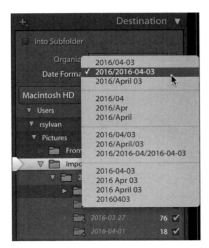

**Figure 2.28** You can choose a number of folder structure formats based on the date the photos were taken.

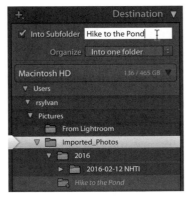

**Figure 2.29** You can create new folders for your photos as part of this process.

Notice that down below my selected parent folder a new folder matching the name I entered is shown in italics. Italicized folder names mean that Lightroom will create those folders as part of the import process, but they don't exist on the drive yet.

No matter which option you choose for your folder structure, you just need to be the one actively making the decision or else Lightroom will revert to its default behavior and place the copies in the Pictures folder. With your source and destination choices made, you can now turn your attention to the optional time-saving choices that exist in the other panels on the Import screen.

# File Handling

The File Handling panel gives you the options to (**Figure 2.30**):

▶ Schedule the building of regular previews.

▶ Create Smart Previews.

▶ Ignore duplicates—that is, photos in the selected source that have already been imported.

▶ Make a second copy of the memory card, in a location different from what is chosen in the Destination panel.

▶ Add the photos to a collection.

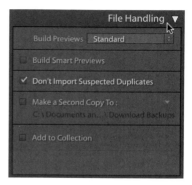

**Figure 2.30**  The File Handling panel can help with creating previews, backing up the memory card, and adding photos to a collection.

Chapter 1 discussed previews in great detail, so suffice it to say that on the Import screen you can schedule the type of previews you want Lightroom to start creating the moment the import process is complete. In addition, you can choose to create Smart Previews right off the bat, which could be helpful if your chosen destination is an external drive that may often be disconnected (offline).

When you're importing from a memory card, it may contain photos that were already imported. I recommend formatting your memory card after each shoot has been safely copied to a final destination and backed up, but sometimes we forget. In those cases, the Don't Import Suspected Duplicates checkbox is there to prevent you from re-copying those previously imported photos to your hard drive; it is selected by default, and I suggest leaving it that way.

The sole purpose of the "Make a Second Copy To" checkbox is to give you a way to duplicate the memory card to a second location as a short-term backup solution. This

is to give you time for your normal, full-system backup process (whatever that may consist of for you) to get around to including your new photos in the backup. The second copy made by Lightroom is not intended to be a long-term solution. When your photos exist only on a memory card, they are very vulnerable to loss or damage. After you copy them to your hard drive, they are duplicated once, which is great, but you probably want to format that card and go take more photos, and that results in having only one copy of your photos again. The "Make a Second Copy To" option is Lightroom's way of letting you create two different copies of your memory-card photos in two different locations so that you can reformat the card knowing you have a temporary backup. After you select the checkbox, just click the path to change the destination to a different drive than the one chosen in the Destination panel. After the second copy is created, Lightroom never refers to it, changes it, or removes anything from it. It is up to you to manage those duplicates over time. My recommendation is to periodically delete them once your full system backup has all new photos included.

The final option, "Add to Collection," is a convenience feature for adding the new photos to a collection. This can speed things up when you need it, but it is entirely optional. (Chapter 4 covers collections in more detail.)

## File Renaming

As you probably guessed, the File Renaming panel is all about options for renaming your new photos (**Figure 2.31**). This panel is visible only when a Copy or Move option is chosen at the top of the Import screen, because Lightroom can rename photos only as part of a copy or move operation. If you select Add, this panel (along with Destination) goes away. Chapter 3 examines file renaming and creating filename templates in great detail. For now, all you need to know is that if you choose to rename your photos during import, you can select an existing filename template from the drop-down menu or create a new template. Lightroom will use the selected template to rename your photos.

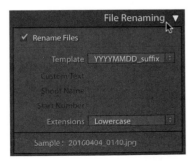

**Figure 2.31** It is possible to rename your photos as part of the import process.

# Apply During Import

Lastly, you have the option to apply a Develop preset, a metadata template, or keywords to all imported photos (**Figure 2.32**). Any of those things can be done or changed later, so this is strictly intended to save you time and get it done from the start.

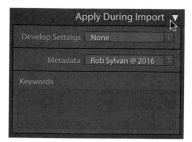

**Figure 2.32** Save time by applying certain things to your photos as part of the import process.

You may not have many Develop presets when you are just starting out, but there may come a time when you have a preset (simply a one-click way to apply an adjustment recipe to a photo) that you want to apply to all photos during import. When that day comes, just select the preset from the Develop Settings drop-down menu, and it will give your imported photos a new starting point.

I do recommend adding a metadata template on import. Chapter 5 goes over how to create a metadata template and all that it can contain, but for now simply understand that it is a very convenient way to apply things like your contact and copyright information to every photo being imported. I apply a simple template containing that information to all my photos.

Chapter 5 also delves into keywording, but again, if a few keywords are common to all photos being imported, you can add them here to speed up the process or to help you more easily find the photos later.

Once you have the Import screen configured to your liking and you've double-checked your settings, just click the Import button at the bottom of the screen to start the process. From here on out, you will want to use Lightroom to do the file management tasks related to maintaining your photo library over time, which is the topic of the next chapter.

# 3

# FILE MANAGEMENT, LIGHTROOM STYLE

Now that you understand the purpose of the import process, let's look at the tools Lightroom provides to help you manage your photos and videos. When you use Lightroom to perform basic file management tasks, such as creating, deleting, and renaming files and folders, you keep your catalog in sync with those changes. Following the procedures outlined in this chapter will help you get these common jobs done while keeping your catalog in sync. Should you have been less than diligent in the past or in case an accident strikes, you'll also learn how to reconnect the catalog to your photos and folders if they do get out of sync.

## Understanding the Role of the Folders Panel

The Folders panel may be one of the most used panels in all of Lightroom, but it is also one of the least understood (**Figure 3.1**). This little panel packs quite a bit of functionality, and it puts a lot of data at your fingertips to help you manage your photos and keep tabs on your drives. The Folders panel is not, however, a file browser. It displays only folders that have been through Lightroom's import process. Just like the photos that reside within them, folders do not appear in Lightroom unless they were introduced to the catalog first.

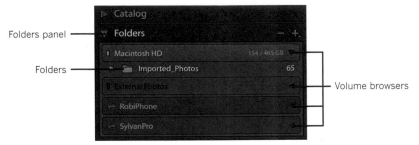

Folders panel

Folders

Volume browsers

**Figure 3.1** The Folders panel gives you access to the folders in which your photos are stored.

The Folders panel contains a *volume browser* for each drive that contains folders you have imported into Lightroom, and under each volume browser you will find all of those folders. In Figure 3.1, the volume browser for my Macintosh HD drive is expanded to show the top-level folder that has been imported into this catalog. Below that, the volume browser for my external drive is collapsed. Below that are volume browsers representing the mobile devices I have synced with Lightroom Mobile (see the sidebar "Volume Browsers for Lightroom Mobile"). Being able to expand or collapse each volume browser makes the Folders panel much easier to navigate, especially if you have multiple drives with multiple folders on each. Click a drive's volume browser to expand it and see a listing of the folders on that drive that you have imported into Lightroom. Click it again to collapse it.

Remember that you will see only *imported* folders displayed in the Folders panel. You can import any number of folders and subfolders. A subfolder will nest under its parent folder (assuming you imported it as well) in the Folders panel listing, mirroring the folder hierarchy you see in your file browser (i.e., Finder or Windows Explorer) because you are looking at the same set of folders. Lightroom automatically displays your folders alphanumerically on each level of your folder hierarchy.

Although it may be tempting to import only the specific subfolders you need for a project, I find it preferable to import the top-level or parent folder that contains the subfolders where my photos are stored. This enables me to collapse that group of subfolders so that the list doesn't run on forever, and it makes it much easier to move that entire tree of folders to a new drive if necessary—just drag and drop the top-level folder (which I show you how to do later in this chapter).

# Volume Browser Indicators

With a glance at the volume browsers you can determine a few useful facts about your drives. **Figure 3.2** shows the Folders panel with two volume browsers: one labeled Macintosh HD, for my Mac's internal hard drive, and another labeled External Photos, for my external drive. A volume browser displays a drive's name on a Mac; on a Windows system, you'll see the relevant drive letter. A green indicator on the left of a volume browser indicates that the drive has ample free space, and the numbers on the right indicate the available space and total capacity of the drive. As you can see in Figure 3.2, my Macintosh HD drive has 154 GB free out of 465 GB. The External Photos drive is offline, as shown by the gray indicator and the faded name label. Because it's offline, Lightroom can't display how much free space it has. When I reconnect the drive to my computer and it comes online, the volume browser indicator will change from gray to green (more on this at the end of this chapter). As free space drops on a drive, the indicator changes color: to yellow when 10 GB remain, to orange when 5 GB remain, and finally to red when the disk has only 1 GB free. (For best performance, try not to let your drive get that full.)

Free space isn't the only information the volume browser reveals. If you right-click a volume browser, you can choose to display the drive's disk space, photo count, or status, or nothing at all (**Figure 3.3**). In addition, you can open that drive in Windows Explorer or Finder and even access additional information about it.

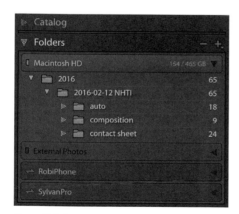

**Figure 3.2** Expanding the top folder reveals the subfolders inside it.

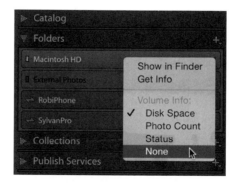

**Figure 3.3** The volume browser provides important information about the drives where your photos are stored.

## Volume Browsers for Lightroom Mobile

If you are using Lightroom Mobile, which is part of the Creative Cloud sub-scription, and have your catalog synced with a mobile device, you will see that device listed on a volume browser in the Folders panel. For instance, Figure 3.1 shows volume browsers for the iPhone (RobiPhone) and iPad (SylvanPro) that I have synced with this catalog.

The folders that appear under these volume browsers contain the photos that originated on my mobile devices, were imported into Lightroom Mobile, and were then downloaded to my computer as part of the synchronizing process. We'll delve further into Lightroom Mobile in Chapter 10.

# Show or Hide a Parent Folder

If you did yield to temptation and imported your photo subfolders without their parent folder, don't worry. It's not too late, because you can import the parent folder right from the Folders panel. Just right-click the topmost folder in the panel, and choose Show Parent Folder from the context menu that appears. Lightroom then automatically imports the parent folder, displays it in the Folders panel, and nests its subfolders underneath it. For example, in Figure 3.2 you can see that the top-level folder is named 2016. On my hard drive, however, I know that the 2016 folder is stored inside my Imported_Photos parent folder.

If I right-click the 2016 folder and choose Show Parent Folder (**Figure 3.4**), Lightroom adds the Imported_Photos folder to the panel and nests 2016 underneath, just like it exists on my drive (**Figure 3.5**).

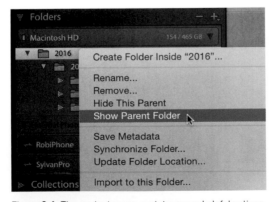

**Figure 3.4** The context menu contains many helpful options.

If I repeat that process again by right-clicking the Imported_Photos folder, Lightroom imports and displays that folder's parent, which is the Pictures folder (**Figure 3.6**).

If, like me, you display one level too many, you can reverse your mistake easily. If you have a top-level folder that you don't want to be displayed in Lightroom, right-click that folder and choose Hide This Parent to make it go away.

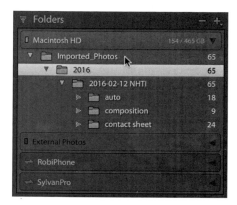

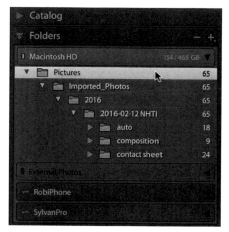

**Figure 3.5**  The parent folder of my 2016 folder now shows in the Folders panel.

**Figure 3.6**  I've displayed one parent folder too many in my folder structure.

## Find Your Folders and Photos

As you've learned, the best practice is to keep careful control of where your photos are stored during the import process, as sometimes your best-laid plans go awry or you may simply forget where you stored a folder or photo.

From inside Lightroom, you can identify where your folders and photos exist on your drive in a couple of ways. The easiest is the good old context menu. Right-click any folder in the Folders panel, and choose the "Show in Explorer" (Mac: "Show in Finder") option. This will open your file browser right to that folder and show you where it exists on your drive. Similarly, you can right-click any photo and choose "Show in Explorer" or "Show in Finder" to go right to that photo in your file browser. You don't have to leave Lightroom to find that information, though. If you hover your cursor over a folder, you should see its path revealed in a tool tip (**Figure 3.7**).

**Figure 3.7**  The path to the folder is displayed in the tool tip.

So take a moment to make sure you know exactly where all your photos are located on your drive.

# Create New Folders and Remove Old Ones

The folders currently showing in your Folders panel may have suited your needs when they were imported, but those needs may change over time or depending on your current project. As you move on in your Lightroom experience, you may need to create new folders for organizational purposes or even remove empty unwanted folders. Lightroom makes it easy to do both.

## Adding New Folders

In typical Lightroom fashion, there are several ways to create new folders. Suppose you buy a new external drive with the intention of storing photos on it because your existing drive is filling up. To add folders to it, either press Ctrl+Shift+N (Mac: Command+Shift+N), or choose New Folder from the Library menu, or click the plus sign at the top of the Folders panel and choose Add Folder. All three actions launch the "Choose or Create New Folder" dialog box (**Figures 3.8** and **3.9**).

**Figure 3.8**  Windows version of the "Choose or Create New Folder" dialog box

**Figure 3.9**  Mac version of the "Choose or Create New Folder" dialog box

From here, the process is simple:

1. From the drop-down menu, select the drive to which you want to add folders. In Figure 3.9, I selected the one named Sparta.

2. Select an existing folder, or create a brand new folder by clicking the New Folder button and giving the new folder a name, such as Imported_Photos. Lightroom creates the folder on the selected drive.

   I like to have a parent folder named Imported_Photos on each drive I use to contain photos managed by Lightroom, but you can use a name that makes sense for your setup.

3. Click the Select Folder button (Mac: the Choose button) to return to Lightroom, where you can see the drive and folder you added in the Folders panel. **Figure 3.10** shows my new volume browser for the Sparta drive.

**Figure 3.10**  A new folder was added on a new drive.

After you add a new drive or folder, you can use it as a destination during future imports, or you can use Lightroom to move photos and folders from other locations to that folder (more on that later in this chapter).

Perhaps, rather than adding a whole new drive, you simply need to create subfolders within existing folders to help with your organizational needs. This process works in a similar fashion, but you start by selecting the parent folder you want to create the subfolder within. Right-click the folder that you want to become the parent folder; then choose Create New Folder Inside "[folder name]" to open the Create Folder dialog box (**Figure 3.11**). In the Create Folder dialog box, give your new subfolder a name and click Create to complete the process. For example, I right-clicked the Imported_Photos

folder on my Sparta drive to add a 2016 folder within it. The subfolder now appears in my Folders panel (**Figure 3.12**). These two new folders are ready for me to add photos and even new folders to as my organizational needs demand.

**Figure 3.11** The Create Folder dialog box allows you to name your new folder.

**Figure 3.12** When you create a subfolder, it appears under the parent folder in the Folders panel.

## Renaming Folders

Did you make a typo when naming your new folder? You can easily change the name of a folder by right-clicking the folder and choosing Rename from the context menu (**Figure 3.13**). In the Rename Folder dialog box that appears, simply enter the new name and click Save to commit the change. The folder will be renamed on the drive, and that change will be reflected in the Folders panel.

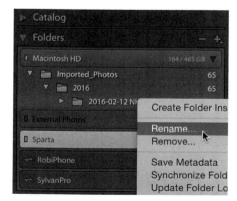

**Figure 3.13** Renaming folders from within Lightroom keeps the catalog up to date.

## Removing Empty Folders

Knowing how to remove folders is important too. Whether you deleted all the photos from a folder or you've reorganized by moving all the photos into a different folder, there's no need to keep an empty and unused folder around. Simply right-click the empty folder and choose Remove from the context menu. Lightroom will remove the folder from the Folders panel and, if it was empty, delete the folder from your drive.

What if the folder isn't empty? Well, in that case, Lightroom removes the folder from the Folders panel and the Lightroom catalog but also displays the warning in **Figure 3.14**, which explains that the photos will be removed from the Lightroom catalog but that the folders and files will *remain on your hard drive*.

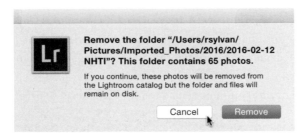

**Figure 3.14** Removing a folder that contains photos results in this warning.

If you're sure you want to remove the folder this way, click Remove but consider the implications carefully. You will end up with a folder full of photos that aren't being managed by Lightroom and are just taking up disk space. This is not the best practice, and unmanaged files consuming valuable space is usually not what you want. If you want to totally get rid of the photos, you need to delete them from your hard drive first (more on that in the next section) and then remove the empty folder.

# Using Lightroom to Delete Photos

If you are like me, you've deleted almost as many photos as you've kept. That's the beauty of digital cameras—you can take as many images as you want and get rid of the ones that are not up to your standards. Before you import photos into Lightroom, you can delete them any way you want; Lightroom doesn't care, because the program doesn't know anything about them (yet). After the photos have been through the import process, however, it is important that you do your deleting from *inside* Lightroom.

## Deleting Lots of Photos at Once

When you want to perform a single action on a lot of photos at one time, the best place to do that is in Grid view in the Library module, as you learned in Chapter 2. When you have multiple photos selected in Grid view, the default behavior is to apply whatever action you choose to all selected photos. So if you need to delete several images at once, head for Grid view.

To get there, press the G key from anywhere in Lightroom; you will be transported to the Library module, set to Grid view. But just being in Grid view is not always enough when it comes to deleting photos. You see, Lightroom can delete photos from the hard drive only when you are viewing the photos from within a folder. You cannot delete images while viewing them in a *collection*, which is a way to use the catalog to group photos. (You'll learn more about collections in Chapter 4.)

To ensure that you are viewing your photos from within a folder, you can always right-click the photo and choose "Go to Folder in Library" (**Figure 3.15**). Lightroom will show you the photo within the context of the folder in which it resides on your drive.

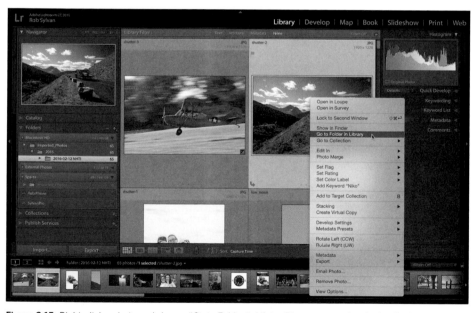

**Figure 3.15**  Right-click a photo and choose "Go to Folder in Library" to ensure you're viewing the image from a folder.

While viewing the contents of a folder in Grid view, you can delete any number of photos (even just one) by selecting them and pressing the Backspace key (Mac: the Delete key). As soon as you press that key, Lightroom displays a prompt giving you three options: Delete from Disk, Cancel, and Remove (**Figure 3.16**).

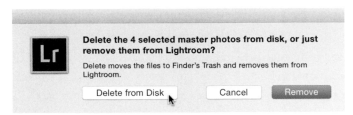

**Figure 3.16** Attempting to delete photos comes with a choice.

If your goal is to delete the files entirely, then choose "Delete from Disk." The default option is Remove because Lightroom doesn't want you to accidentally delete photos from your hard drive, but it removes photos only from the catalog, not from the drive; you don't want a bunch of bad photos left behind in folders, so Remove is rarely the option you want to choose. Cancel is your escape plan in case you hit the key by accident.

## More Ways to Delete Photos

If you are viewing photos while in Loupe view in the Library or Develop module, then you can still press the Backspace (Mac: Delete) key to delete or remove the active photo, but *only* the active photo, even if you have other photos selected in the Filmstrip. Lightroom plays it safe. When you are not in Grid view, the program assumes you want to apply the action only to the photo you are viewing.

Alternatively, you can right-click a photo and choose Remove Photo to bring up the delete and remove options. If you right-click a thumbnail in the Filmstrip (even in Loupe view) and you have multiple photos selected, however, then Lightroom assumes you want to apply the action to all selected photos. Are you starting to see the logic here? The Remove Photo option under the Photo menu brings up the same options.

Finally, one more way to delete photos involves using what Lightroom calls *flags*. Chapter 5 covers Flags in more detail, but suffice it to say that flags are a tool you can use to mark photos a certain way, either keeping them or rejecting them. Using flags to mark photos as rejected can be a more efficient way to prepare photos for deletion, which I'll demonstrate within a workflow in Chapter 8.

## Moving Photos and Folders

Moving photos and folders of photos is a fundamental task that you will do over and over. As with everything covered so far in this chapter, if you perform the task in Lightroom, the catalog stays in sync with the changes you make.

## Moving Photos Between Folders

The most basic move operation is to move one or more photos from one folder to another folder. Lightroom is all about drag and drop when it comes to moving, so it is critical that you already have a destination showing in the Folders panel into which you can drop the photos. If your destination folder does not yet exist or is not yet accessible in the Folders panel, then you'll need to add that folder to the Folders panel first.

Once the destination folder is accessible, open the folder that contains the photos you want to move by clicking it. Select the photos you want to move by clicking their thumbnails. You can select multiple photos by holding the Ctrl (Mac: Command) key and clicking each photo, or you can select a continuous range of photos by selecting the first photo, holding the Shift key, and then selecting the last photo in the range; you can select all the images in a folder by pressing Ctrl+A (Mac: Command+A).

Click a selected thumbnail and drag it to the destination folder. As you drag it, you will notice that the cursor changes to an arrow and thumbnail icon (**Figure 3.17**). If you have multiple photos selected, you will see a thumbnail stack containing the number of photos selected (this is a great way to check whether you accidentally selected more than one photo).

When you move the cursor over a folder, the folder is highlighted, and the cursor shows a green plus badge. Release the mouse button to drop the photos into that folder. Lightroom will display a confirmation dialog asking if you really want to move the files (**Figure 3.18**). Click the Move button to continue the operation. Lightroom will then move the photos to the new folder and update its catalog to reflect this change. In the warning box, you could select the "Don't show again" option before clicking Move, but I recommend leaving it unselected as a precaution against accidental moves in the future.

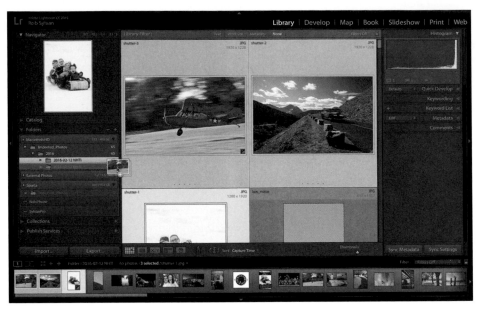

**Figure 3.17** You can select multiple photos at once and drag them to a new folder.

**Figure 3.18** Lightroom wants you to be sure about moving the photos before it completes the move.

## Moving Folders

You can move one folder into another folder just as you move photos. Just select the folder in the Folders panel and drag it into the destination folder. Lightroom will again ask you for confirmation, so you'll need to click the Move button to proceed.

You can even select multiple folders in the Folders panel and move them all at once to a destination folder. This can be extremely useful when moving a lot of folders at once to a new drive. That said, it is important to keep in mind that a move operation is essentially a copy operation followed by a delete operation. Don't move files around without having a good backup in place; if something goes wrong during the move operation (like losing power), you risk losing data. The next section outlines a safer way to move a large number of files.

## Moving Large Groups of Photos Safely

Buried in the folder context menu is a lesser-known option for moving folders: Update Folder Location. With this option you can direct the catalog to reference an identical copy of a folder that resides in a new location. Why would you ever want to do that? Well, Lightroom is not the fastest means by which to move large amounts of data between two locations, such as when you buy a larger drive for your photo library and you want to put all your photos on it. A faster (and safer) way to put your photos on the new drive is to use third-party drive-cloning software, or even just your operating system's file browser, to *copy* your photos from the old drive to the new drive.

Once the copy has been made in the new destination, you can use the Update Folder Location command to tell the catalog to stop referring to that folder structure of photos in the old location and instead refer to the copy in the new location. Here's how:

1. Open your file browser.

2. Copy the entire folder structure (as is, without changing the structure) to the new drive.

3. Open Lightroom.

4. Once the copy operation is complete, right-click the top-level folder in the Folders panel and choose Update Folder Location from the context menu.

5. In the resulting dialog box, navigate to and select that same top-level folder in the new drive (the one you just copied over there).

Lightroom will update the catalog to point to the new folder (and everything inside that folder). If you have all your folders and photos in a single parent folder, then you are done; if there are additional folders at the same level as that top folder, you just need to repeat steps 4 and 5 with those folders. Give it a test run to make sure everything is as it should be before removing the originals.

> **NOTE** When you copy the data from an existing drive to a new drive, you want it to be a mirror image of the original location. Don't take this opportunity to change things like folder names or filenames outside Lightroom, because the copy has to be an exact match of the original.

## Move Shortcut

Now that you know the basics, there is one other feature that is designed to assist in moving photos, and it can be accessed via the right-click context menu. It works like this:

1. Select the photo (or photos) you want to move.

2. Right-click the folder you want to move those photos into, and choose "Move Selected Photo(s) to this Folder" from the context menu.

3. Click Move in the confirmation dialog, and Lightroom will move the photos.

# Using Lightroom to Rename Photos

File renaming may be one of the more mundane tasks in a digital photography workflow, but it is a critical component of digital asset management. Lightroom's file-renaming function is powerful and customizable. Let's look at all the ways you can rename using Lightroom:

▶ The File Renaming panel of the Import screen when you are using Lightroom to copy, copy as DNG, or move your photos.

▶ The File Name field of the Metadata panel in the Library module to rename individual files.

▶ The Library > Rename Photos menu in the Library module when you want to rename a batch of photos.

▶ The File Naming panel of the Export dialog box when you just want to rename the copies you are exporting.

If you are used to using Adobe Bridge or some other software to rename your photos, you can still do that *before* you import them into Lightroom. Once those photos are part of a catalog, however, you'll want to use Lightroom from that point forward. After a photo has been through the import process, its name becomes an important piece of data that links the work you do in Lightroom to that photo. If you rename one or more imported photos outside Lightroom, you break that link and are then faced with the tedious task of reconnecting all of those photos to the catalog. Avoid breaking the link by using Lightroom to do the renaming.

## Rename a Single Photo

If you need to change the name of a single photo inside Lightroom, the process is very straightforward:

1. Select the photo you want to rename.

2. Expand the Library module's Metadata panel and, from the top drop-down menu, choose Default.

3. Click in the File Name field, and edit the name as needed (**Figure 3.19**).

That's fine for renaming a single image, but Lightroom's real power is in the batch renaming process. Typically, a filename provides some information about the photo and possibly some information about the creator, as well as a unique identifier like a

sequence number. There are many possible combinations of those pieces of data, and in the Filename Template Editor, Lightroom allows you to create a custom filename template that you can then apply to other photos in your library or even to new photos during import.

**Figure 3.19**  You can rename an individual photo right from the Metadata panel.

## Create and Apply Custom Filename Templates

As usual, Lightroom provides flexibility to suit any workflow. You can access the Filename Template Editor and the custom filename templates you create there from anywhere in Lightroom that you can batch rename photos—during import, during export, and in the Library module. Let's walk through the simple process of creating and applying a custom filename template via the Library module. First, you'll select a folder full of photos. Then you'll create a custom filename template that contains custom text (meaning you can enter your own unique text each time you use the template) and a sequence number. Finally, you'll apply that filename template to the selected photos.

1.  From Grid view in the Library module, select all photos you want to rename.

2.  Choose Library > Rename Photos to launch the Rename dialog box.

**Figure 3.20** You can choose an existing template or launch the Filename Template Editor from the Rename dialog box.

3. Click the File Naming drop-down menu (**Figure 3.20**) and choose Edit to open the Filename Template Editor (**Figure 3.21**).

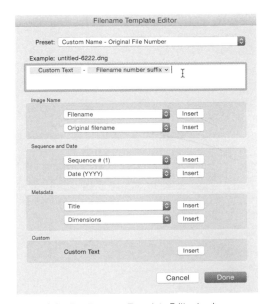

**Figure 3.21** The Filename Template Editor is where you create and edit custom filename templates.

Note that there are several pre-installed filename templates in the Preset drop-down menu, and the settings for the active template appear in the editor upon opening. A filename template comprises various *tokens*; each token represents some piece of data, such as elements of the capture date or time, the original filename, EXIF and IPTC metadata, and even custom text placeholders.

4. In the Filename Template Editor, click in the edit field and delete any existing tokens you see there.

5. Click the Insert button next to Custom Text at the bottom of the editor to add a Custom Text token to the edit field. Notice the cursor blinking next to the token you just added. You can also type directly into the edit field to add any bit of text you want to include in your template. In my case, I pressed the underscore key to add an underscore after the Custom Text token. This separates the custom text from the sequence number, which you'll add next.

6. Click the Sequence # drop-down menu, and choose a sequence number token that specifies the total number of digits you want to include in your template. I usually choose at least a three-digit sequence. This is reflected in the Example text shown on the editor.

7. Save this as a new template by clicking the Preset drop-down menu and choosing "Save Current Settings as New Preset." Then give it a name that helps you identify what the template does (**Figure 3.22**). Click Done to exit the editor and return to the Rename dialog box with your new template selected.

**Figure 3.22** My custom filename template has been configured and saved.

8. Enter the text you want to use in each name in the Custom Text field, and enter the first number of your sequence in the Start Number field (**Figure 3.23**).

9. Click OK to apply the template to the selected photos.

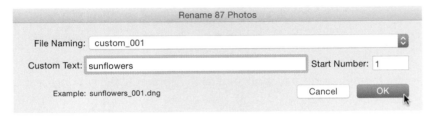

**Figure 3.23**  The new filename template is ready to be applied to all selected photos.

The text templates you create are also available for use in the Import and Export dialog boxes.

# Reconnecting Missing Folders and Photos

If you've taken to heart everything I've taught you so far, then you'll be well protected against unsynced-catalog headaches. But what if you have to take a drive offline while you travel or you weren't quite so diligent with best practices in the past? There are times when it is perfectly normal for your photos to be offline, and it is useful to be able to reconnect them. As long as you are always in the driver's seat on these decisions, then it is no big deal. Let's walk through a few scenarios you might encounter and how to resolve them peacefully.

## Dealing with an Offline Drive

Using external hard drives to store photos and videos is incredibly useful and common. Because Lightroom stores all the data about your photos in its catalog file and keeps a special folder (called a cache) full of previews of your photos alongside the catalog file, it is possible to open Lightroom and work with your photos (to a limited extent) when the actual photos are stored on an offline (disconnected) drive.

Through the volume browsers in the Folders panel, Lightroom gives you a clear indication when a drive is offline. In **Figure 3.24**, for example, you can see that my external drive (cleverly named External Photos) is offline because its name is grayed out and the indicator light next to its name is off. Expanding the volume browser for the offline drive displays the folder listing, and each folder has a question mark on it—a further hint that the drive is offline and the folders are inaccessible. Similarly, the thumbnails of the photos display exclamation points (**Figure 3.25**). Moving your cursor over any exclamation point reveals the tool tip "Photo is missing." The same message even gets displayed in the Histogram panel. I give Adobe credit for increasing the number of ways Lightroom delivers this message.

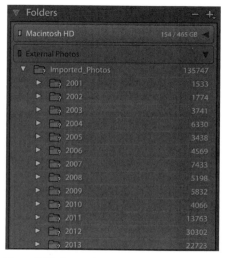

Figure 3.24  A grayed-out volume browser and question marks on folders indicate that this drive is disconnected.

Figure 3.25  Thumbnails display an exclamation point when the photo is offline or missing.

As alarming as that all looks, you can easily fix it by simply plugging the drive back in. As soon as you reconnect the drive to your computer, the drive name will turn white in the volume browser, the indicator will change color to reflect the amount of free space on that drive, and the question marks and exclamation points will go away (**Figure 3.26**).

**Figure 3.26** Problems are solved as soon as the drive is back online.

## Dealing with Deleted Photos

Here's an even easier problem to fix: If you deleted photos outside Lightroom but still see the thumbnails inside Lightroom, then select the thumbnails in Lightroom's Grid view and press Delete. Choose Remove when prompted, and Lightroom will remove them from the catalog. Done.

## Dealing with Folders and Photos Moved Outside Lightroom

If you use Finder or Windows Explorer or some other file browser (such as Adobe Bridge) to move or rename a folder, then the path stored in Lightroom's catalog is no longer valid and you will have to update the catalog with the new path information. One way to fix it is to simply put the folder back to the way it was before. The alternative is to reconnect the catalog to the folder in its new situation. Here's how to reconnect a moved folder:

1.  Right-click the folder displaying the question mark in the Folders panel, and choose Find Missing Folder from the context menu (**Figure 3.27**).

2.  Manually navigate to the new location of that folder and select it. Click OK (Mac: click Choose).

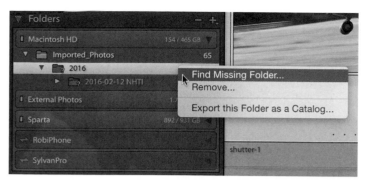

**Figure 3.27** You can reconnect a missing folder if you know where it has gone.

Lightroom will then update its catalog with this new location, reconnect to that folder, and reconnect to all the subfolders and photos within it. The key here is that you have to know that folder's location or, if you renamed it, new name. Find Missing Folder does not tell Lightroom to go find the missing items; rather, it means you have to go find them yourself. In the example in **Figure 3.28**, I had moved the folder to my desktop outside Lightroom, which broke the link. I updated the catalog, and now that folder shows under the Desktop folder on the appropriate drive.

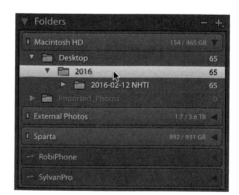

**Figure 3.28** Lightroom has been reconnected to this folder's new location.

The process is essentially the same for reconnecting individual photos that you moved while outside Lightroom. Here's how to reconnect a moved photo (when its original folder has not been moved):

1. Click the exclamation mark icon on a thumbnail.

2. Note the "Previous location" text in the resulting dialog box; this is the last place Lightroom knew that photo to be located. Click the Locate button (**Figure 3.29**).

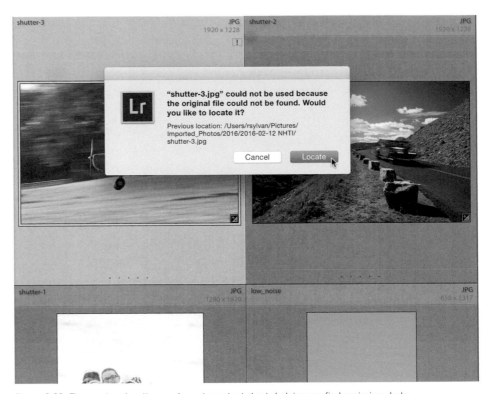

**Figure 3.29** The previous location can be an important clue in helping you find a missing photo.

3. The filename of your missing photo also appears in the Locate Missing Photo dialog box. Navigate to the new location of that photo (you need to know this), select the photo, and click Select (**Figure 3.30**).

If you've moved other photos to that location, you can reconnect them as well simply by selecting the "Find nearby missing photos" option before clicking Select. As long as the filenames of the other missing photos haven't changed, Lightroom will update them as well.

**Figure 3.30** Once you've found the missing photo, you can select it and update the catalog with its new location.

## Dealing with Photos Renamed Outside Lightroom

The best solution to the problem of a file being renamed outside Lightroom is to avoid it completely; rename your files in Lightroom only. Reconnecting renamed files is tedious because you must do each one individually.

The steps are the same as for reconnecting moved folders and photos. The only difference is that you must repeat the steps over and over for each renamed photo. Lightroom has no way of knowing the new name of each photo unless you tell it and confirm it each time.

If you have lots and lots of renamed photos, it would probably be easier to rename them back to the original name outside Lightroom (use the same application you used to change the name). That way, Lightroom will simply reconnect to them as if nothing had changed. Then, you can rename them properly from *within* Lightroom—and swear to yourself that you'll never make the same mistake again.

Remember that you can save yourself a lot of frustration and avoid wasting time by performing all your moving, renaming, and deleting tasks from inside Lightroom. If you forget, however, it's not the end of the world.

4

# USING COLLECTIONS
# FOR ORGANIZATION

In the previous chapters I've made a big deal about the fact that your photos only ever exist in folders on your hard drive and that those folders form the first level of your organizational system for your photos. Now, let's take a look at a second level of organization. One significant advantage of using a catalog to manage the data about your photos is that you can use *collections* (think of them as virtual folders) as a tool for helping you further organize and gain easy access to your photos.

## The Case for Collections

Before database-driven programs like Lightroom, you were limited to using folders to group and organize your photos. For instance, you could create a new folder for each shoot and put all the photos from that shoot into it. However, what if you wanted to do a project using your photos? For example, what if you wanted to create a photo album for a family member to give as a gift?

You might start by creating a new folder for the album, and then you might place a copy of each photo you wanted to include in the album into that folder. Pretty simple and straightforward, right? The downside to this approach is that you're most likely going to create duplicates of all the album photos on your drive, which takes up more disk space. Suppose you wanted to create an album for every holiday or every vacation, or perhaps a "best of" album of your favorite photos. Over time you would end up dedicating more and more disk space to duplicates of your photos in these new album

folders. Now imagine that you decide you want to go back and reprocess some album photo using a new technique you learned; you've got to reprocess the original and then update all of those folders with duplicates of the new version too. What a headache!

Because Lightroom uses a catalog to manage your photos, you can instead create *collections*, which are like "virtual folders," for each photo album and avoid wasting disk space on duplicates. Lightroom uses the power of the catalog to simply reference the source photo in its original folder but have it appear in a collection's virtual folder.

The Collections panel (**Figure 4.1**) gives you the power to create an infinite number of collections (or virtual folders or photo albums, if that's easier to visualize) based on whatever needs you may have for gathering a bunch of photos together. Because it uses the catalog to reference the original source photo each time, you are not creating any duplicates of your photos, and you have the power to place any individual photo in as many collections as your heart desires. That is a really useful and powerful feature. But wait, there's more! Because the collection references the original source photo, any time you make a change to that source photo (no matter whether you are viewing it in a collection or its home folder), that change instantly appears on that photo in every collection it belongs to as well—*because it is all the same photo*.

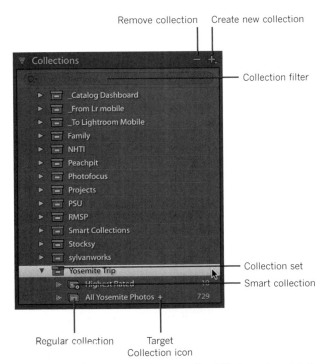

**Figure 4.1** The Collections panel gives you the ability to create an infinite number of virtual folders to suit your organizational needs.

# The Collections Panel

There are actually three types of collections you can use inside Lightroom:

▶ *Regular collections* are useful for manually grouping photos together based on a common theme or purpose.

▶ *Collection sets* are essentially containers for other collections and enable you to create an organizing structure for your various collections.

▶ *Smart collections* are basically saved searches that automatically gather photos together based on criteria you choose.

You can click the plus sign (+) in the header of the Collections panel to access the menu command for creating each type of collection (**Figure 4.2**).

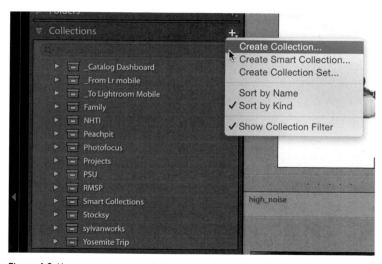

**Figure 4.2** You can create new collections using the button at the top of the panel.

Which type of collection you use depends on its role in your organization and on how you like to work. For example, you might have a collection set named for a trip or event, and then within that set you could have a combination of regular collections and smart collections that contain relevant photos grouped together based on any criteria that suit your needs, such as dates, names of people, locations, and so on.

I typically use regular collections when I am choosing specific photos that I want to manually group together for some reason, but I use smart collections when I want to automatically gather up a group of photos that all meet the same criteria. For example, I might create a regular collection to hand-pick a small group of photos I want to print as photo cards for birthday presents or create a smart collection to automate the

gathering up of all photos taken in a given year that have at least four stars and have been processed in the Develop module. I organize those various collections inside relevant collection sets.

Collection use is entirely optional inside Lightroom, but collections do provide one major advantage over folders: You can get at them in more places. The Collections panel appears inside all modules, whereas the Folders panel exists only in the Library module. You can create collections based on your needs and then have easy access to them when processing in the Develop module or preparing different forms of output with the Print, Web, Slideshow, and Book modules.

Beyond increasing accessibility inside Lightroom, collections are also the means by which you can sync photos between your catalog and Lightroom Mobile. I've dedicated Chapter 10 to Lightroom Mobile integration, so I won't dive too deep now, but suffice it to say that the only way to get your photos from your desktop catalog to the Lightroom Mobile app is through your regular collections.

## The Catalog Panel

There is one other place where you can find a special set of collections: the Catalog panel (**Figure 4.3**). This panel is intended to provide you with a series of shortcuts to certain groupings of photos that Lightroom creates based on your activity within the program. For example, the All Photographs choice at the top of the panel gives you a one-click way to call up every photo (and video) that has been imported into Lightroom. Aside from providing you with an at-a-glance tally of how many photos are in your catalog, All Photographs is useful when you want to perform a search or filter of your entire library. The Quick Collection choice is just that: a quick way for you to put some group of photos aside for easy access later on (we'll cover this in more detail later). The Previous Import choice (it's called Current when an import is in progress) is intended to give you a way to see the last batch of photos to pass through the import process.

**Figure 4.3** The Catalog panel gives you access to special collections such as All Photographs, Quick Collection, and Previous Import.

The panel shown in Figure 4.3 is for a new (and empty) catalog to show the three default collections you'll find in your catalog, but as you do more things in your catalog you may start to see other collections appear there as well.

For example, in **Figure 4.4**, I have collections named All Synced Photographs, which represents all the photos I have synced with Lightroom Mobile; Updated Photos, which is a collection of photos for which I had Lightroom update metadata; Previous Export as Catalog, which contains photos I exported as their own catalog; and Added by Previous Export, which was created when I exported a single photo and added it to the catalog as part of that process. You may have other collections or just the default collections.

If your Catalog panel is getting cluttered with these extra collections and you no longer need them, you can always right-click one and choose "Remove this Temporary Collection" from the context menu that appears (**Figure 4.5**).

Now that you have a sense of what collections are and where to find them, let's dig deeper into how to use them.

**Figure 4.4**  Other activities you do in your catalog may generate special collections of their own.

**Figure 4.5**  You can remove the temporary collections from the panel.

# Collecting Your Photos

Keeping in mind that the Collections panel is available in all modules (and to a certain extent Lightroom Mobile) can help you determine your approach to how you might use collections. There really is no one right way to use them, and I've worked with a lot of photographers and seen all kinds of approaches. All that matters is that, like your folder structure, it has to make sense to you. Let's go through the mechanics of using each type of collection.

## Creating Structure with Collection Sets

**NOTE** In Figure 4.6 you can see that all the collection sets have solid disclosure triangles and that the collections have dotted ones. Lightroom uses the same convention for folders and collections, which is that when one contains a sub-level, then it has a solid disclosure triangle, whereas the base level has a dotted disclosure triangle. That way, you have an additional clue as to whether or not there is another level down.

Collection sets are the tools you can use to collect your collections. They can hold both regular collections and smart collections, and they can also hold other collection sets. For example, in **Figure 4.6** you can see I have a collection set named Peachpit, and inside of that are collection sets for each book I have written for Peachpit Press as part of the Snapshots to Great Shots series on different camera models (Nikon D600, D750, D3200, and so on). Inside the D600 collection set you can see a regular collection holding the photos used in each chapter of the book, potential cover photos, and so on. Pretty straightforward, yes?

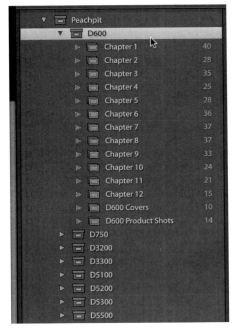

**Figure 4.6** Collection sets can hold other collections and other collection sets.

When starting a new project, I like to create a parent collection set by clicking the plus sign at the top of the panel and choosing Create Collection Set from the menu. This opens the Create Collection Set dialog (**Figure 4.7**), where I can give the collection set a name and even choose to include it within an existing collection set (or not, if it is a top-level collection set). Once I enter a name, I click the Create button to add the set to the panel.

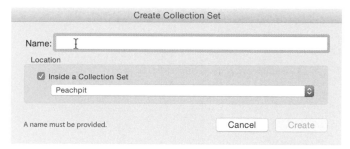

**Figure 4.7**  The Create Collection Set dialog is where you can create collection sets and assign them to existing collection sets.

Collection sets can also be dragged and dropped into other collection sets if you need to reorganize things or if you just forget to check the box to include a collection set within another.

## Grouping Photos with Regular Collections

Once you've created a collection set, you may find it easiest to start by creating a regular collection to gather up the photos for that set. I think of regular collections like baskets—you can just drag and drop photos from any folder into them. You can create a regular collection from the same plus sign button at the top of the Collections panel that you used to create the collection set, or you can choose Library > New Collection. The bonus of using the menu bar at the top is that you can also see the keyboard shortcuts associated with various collection-related tasks (**Figure 4.8**).

**Figure 4.8**  The Library menu also contains commands for creating new collections, smart collections, and collection sets (among other things).

Whichever route you take to it, in the Create Collection dialog you can name the collection, add it to a collection set, and configure additional options (**Figure 4.9**). For example, I created a collection for all the photos from my 2015 trip to Yosemite and added it to my existing Yosemite collection set that contains photos from a previous trip.

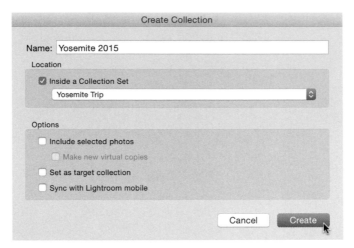

**Figure 4.9** The Create Collection dialog contains all the options for creating a new collection.

In the Options section of the dialog you can:

▶ Include selected photos in the collection you're creating

▶ Make new virtual copies (see the sidebar "Virtual Copies")

▶ Set the collection you're creating as a target collection (more on this in a bit)

▶ Sync the collection you're creating with Lightroom Mobile (more on this in Chapter 10)

If you have the foresight to select all the photos you want to add to the new collection first, then selecting the "Include selected photos" checkbox is a real help.

**TIP** You can quickly create a new collection from an existing folder simply by dragging and dropping the folder from the Folders panel to the Collections panel.

## Virtual Copies

A virtual copy is another way to leverage the power of the catalog. As each photo is imported into the catalog, Lightroom creates a database record for that photo. That record contains a set of instructions on how to process the photo based on the adjustments you make in the Develop module. A *virtual copy* is simply a convenient way to make additional sets of instructions that all reference the same source photo. That way, you can have one set of instructions (or virtual copy) for creating a black-and-white version, for example, along with the original set of instructions (the master copy) for the color version. Sometimes when creating a collection, you might want to also fill that collection with virtual copies, so the option on the Create Collection dialog box to make new virtual copies just facilitates that process.

After you create a new, empty collection, such as mine inside my Yosemite Trip collection set, you can easily add the photos to it. Select them in Grid view, and then drag them into your collection (**Figure 4.10**).

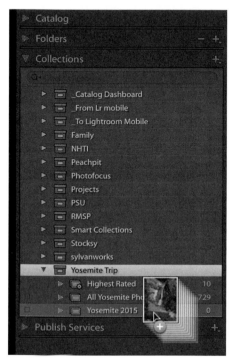

**Figure 4.10**  Adding photos to a regular collection is as simple as drag and drop.

Regular collections are helpful, but you can, however, make your collections a little smarter. Take a look.

## Automating with Smart Collections

Smart collections (think saved searches) enable you to automate the process of finding, grouping, and organizing your photos in meaningful ways by leveraging the information contained in your photo's metadata, plus any additional data you may have added to the catalog. To help illustrate this saved search functionality further, Lightroom comes preinstalled with a collection set named Smart Collections, which contains six starter smart collections:

▶  Colored Red: Contains all photos in your catalog with the red color label applied.

▶  Five Stars: Contains all photos in your catalog with a five-star rating.

▶ Past Month: Contains all photos in your catalog whose capture date is within the last month.

▶ Recently Modified: Contains all photos in your catalog whose edit date is within the last two days.

▶ Video Files: Contains all video files that have been imported into your catalog.

▶ Without Keywords: Contains all photos within your catalog whose keyword field is empty.

The very simple smart collections in this "starter kit" are intended to give you a sense of how you can use different types of criteria and image metadata to smartly gather up matching photos. You can also remove any or all of them, if you like. Even better, by looking at how these collections are constructed, you can learn a lot about how to create your own. For example, let's take a look inside the Colored Red collection. Double-click the collection name or its smart collection icon to open the Edit Smart Collection dialog (**Figure 4.11**).

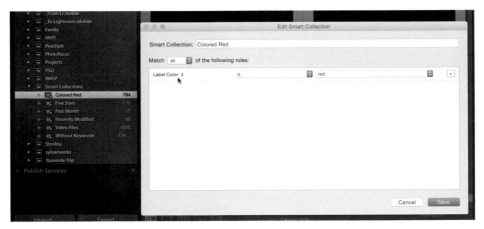

**Figure 4.11**   You can edit smart collections at any time to change up the rules that govern them.

The Edit Smart Collection dialog features a name field at the top and a list of rules Lightroom uses to create the collection underneath. This collection is based on a single rule being applied to the entire catalog: *Label Color is red*. Lightroom essentially scans the entire catalog for photos matching that criterion and automatically adds them to the collection. Click Cancel to close the dialog without making any changes. Take a moment to double-click the preinstalled smart collections to view the rules they contain. As you can see, a smart collection is nothing more than a saved search that can be as simple or complex as your needs demand.

To create a new smart collection, you can use the Create Smart Collection menu in the panel header, choose Library > New Smart Collection, or simply right-click anywhere inside the Collections panel to access the same Create Smart Collection menu (yet another way to access all those Create Collection options). The Create Smart Collection dialog is similar to the Edit Smart Collection dialog, but it has the addition of the Location section, which allows you to add this new smart collection to an existing collection set or leave it at the top level of the Collections panel (**Figure 4.12**). Remember, you can always drag and drop collections into collection sets later.

**Figure 4.12**  The Create Smart Collection dialog box is where you configure the rules.

When it comes to creating the rules for the smart collection, you first need to decide if you want the photos added to this collection to match all, any, or none of your rules. Simply choose the option you prefer from the Match drop-down menu. Leaving match set to "all" is the most straightforward (and default) way to get started (which I'll use in the example that follows). Choosing the "all" option means that only photos matching every single criterion are added to the collection. Setting Match to "any" means that any photo matching any rule will show. Setting to "none" means only photos that *don't* match any of the rules will show. Experimenting with each setting is the best way to get a handle on how they affect the results.

To see all of the possible rules at your disposal, click the rule drop-down menu and scroll through the list. For example, when I am writing books on a specific camera model, I create smart collections that pull together all the photos I've taken with that specific camera as the first rule, and then I might add additional rules for specific camera settings, capture dates, ratings, focal length, and so on (**Figure 4.13**). This automates the process of pulling those photos together in groups that fit my needs for that project.

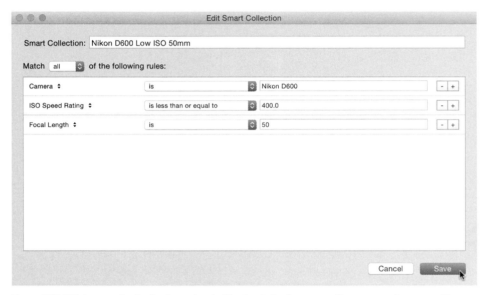

**Figure 4.13** This is a smart collection I use when looking for photos from a specific camera and camera settings.

## Create an Example Smart Collection

To help you better understand the power of smart collections, let's build one that you can use to pull together your best unedited photos from a trip. Imagine you know you will be on a shooting assignment from February 21 to February 24, 2017 (or send yourself on vacation for those dates, if you'd rather). You also know that you will want to pull together all the photos to which you assign a star rating of 4 or higher and that you have not yet worked on in Develop. By collecting them in one place, you can easily find all of your 4-star or higher photos from this trip that still need processing in the Develop module before you export them. To create your collection set and smart collection, follow these steps:

1.  Create a new collection set by clicking the plus sign in the Collections panel header and choosing Create Collection Set. Give your set a name, and unless you are putting the set inside another set, leave "Inside a Collection Set" unselected. Click Create.

2.  Select the collection set you just created; then click the plus sign again and choose Create Smart Collection to open the Create Smart Collection dialog. Give the smart collection a name.

    Starting with the collection set selected expedites the process of adding the new collection to the selected collection set, so that when you select "Inside a Collection Set," your collection set should be used automatically.

3.  Click the drop-down arrow for the first rule, and choose Date > Capture Date. Set the condition to "is in the range," and enter the start and end dates of the range you want to target. I used 2017–02–21 to 2017–02–24 for this example (**Figure 4.14**).

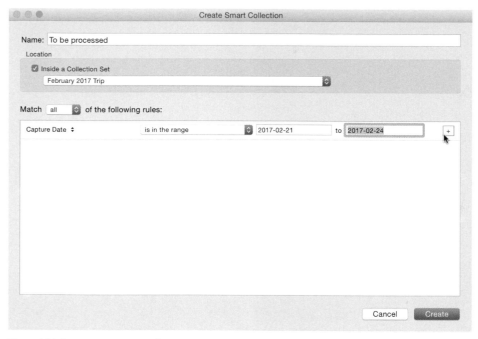

**Figure 4.14**  I've given my smart collection a name and added the first rule.

4.  Click the plus sign at the end of the first rule to add a second rule. Rating, the next rule you need, appears by default because it is at the top of the list. Leave Rating and "is greater than or equal to" set, and click the number of stars you want defined for your rule.

    Now that you have more than one rule, a minus sign also appears at the end of each rule, which allows you to delete a rule.

**TIP** Hold the Alt key (Mac: Option), and the plus signs all change to pound signs. Click a pound sign, and you can add additional advanced conditions to your set of rules for that smart collection.

5. Click the plus sign at the end of the second rule to add the third. Click the rule drop-down menu, and choose Develop > Has Adjustments. Change the condition to "is false" so that only photos without any Develop settings will be added (**Figure 4.15**).

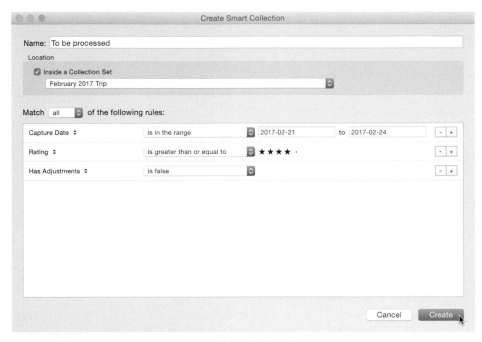

**Figure 4.15** The completed smart collection has all the rules I need.

6. Click Create.

   As soon as you click Create, the dialog closes, Lightroom adds the smart collection to the set, and photos matching the criteria automatically appear in the collection. Because the example trip is in the future, however, don't be surprised when no photos appear.

## Removing Photos from Smart Collections

The only way photos can be removed from a smart collection is when a particular photo no longer matches the defined criteria. So in the example, as soon as any photo gets adjusted in any way, it will no longer match the rules; Lightroom automatically removes it from that smart collection. Similarly, if I change my mind on a photo's rating and reduce it to three stars, it too would be automatically removed. This is just one of the many ways smart collections can leverage the power of the Lightroom catalog and make your life simpler.

# Maintaining Collections Over Time

As you play around with ideas for collections, you will undoubtedly need to move photos between collections, remove photos from collections, remove collections entirely, rename collections, and so on. You can never escape housekeeping chores, and keeping the Collections panel clean will only help you in the long run.

## Moving Things Around

Because any photo can be in any number of collections without duplicating the original photo on your drive, it makes sense that you'll have situations where you have a photo in one collection and decide to add it to another. Smart collections handle this sort of situation automatically; photos appear in a smart collection when they meet all of a smart collection's criteria, and Lightroom removes them when they no longer meet the criteria. When it comes to regular collections, however, you have to manually add or remove photos from the collections.

If you are viewing a photo in one regular collection and decide to add it to another, you can simply drag and drop the photo onto the other collection. Remember, however, that doing so does not remove the photo from the original collection; it only adds the photo to the destination collection. If you want to remove the photo from the original collection, you have to select it while viewing that collection and press Delete.

> **NOTE** Because Lightroom is only referencing the original when you view a collection, the Delete key acts as a "remove from collection" button and does not delete the photo from your drive. If you need to delete an image from your drive, do so when viewing the source folder.

Likewise, you may need to move a collection into a collection set or even move an entire collection set into another collection set. In each case, you select the collection and then drag and drop it into the destination collection set, all within the Collections panel.

## Using a Target Collection

Setting a regular collection as the target collection gives it a special keyboard shortcut that enables you to quickly add photos to that collection with a single keystroke. Only regular collections can have this honor, and the original default target collection is the Quick Collection, found in the Catalog panel. Before you delve deeper into how to use a target collection, it can help to understand the role of the Quick Collection.

The purpose of the Quick Collection is to provide a simple way to quickly gather together a group of photos for whatever reason that makes sense to you. Perhaps you need to temporarily round up several photos that are stored across a range of folders for a quick export, or maybe you need to print them to give to a family member or have some other short-term reason that doesn't quite justify creating a long-term collection for that group of photos.

You can drag and drop photos into the Quick Collection just like a regular collection, but the real benefit of the Quick Collection is its keyboard shortcut (the B key), which enables you to send selected photos to the Quick Collection with a single keystroke. If you prefer, a click of the small round button that appears in the upper-right corner of thumbnails when you move the cursor over the photo does the same thing (**Figure 4.16**). The button stays visible on photos in the Quick Collection to provide a visual clue to their status.

**Figure 4.16**  This button allows you to send photos to the target collection, which in this example is the Quick Collection.

You can remove photos from the Quick Collection by selecting them and pressing the Backspace key (Mac: Delete), by pressing the B shortcut, or by clicking that round button.

As you can see, the functionality of the Quick Collection is very useful, and now we come full circle back to another way to use the target collection. You can assign any regular collection to be the target collection (only one target collection can be assigned at a time). When you assign a regular collection as the target collection, the B key and the round button send selected photos to that collection instead of to the Quick Collection. To assign a collection as the target collection, right-click the collection and choose Set as Target Collection from the context menu that appears. The chosen collection will be marked with the same small + icon that was previously showing on the Quick Collection as a visual reminder of its new status (Figure 4.1). Or, when creating a new collection, you'll see the option "Set as Target Collection" appear in the Create Collection dialog.

One way I love to use the "Set as Target Collection" feature is when I need to sort through large numbers of photos to add them to different collections, such as when I am working on a book project and I need to choose photos for the various chapters. I start by creating a collection set for the book, and then I create a regular collection for each chapter. I'll assign the chapter I want to work on as the target collection, and then it is easy to go looking through my catalog and quickly add photos to that target collection just by selecting the photo and pressing the B key. It is a simple little feature, but one that saves me a lot of time, and I think you'll find it just as useful in your workflow.

## Renaming and Deleting

For one reason or another you will eventually come upon the need to rename existing collections and collection sets, or even delete them outright. You can delete any collection from the Collections panel by selecting the collection and clicking the minus sign that appears in the panel header (Figure 4.1). Deleting the collection removes it from the panel (but remember that it does not delete the photos from the drive).

My go-to option, however, is the context menu that appears when you right-click. This trick works all over the place inside Lightroom, so when in doubt anywhere, right-click and see what context options appear. For example, suppose your February trip got postponed to April, so now you need to rename your collection set and update your smart collection relating to that trip. All you need to do is right-click the collection set and choose Rename from the context menu (**Figure 4.17**).

**Figure 4.17**  The context menu on a collection brings up a number of useful options.

Choosing Rename from the menu opens the Rename Collection Set dialog, where you can update the name and click Rename to commit the change. There is a Delete option in that menu too, and that's the route I usually take when I want to delete a collection.

The right-click trick comes in handy on a photo when you are viewing it in a collection and you want to quickly jump to its source folder for some reason (such as to delete it from disk). Just right-click the photo and choose the "Go to Folder in Library" option to quickly jump to the folder view. Alternatively, you can choose "Go to Collection" from the menu and jump to another collection that the photo belongs to as well (**Figure 4.18**).

Now that you have a better appreciation for how the information you add to your photos (aka metadata) in Lightroom can begin to help you in your organizational efforts, let's move on to the next chapter to learn all the ways that info can actually be added.

**Figure 4.18** The context menu on a photo gives you all kinds of shortcuts.

5

# USING METADATA

Metadata is simply data that describes other data. From a Lightroom perspective, metadata is useful descriptive information about your photos, whether it takes the form of titles, captions, keywords, GPS, or more. Lightroom is a database at its core, and as you learned in Chapter 4's discussion of collections, the more data entered into that database the more you can leverage it for your own purposes (such as when using smart collections). In this chapter, I'll introduce you to each type of metadata, how to create metadata, and how to use it to help you tame your photo library. Much of the metadata creation, organization, and application is done in the Library module, so let's start there.

# The Metadata Panel

Inside the Library module, you'll find the Metadata panel (**Figure 5.1**) on the right side of the interface. The Metadata panel is primarily used for viewing information about your photos, but it also contains editable fields that you can use to enter new information.

**Figure 5.1** The Metadata panel can be used for viewing and adding information about your photos.

**NOTE** EXIF stands for Exchangeable Image File Format. You can learn more about the EXIF standard by going to exif.org.

## Metadata Panel Views

At the top of the panel is a view drop-down menu, which you can use to change what information is shown inside the panel. This can help illustrate which fields are for display only and which fields are open for you to edit as needed. For example, if I switch to EXIF view, you can see that most of the fields are un-editable and contain data that

was created by the camera at the time the photo was taken (**Figure 5.2**). Go ahead and click through each view to see what data is displayed—you'll see some of the same fields displayed in different ways.

For media photographers, the IPTC view and its associated editable fields are very important to their work, as this is where they can enter their copyright, contact information, and a wide range of image-specific descriptive data (**Figure 5.3**). In Chapter 7 I'll cover how to create metadata templates that can speed up the entry of data for many of these fields during and after import.

**NOTE** IPTC stands for International Press Telecommunications Council. You can learn more about the IPTC standard by going to iptc.org.

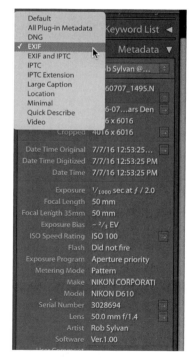

**Figure 5.2** The Metadata panel has several views that show different configurations of metadata.

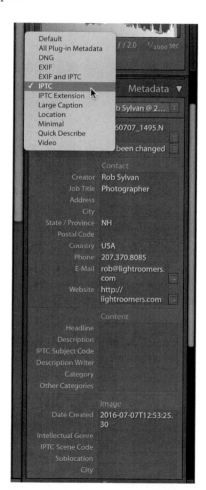

**Figure 5.3** The IPTC view shows all of the editable fields available for adding descriptive information about you and your photos.

Much of the information that you can enter via this panel you can also leverage later when using text templates in other modules (Chapter 7), when creating smart collections (Chapters 4 and 8), when exporting copies (Chapter 8), and when using the Library Filter (Chapter 8). Don't think about adding metadata for the sake of stockpiling data; rather, think about how you can use that information to help you in your workflow.

## Adding Titles, Captions, and More

I think the most common type of photo metadata people are familiar with is the kind used in newspapers and online news sources: photo titles and captions. The process for adding this information is the same as for any of the other editable fields. You can see that the camera-generated EXIF data is not editable (Figure 5.2), whereas the IPTC fields are all open for editing (Figure 5.3). Near the top of the Default view (the most commonly used field), you can see that there are Title and Caption fields, which are both open for editing (**Figure 5.4**).

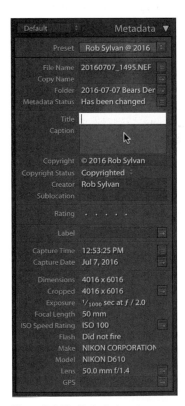

**Figure 5.4** The Default view gives easy access to commonly used fields, such as Title and Caption.

Here's how it works:

1.  Select a photo (I find it easiest to work in Grid or Loupe view), and expand the Metadata panel.

2.  Click into the Title field to activate it.

3.  Type in the title you want to apply to the selected photo. Titles are usually short and don't have to be complete sentences (**Figure 5.5**).

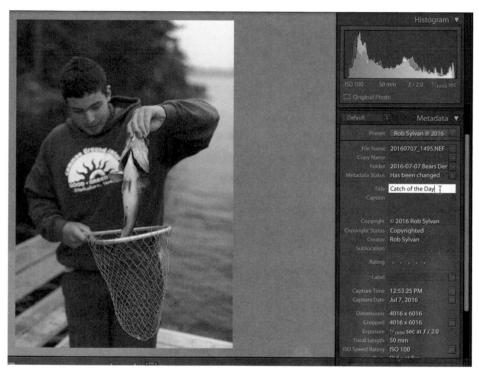

**Figure 5.5** The title has been entered into the Title field.

4.  Press the Tab key to jump to the Caption field, and enter a description of the photo. Captions are often short sentences that describe the photo (**Figure 5.6**). Press Enter to apply the data.

**Figure 5.6** Now the caption has been entered into the Caption field.

As you enter titles and captions, think about how and where you might use them. Perhaps you're creating a web gallery, and you'd like the title and caption to display along with the photos, or perhaps you are a photographer and need the title and caption to be included in the metadata of the copies you export later to deliver to a client. There's no wrong answer here as long as you are using the fields in accordance with your intended purpose.

Here are a few tips to speed up your workflow when entering information in the Metadata panel:

▶ In an active field, pressing the Tab key moves you down the panel to the next editable field. (If you press Tab and the panel hides, press Tab again to bring it back, click into the field to make it active, and then press Tab again to move to the next field.)

▶ Holding the Shift key while pressing Tab moves you up the panel instead.

▶ While in an active field, hold the Ctrl key (Mac: Command key) and press the left or right arrow key to move to the previous or next photo, respectively, while remaining in that same metadata field on the new photo.

▶ As you begin to type in a field, Lightroom will attempt to auto-complete the data entry if it matches what you are typing (**Figure 5.7**); press Enter to accept the auto-complete result.

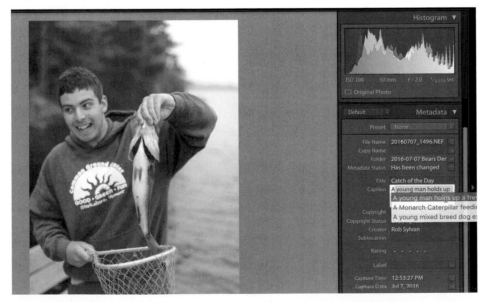

**Figure 5.7** Lightroom attempts to speed up the process by showing auto-complete results that match what you are typing.

Used together, these tips can really speed up the application of metadata by keeping your fingers on the keyboard as you move through a shoot. If you have a lot of similar images, you can also take advantage of some batch application tools.

## Applying Metadata to Multiple Photos

It is not uncommon to have a shoot with many similar images that can share some of the same metadata fields. The easiest way to apply the same information to multiple photos at once is to work in Grid view and select the photos to which you want to apply this information. When multiple photos are selected, you will see the word "<mixed>" appear in the fields that have differing information (**Figure 5.8**). This is Lightroom's way of warning you that you risk losing existing work if you continue.

**Figure 5.8** When you have multiple photos selected in the Library module, <mixed> appears in fields where the data is not the same on all photos.

To enter the same info for all fields, just type that data into the desired field and press Enter. Because I had some photos with an existing title selected, I got the <mixed> warning when I started, and when I pressed Enter, Lightroom prompted me to make sure I really wanted to apply that title to all selected photos (**Figure 5.9**). If I had started with photos that were all missing titles, I wouldn't have seen <mixed> appear in the Title field, but Lightroom would still have prompted me before applying the change to all selected photos.

**NOTE** If you go to the Metadata menu and select "Show Metadata for Target Photo Only," then you will see the metadata only for the active, or "most selected," photo, and the metadata you add or edit will be applied to that photo only.

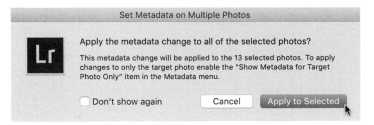

**Figure 5.9** Lightroom helps you avoid changing things accidentally with this warning.

**NOTE** The Sync
Metadata function
works for other
metadata too, such
as keywords, ratings,
color labels, and so
on. If the information
is displayed in the
Synchronize Metadata
dialog, you can
sync it across all
selected photos.

Alternatively, because I had already added a title and caption to one photo, I could select all of the similar photos in Grid view and then click the Sync Metadata button below the Metadata panel to open the Synchronize Metadata dialog (**Figure 5.10**). Here I can select the box next to any (and all) metadata fields I want to synchronize (be the same) across all selected photos. In this case, I just selected the Caption and Title fields. Clicking the Synchronize button applies that information to all selected photos.

I hope you are starting to see the pattern that the more data you add, the faster and easier it is to add it to more photos. Let's move on to discussing keywords.

**Figure 5.10** The Synchronize Metadata dialog allows for selective synchronization.

# Keywords

Keywords have a different role than titles or captions. Although they are words that can be used to describe a photo, keywords are primarily used to help you find your photos rather than being an outward display to a viewer of what a photo is about. Keywords can be a simple list of words that are little more than a checklist of the most important aspects of a photo. For example, consider Figure 5.7. For that photo of my son holding a fish, the top five keywords might be *fishing, lake, male, New Hampshire, Summer*. I could also include his name (I'll cover assigning names to faces in the next section) and more detailed location information (I'll cover that at the end of the chapter).

Keywords can be a very personal topic, meaning your specific keyword needs can be very different from mine, and that's OK, as long as they do the job you need them to do. Aside from my personal photos, I also do stock photography, and the keywording I need for that is vastly different from that of my personal photos. That said, the mechanics of creating a keyword list, managing that list, and applying the keywords is the same in all cases, and even a few keywords, consistently applied, can be really useful over time. The goal is to have additional tools to easily find a photo in the future (weeks, months, or years from now); keywords, in conjunction with other metadata, can help you do that.

Two panels in the Library module are used with keywording: the aptly named Keywording panel and Keyword List panel (**Figure 5.11**).

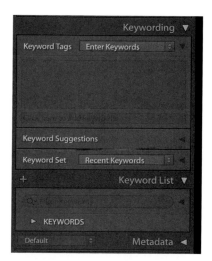

**Figure 5.11**  The Keywording and Keyword List panels work together to help you keyword your photos.

There's a lot of functionality in each panel, so let's take a closer look at each one. This will get you prepared for Chapter 8, when I show you how they can be used to apply keywords to photos in the context of a larger workflow.

## The Keywording Panel

The Keywording panel (**Figure 5.12**) is useful for direct entry of keywords to photos, meaning you can select a photo and type a keyword into the Keywording panel and that word will be applied to your photo. I don't think that is the most efficient way to apply keywords, but it works.

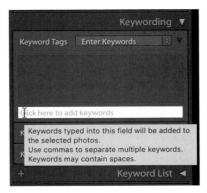

**Figure 5.12** You can apply keywords simply by selecting a photo and typing the keyword into the Keywording panel.

Notice when you click into the "Click here to add keywords" field that a helpful tool tip appears as well, explaining that you can "use commas to separate multiple keywords, and that keywords can contain spaces." So, going back to my earlier list of five keywords for the photo of my son fishing, I could type them right into that field (like so: fishing, lake, male, New Hampshire, Summer), and those words will be applied to the selected photo (or photos, if I select multiple photos in Grid view). Notice that because I used commas to separate each keyword, I was able to use a space in "New Hampshire."

## Keyword Hierarchy

Now take a look at **Figure 5.13**; above the field where I entered those keywords, you can see that those words have been applied to the selected photos. Notice that even though I typed in "fishing," the keyword displays as "fishing < outdoor recreation" after Lightroom applies it. As you enter keywords in the Keywording panel, those words are added to the Keyword List panel. In addition, if you enter keywords that are already in your keyword list, Lightroom recognizes those words, and I happen to have a very large keyword list.

So, where did "outdoor recreation" come from then? Well, if I expand the Keyword List panel and filter on "fishing" (more on that later), you can see in **Figure 5.14** that my keywords are organized in a hierarchal structure. "Fishing" is a child keyword of the parent keyword "outdoor recreation," so Lightroom automatically adds the parent keyword as well as the child I typed (more on how this works in the "Creating New Keywords" section).

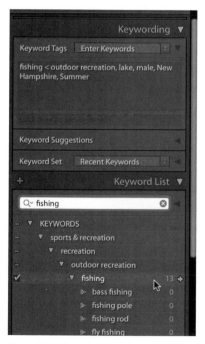

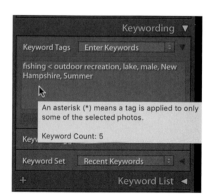

**Figure 5.13** You can see all keywords applied to a photo in the Keywording panel.

**Figure 5.14** The keywords you add in the Keywording panel are added to (and pulled from) the Keyword List panel.

Another benefit of having an existing keyword list is that Lightroom can speed up the entry process by auto-completing entries as you type. For example, if I begin to add the keyword "fish," Lightroom automatically displays all of the existing keywords that match the letters I've typed so far, and I can select the correct one from the list and then press Enter to apply it to the photo (**Figure 5.15**). The other benefit of pulling from my existing list is consistency, meaning that by always using words in the existing list I don't accidentally end up with multiple variations of a given word due to accidental spelling differences. (We'll delve deeper into creating keywords and developing your own keyword list when we discuss the Keyword List panel.)

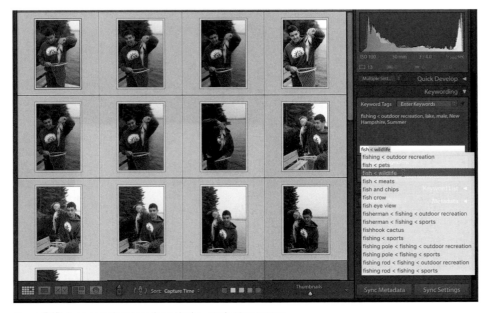

**Figure 5.15** Auto-complete speeds up the keyword entry process.

## Keyword Views and Time-Savers

In the Keywording panel, the Keyword Tags drop-down menu (**Figure 5.16**) gives you access to a variety of views of entered keywords. The default setting of Enter Keywords is what we've been using, and although you can type right into the area where the keywords are displayed to add more keywords, I recommend sticking to the "Click here to add keywords" field to avoid accidental keyword deletions. When you set the view to Keywords & Containing Keywords, you can see the keywords you've entered and all of the parent keywords containing those keywords (if you have a hierarchal list). The Will Export view shows only the keywords that are configured to be included with

exported copies (some keywords may be useful for your hierarchal structure, but you may not want them included with exported copies).

Other tools to help speed up the keywording process are the Keyword Suggestions and Keyword Set sections of the panel (**Figure 5.17**). As you apply keywords to photos in a shoot and then move on to other photos, you will see that Lightroom tries to help you by providing suggestions based on what you've applied so far. Additionally, the Keyword Set section is set to Recent Keywords and displays the most recent keywords you've added. Each of the words in those sections is a live button, and you can click any of them to add the associated keyword to the selected photo. If you hold down the Alt key (Mac: Option key), you'll see numbers appear in the Keyword Set section; they correspond to the keyboard shortcut that you can use to add those words to your photos even faster. In this case, I can press Alt+5 (Mac: Option+5) to apply the keyword "lake" to the photo.

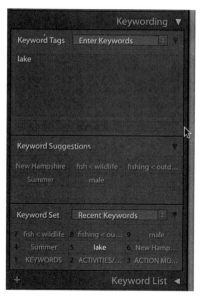

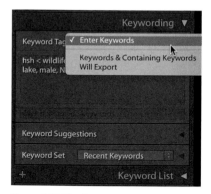

**Figure 5.16** The Keyword Tags drop-down menu has other options for viewing applied keywords.

**Figure 5.17** The Keyword Suggestions and Keyword Sets sections speed up the application of keywords.

Taking it a step further, you can also access and create other keyword sets by clicking the Keyword Set drop-down menu (**Figure 5.18**). Keep in mind that you can add only up to nine keywords to a given set, but I know sets are useful to some photographers. As you can see, Lightroom comes installed with three keyword sets (for outdoor, portrait, and wedding photography) to help you get started.

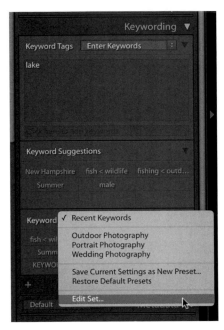

**Figure 5.18** You can access and create custom keyword sets to match your needs.

Choosing Edit Set opens the Edit Keyword Set dialog, and from there you can click the Preset drop-down menu to access and edit the pre-installed sets or create completely new ones. You might start by selecting an existing set and then customizing it to fit your needs. When ready, click the Preset drop-down menu again, choose Save Current Settings as New Preset from the list, and give it a name, which leaves the original set unaltered alongside your new set (**Figure 5.19**).

**Figure 5.19** Start with keyword sets by customizing an existing set.

# The Keyword List Panel

The Keyword List panel is home to all the keywords you've entered directly into the Keywording panel, all keywords you've created using the Keywording List panel, and any keywords that have entered your catalog via the import process (**Figure 5.20**).

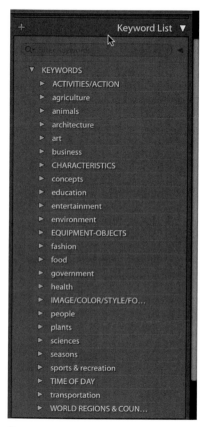

**Figure 5.20**  The Keyword List panel is home to your keywords.

In my case, I have a rather large hierarchal list of keywords that I purchased many years ago from controlledvocabulary.com to use with my stock photography efforts. This is a very thorough list of more than 10,000 words, and it really got me off to a great start. However, it is most likely overkill for anyone not involved in stock photography or journalism. There are smaller (and free) keyword lists out there too. One place to check out is the Lightroom Keyword List Project (lightroom-keyword-list-project.blogspot.com). These prepared keyword lists are simply plain-text files that you can import into your catalog via the Metadata > Import Keywords menu (you can also export your keyword list as a text file from the Metadata > Export Keywords menu).

Although you may not need a list as in-depth as mine, I highly recommend moving beyond a flat list of words to something that has an organizational structure. The main reason for this is that it gives you greater flexibility in your ability to keyword your photos. For example, imagine you have a photo of yourself wearing your lucky orange shirt and you want to tag all photos of yourself in that shirt with the word "orange" to describe the color. What happens when you take a tour of an orange grove and want to tag those photos with the word "orange" to describe the fruit? In a flat keyword list, you could have only one instance of the word "orange" even though it has multiple meanings. By creating a structure, you could have a parent keyword "color," and "orange" could be a child keyword, and then you could have another parent keyword of "fruit," and "orange" could be a child of that one. See what I mean?

Most Lightroom users I know have at least dabbled with keywords, so you may already have an existing keyword list. Let's take a look at how to create new keywords, and how to organize any existing keywords into a structured list.

## Creating New Keywords

At the top of the Keyword List panel is a + sign; when clicked, it opens the Create Keyword Tag dialog (**Figure 5.21**), which is used to add new keywords to your list.

**Figure 5.21** You can create and configure new keywords here.

It helps to put some thought into your keyword structure, so let's take a simple example of adding keywords pertaining to colors. Start with the parent keyword "colors," and enter that into the Keyword Name field. Whether you use upper- or lowercase letters for your keywords is entirely up to you. I went with using all uppercase for structural words that are not exported and lowercase for all others.

After you enter the keyword, you have some options to consider (**Figure 5.22**). The Synonym field is optional, but it's useful if the word you are entering has synonyms that you'd like to be included on exported copies, such as the plural form of the word, other words that mean the same thing, or even alternative spellings (such as "colour" in this case). The remaining options are self-explanatory, with the possible exception of Export Containing Keywords, which when selected means that the parent keywords of this keyword will also be applied to the exported copies.

**Figure 5.22** Ready to create this keyword and add it to my list.

When it comes to exporting keywords, it is important to think about your purpose for keywording. If you are just keywording for the sake of being able to find your own photos within your catalog, then applying keywords to exported copies is not terribly important. If, however, you are sending your exported photos on to a destination that can use the keywords included in the metadata of your photos, then it becomes very important. For me, when I upload photos to a stock website, the metadata of the photo is ingested into the stock website's system, which saves me the trouble of having to re-apply the keywords later. By choosing to include the containing keywords

on export, it saves me from having to explicitly apply each parent (and grandparent, and so on) keyword inside Lightroom, because by simply applying the child keyword (such as "orange"), the parent keyword ("color") and its synonyms ("colour") will also be applied to exported copies, which is a time-saver. Because of this, I am a little more thoughtful about what keywords are included in my exported copies.

We'll talk about Person keywords in the next section, on assigning names to faces, so skip that for now.

At the bottom of the panel are some creation options designed to make this process more efficient. In my case, I have a top-level structural parent keyword named KEY-WORDS, and the dialog is asking me if I'd like to include my new keyword as a child inside it. I do, so I will select that box. You'll need to decide that on a case-by-case basis. In addition, there is a checkbox called "Add to selected photos," which is useful if you had the foresight to first select the photos you want to apply this keyword to before launching the Create Keyword Tag dialog. In my case I didn't, so I left it unselected. When you are ready, click Create to add this new word to your list.

Now I can add all of the color keywords I want to include as child keywords of "color." An easy way to add child keywords is to right-click the parent keyword and choose "Create Keyword Tag inside" from the context menu that appears (**Figure 5.23**). That way, the "Put inside" checkbox will already be selected when the Create Keyword Tag dialog box opens.

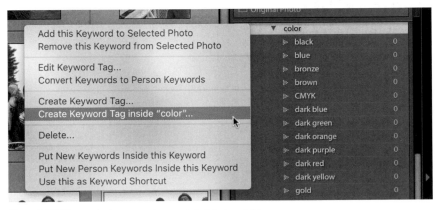

**Figure 5.23** The context menu on keywords is full of useful items.

## Editing Existing Keywords

If you've already begun entering keywords but never considered the options, you can always right-click a keyword or just double-click the keyword to open the Edit Keyword Tag dialog, which is very much like the Create Keyword Tag dialog (**Figure 5.24**).

**Figure 5.24**  You can always edit existing keywords.

## Ordering an Existing Keyword List

If you have already assigned keywords to photos and you want to retain those assignments and create a more structured list, you can (and should) do that right inside the Keyword List panel.

You can drag one keyword and drop it onto another to nest them together. Suppose you have a flat keyword list that contains *animals*, *dogs*, *mammals*, and *golden retriever*. You can drag "golden retriever" onto "dogs," then drag "dogs" onto "mammals," and then drag "mammals" onto "animals," creating a logical hierarchy while maintaining the assignments inside the catalog you already made with those keywords.

You can also move a child keyword out of a parent-child relationship by dragging it above its top-level parent keyword until you see the space above the parent keyword become highlighted (indicating you are leaving that structure) and then releasing the keyword.

## Removing Unwanted Keywords

If you simply want to remove a keyword from all photos and remove the keyword itself from your keyword list, you can select the keyword in the Keyword List panel and click the minus sign (–) that appears in the panel header. Removing a parent keyword will also remove its children.

You can select multiple keywords in the Keyword List section for removal as well. To select continuous keywords, click the first keyword and then hold the Shift key and click the last keyword you want to select. You can select non-contiguous keywords by holding the Ctrl key (Mac: Command key) while clicking individual keywords.

At the bottom of the Metadata menu is the option Purge Unused Keywords, which is sort of the nuclear option for removing keywords. When used, it will delete all keywords that have not been assigned to any photos, so be careful with that one. I'd suggest sticking to manual removal so that you can make the decision on a case-by-case basis.

That should put you well on your way to creating and refining your keyword list, so let's move on to Lightroom's functionality for finding faces and assigning names to them.

# Finding Faces and Assigning Names

With the release of Lightroom CC 2015/Lightroom 6, Adobe gave us a new face finding and tagging functionality designed to make it easier to find all the people in our photographs and assign them names. I think it is fair to say that although it may not be perfect, it is still quite useful and, once you get into it, kind of fun.

## People View

To facilitate the use of this new feature, Adobe also added a new type of view in the Library module: People view. Click the icon with a face in the Library toolbar, or press the keyboard shortcut O, to switch to that view (**Figure 5.25**).

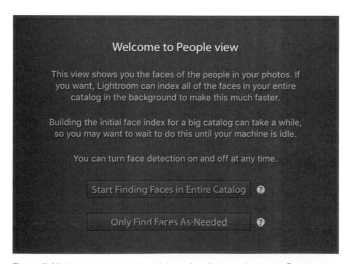

**Figure 5.25**  You have some choices to make when you first enter People view.

If you click Start Finding Faces in Entire Catalog, Lightroom has to churn through all of the pixels in all of your photographs. As you might imagine, this can take a while, and the larger your catalog is, the longer it will take. My recommendation is to click the Only Find Faces As-Needed button so that Lightroom analyzes only the photos in the currently selected view (such as a folder or collection), and not the entire catalog. Once you enable face finding, Lightroom starts to look through the photos to find faces, and it attempts to group similar faces together within the Unnamed People section (**Figure 5.26**).

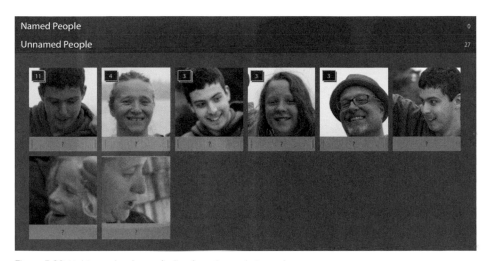

**Figure 5.26** Lightroom has begun finding faces in my photographs.

Sometimes it does a great job, and sometimes it misses faces completely or inserts odd things it thinks are faces. From here, it is your job to tag the faces with names, weed out wrongly tagged photos, and tag any faces that were missed. Let's start with assigning names to found faces.

## Assigning Tags

Under each unnamed face is a question mark if Lightroom doesn't recognize the face. As you tag more and more faces, Lightroom begins to learn who is who, and it will suggest names to help speed the process along. The names you apply to faces are very much like the keywords you just learned about, except they are called *person keywords* and it is into the pool of person keywords that Lightroom dips to suggest names for the faces it finds.

I created a new catalog for these photos so that I could show you this from a clean slate. When you begin, I suggest you create a parent keyword called PEOPLE that you can use to store all of your person keywords. Create that tag just as you would any other keyword (I disabled all export options). Once it's created, right-click that tag and choose Put New Person Keywords Inside this Keyword from the context menu. An asterisk will appear on that keyword to denote its role (**Figure 5.27**).

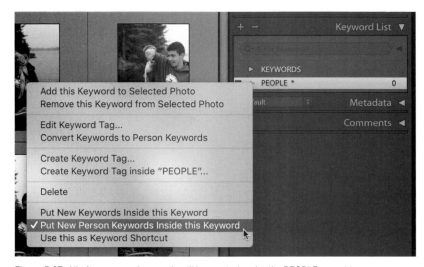

**Figure 5.27**  All of my person keywords will be created under the PEOPLE parent tag.

**NOTE** For privacy reasons, the names shown are fictional.

Another factor to consider is how to create your people name tags, keeping in mind that the Keyword List panel sorts alphanumerically only. If you use the conventional "[first name] [last name]," then the people tags will sort by first name. If you want to keep people with the same last name together, you might consider using "[last name] [first name]." Remember that you can have spaces inside keywords, but not commas (as most programs use commas to separate keywords). For the example, I opted for [last name] [first name], but you need to figure out what works best for you.

Once you know how you want to proceed, you can begin to assign names to each face (**Figure 5.28**). For example, starting with my son, I entered his name below the photo and pressed the Enter key to apply it. Doing this moved his stack of faces up to the Named People section and added his name under PEOPLE in my keyword list. Continue adding names to faces until the Unnamed People section is empty. As you begin to type, Lightroom's auto-completion function tries to speed things along.

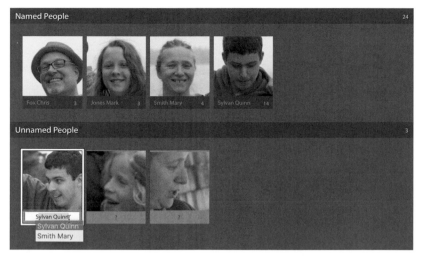

**Figure 5.28**  Lightroom attempts to auto-complete entries.

## Drawing Face Regions

To ensure that Lightroom has found all of the faces in a set of photos, I like to go through each photo looking for face regions. To do this, while still in People view, double-click the first photo in the Filmstrip. Now you can see the entire photo and the face region that Lightroom found on that first photo, along with the name of the assigned tag (**Figure 5.29**).

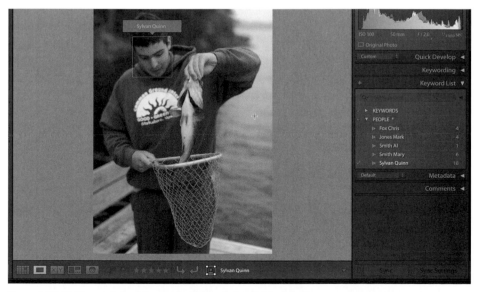

**Figure 5.29**  Lightroom draws a face region box around each face it finds.

You can then use your arrow keys to move through each photo in that shoot and verify that all faces have been found. If you come to a photo that has a face that Lightroom didn't find for some reason, then you can manually draw the face region by dragging a rectangle over the face. This can happen if the person's face was too much in profile or somehow obscured (like in **Figure 5.30**) or if Lightroom just missed it.

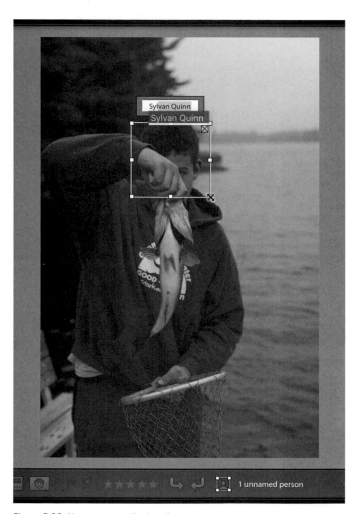

**Figure 5.30**  You can manually draw faces.

While you can manually tag photos to add people tags, those tags don't get factored into the algorithm Lightroom uses to learn whose face is whose, so you don't even have to tag the person's face to tag someone (**Figure 5.31**). That way, you don't risk confusing Lightroom by manually tagging someone's hand or the back of his or her head, but you still have the benefit of finding the person later.

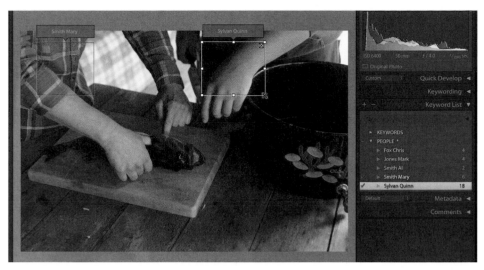

**Figure 5.31** People tags don't have to be applied only to faces.

# Moving Forward

That's the basics of tagging faces, but I want to leave you with a few tips to speed up the process. When you have multiple photos of the same person that you recognize but that Lightroom does not automatically group together, you can select each result in the Unnamed People section and then just apply the tag to one photo to tag them all. Alternatively, you can drag and drop those faces onto a tagged face in the Named People section to apply that tag (**Figure 5.32**).

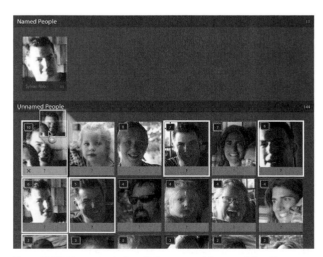

**Figure 5.32** You can select multiple unnamed faces and drag them onto a named face to tag them.

As Lightroom learns faces, it will display the name under the photo, and you can click the checkmark that appears to apply that tag (**Figure 5.33**).

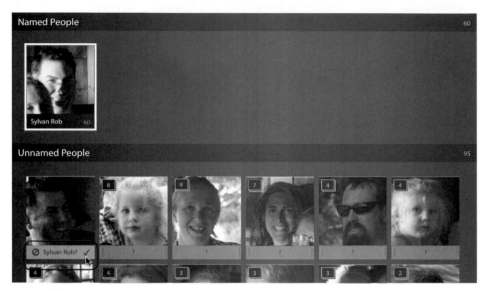

**Figure 5.33** Lightroom can learn to associate the right names with faces.

If Lightroom comes up with something that is clearly not a face, or perhaps it is a face of some random person in a crowd that you don't want to name, you can click the X under the photo in the Unnamed People section to remove the face region (**Figure 5.34**).

When you are done tagging faces in your photos, you can start to tag your photos to locations.

**Figure 5.34** Sometimes Lightroom finds faces where there are none.

# Tying Photos to Locations

The Map module offers a number of cool and useful ways to interact with, organize, and view your photos whether you travel the world or just around your own town.

It used to be that adding GPS data to photos was left to diehard gear lovers, but these days it is hard to find a new communication device that doesn't include both a camera and a GPS chip. More and more cameras have GPS tracking built in, and GPS add-on accessories for DSLRs are becoming more mainstream. Lighroom's Map module provides a great interface for visualizing where your photos with embedded GPS data were taken, and it includes a number of ways to add GPS and location data to other photos.

## Finding Photos with Geolocation Data

While on a photo workshop in Death Valley, I forgot my handheld GPS device at home. I was, however, relieved to find that the GPS in my iPhone was able to embed GPS coordinates in photos even when I was way out in the middle of the Racetrack (which truly is in the middle of nowhere). While walking across the hard, cracked earth of the playa, I spotted a set of small animal tracks embedded in the dried mud and snapped a photo with my phone. **Figure 5.35** shows that photo in the Library module. Notice the pin icon in the lower-right corner of the thumbnail? That means the photo has embedded GPS data. You can also expand the Metadata panel, set it to EXIF view, and see the GPS coordinates (and altitude if your device records it).

**Figure 5.35** My phone's GPS recorded the coordinates at which this photo was taken.

A single click of the pin icon or the arrow next to the GPS field of the Metadata panel will take you to that photo's location in the Map module (**Figure 5.36**). Note that if you hold the Alt key (Mac: Option key) and click either of those buttons, your default web browser will open to that location in Google Maps. The Map module uses the Google Maps API, so you need to have an Internet connection to use the Map module.

**Figure 5.36**  Photos with GPS coordinates can easily be found on the map.

Once in the Map module, you can change the view of the map via the View menu or the Map Style drop-down in the toolbar. The toolbar contains a Zoom slider to zoom in or out on the map, but you can also do this with the scroll wheel on your mouse or the – and + keys. Holding the Alt key (Mac: Option key) enables you to zoom in by dragging out an area on the map.

## Manually Placing Photos on Map

My iPhone photos were automatically placed on the map using the embedded GPS coordinates, which provided a handy reference for me for the rest of the photos from that location. You also can use the Location Filter bar (above the map) to quickly filter out the photos in the Filmstrip to just the photos visible on the map, just the photos tagged with GPS data, or just the photos without a GPS tag, or you can set it to None and reveal all the photos. By clicking Untagged, you can easily find the rest of the photos needing to be tagged and drag them from the Filmstrip onto the desired

location on the map, which will add the GPS coordinates to those photos as well (**Figure 5.37**).

**Figure 5.37** You can drag and drop photos onto the map.

The first time you import photos with GPS coordinates or add GPS coordinates to photos, Lightroom will prompt you about enabling reverse geocoding (**Figure 5.38**).

**Figure 5.38** You can decide whether you want Lightroom to look up locations based on the coordinates.

When reverse geocoding is enabled, Lightroom will use the GPS coordinates to automatically fill in other location information (if it can find it) in the respective field of the Metadata panel (**Figure 5.39**). To commit the reverse geocoded location names, you need to click the label for each field and accept the input (do this with all selected photos for the same location to apply the geocoding all at once). You can, of course, manually type in location information too.

**Figure 5.39** Lightroom can attempt to match the coordinates to location information for you.

You can also search the map for specific locations using the Search field on the Location Filter bar. This provides another easy way to manually add your photos to a specific location or just view previously geocoded photos at that destination.

## Working with Tracks

If your camera doesn't have a built-in or add-on GPS unit and you don't want to manually drag and drop your photos onto the map, you might consider using a GPS device that can save a tracklog. I've been using an old handheld Garmin 60CSx for years, and (when I remember to bring it) I just tuck it in the outside pocket of my backpack while I'm out shooting for the day. There are also a growing number of GPS apps for mobile phones that can save a tracklog file. The most important aspect of using a device like this is to synchronize the date and time in the unit with the date and time of your camera before you start shooting. Here's how to marry the GPS data from your tracklog to your photos in the Map module:

1. Save the tracklog from your GPS device as a GPX file (the GPS Exchange Format is an XML document containing the GPS coordinates and the date/time stamp in a standardized format Lightroom can understand), and transfer it to your computer.

2. Select the photos you want to geocode, and switch to the Map module. I find it easiest to put the desired photos in a collection first.

3. Go to Map > Tracklog > Load Tracklog, or click the Tracklog icon in the toolbar, to access the Load Tracklog menu.

4. Use the Import Track File dialog to navigate to and select the desired GPX file for that shoot.

5. With all of your photos still selected, go to Map > Tracklog > Auto-Tag Selected Photos. Note that if your camera was on the correct time but the GPS device was in a different time zone, you can use the Map > Tracklog > Time Zone Offset to sync it with your camera.

Lightroom will then use the date/time stamp in each photo to associate the matching GPS coordinates contained in the GPX file for that same date and time and show them on the map along with the route contained in the tracklog (**Figure 5.40**). This is much faster and more accurate than doing it manually.

**Figure 5.40** Lightroom analyzed the tracklog and put my photos in the locations along the route.

6

# CARE AND MAINTENANCE OF YOUR CATALOG

I'm sure you've noticed how frequently I bring up the importance of the Lightroom catalog to your entire workflow, so you won't be surprised I'm about to do it again: That catalog file is where all the work you do in Lightroom is stored, so you can't afford to lose it or let it get out of control. Having the best intentions to keep it backed up and optimized is no substitute for actually doing it. So take a break from your photos for a bit and give your catalog itself the attention it deserves. In this chapter, you'll learn how to back up your catalog, keep it optimized, and manage it over time.

## Built-in Backup

Lightroom doesn't have an automated means to back up your photos on a regular or long-term basis. (True, you can back up the memory card from the Import dialog, but that is a short-term option.) However, it does have a built-in function for scheduling a regular backup of your Lightroom catalog. Why is backing up your catalog so important? Recall from Chapter 1 that the catalog stores all the metadata created by the camera at the time the photo is taken (shutter speed, f-stop, ISO, and so on), as well as all the data you add in Lightroom (keywords, IPTC data, ratings, and so on) *and* all the adjustments you make in the Develop module. In addition, any collections you create in the Collections panel are stored only inside the catalog. In other words, everything you do in Lightroom is stored in the catalog, so it is critically important that you keep it backed up.

## Catalog Dashboard

If you go to Edit > Catalog Settings (or Lightroom > Catalog Settings on a Mac) and click the General tab, you will see what I think of as a catalog dashboard of sorts (**Figure 6.1**). Here you can see where the open catalog is stored on your drive, its filename, when it was created, when it was last backed up, when it was last optimized (more on that later), and its total file size. Clicking the Show button opens a window in your file browser to the folder that contains the catalog (a handy shortcut).

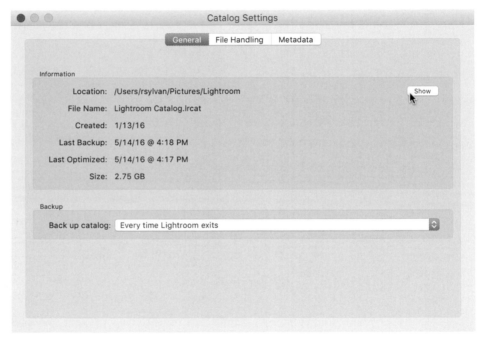

**Figure 6.1**  The General tab of Catalog Settings contains important information about the Lightroom catalog you have open at the time.

## Scheduling and Running the Backup

At the bottom of the Catalog Settings panel's General tab, you can choose a schedule for how often you'd like Lightroom to create a backup copy of this catalog. If you click the "Back up catalog" drop-down menu, you can select a time frame that suits your workflow (**Figure 6.2**).

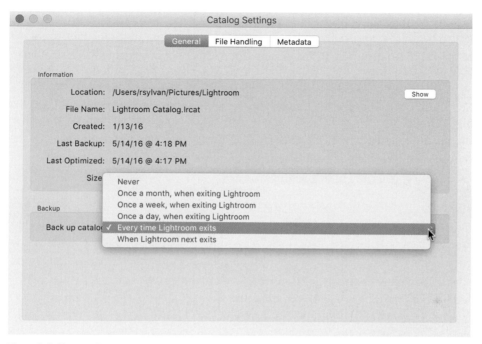

**Figure 6.2** Choose a backup frequency that you'll appreciate if you ever need to recover from a backup.

I have mine set to "Every time Lightroom exits," and you might at first think that is a bit excessive. The truth is that I don't run the actual backup process every time I exit, but I do like to have the option (and the reminder) to run it. Let me explain: Lightroom doesn't back up your catalog automatically; it only prompts you to run the backup process when you quit the program. If you've just completed a big work session and you want to back up the catalog in its current state, it is helpful to have the Back Up Catalog dialog come up as a reminder (**Figure 6.3**).

**Figure 6.3** When you quit Lightroom, the program prompts you to run the backup process, based on the schedule you set.

**NOTE** A helpful way to decide on the frequency of your backups is to imagine a scenario in which you actually have to use one to recover your work. Do you want to imagine that you are feeling really good about how frequently you run the backup process ("Yay, I just backed up yesterday so very little work is lost!"), or do you want to imagine that you are feeling queasy over the fact that you haven't backed up in a while ("Gah, I lost all the work since my last backup!"). Fear can be a powerful motivator.

While the "Back up" button is active by default (you can also press the Enter/Return key to begin the process), you can click the "Skip this time" button when you don't have time to run the backup, just need to exit without delay, or maybe didn't do much work anyway. I probably end up running the backup process two or three times a week, depending on how much work I am doing at the time.

Starting with Lightroom CC 2015/Lightroom 6, you now have the option to change the backup frequency from the Back Up Catalog dialog as well. So if you find that the schedule you originally set isn't meeting your needs, you can change it here instead of needing to go back to Catalog Settings.

The Back Up Catalog dialog is also the only place where you can configure where to store the backup copies. The dialog displays the path for the current location (by default the location is in your Pictures folder), and it provides a Choose button that allows you to choose a new location. My recommendation is to choose a different drive than where your working Lightroom catalog is stored (an external or network drive is a good choice). In my case, I'm running Lightroom from a laptop with only a single internal drive, so I opted to have my catalog backup copies saved to my Dropbox folder, which is automatically synced to cloud storage and my other computer (go to www.dropbox.com to learn more about that service).

There are two main disasters a backup can save you from. One is when something happens to the drive that houses your working catalog (damage, theft, corruption, and so on), and the other is when something happens to just the working catalog file itself (corruption, accidental deletion, human error, and so on). Having your backup copies stored on a different drive can help protect you from the first type of problem. Having it stored in a convenient location can help you with the second type.

## Testing Integrity and Optimization

There are two optional items in the Back Up Catalog dialog: "Test integrity before backing up" and "Optimize catalog after backing up" (**Figure 6.4**).

The "Test integrity" option can provide an early warning if there's a problem in the catalog. It does add a bit of extra time to the backup process, but I think it's worth doing. I've seen cases where a catalog became corrupted but was still operational. If you don't run the integrity check, you may not know until something bad happens (like the catalog failing to open at all), but if you catch it right away, you can roll back to a good backup copy (more on how to restore from a backup in a moment) and move forward without a problem.

**Figure 6.4** These optional functions are all about keeping the catalog running smoothly.

The "Optimize catalog" function runs some database housekeeping on your catalog file to reduce its overall size and make it work faster. In reality it should only make a noticeable difference when the catalog file is already large and it hasn't been optimized in a while, but I just leave this option selected every time I create a backup copy (this option also adds more time to the catalog backup process). If you'd rather leave it unselected and run the optimize function manually, you can always use the File > Optimize Catalog menu when it suits your needs.

## Managing the Backup Copies

Every time the backup process runs, it creates a new copy of the catalog and ignores any existing backup copies. The upside of this approach is that in time you'll have multiple iterations of the catalog that reflect different points in its history. The downside is that, left unchecked, your catalog backups will eventually fill up a drive (**Figure 6.5**).

With that issue in mind, choose a drive that has ample free space, and remember to delete outdated backup copies periodically. Once a month or so, I open the backup folder in my file browser and simply delete all but the three or four most recent copies. That way, I have a few iterative copies on hand if needed (and I've never needed one), and I keep the files in check.

With the release of Lightroom CC 2015/Lightroom 6, the backup copies were compressed into zip files, for two reasons. The main reason is that catalog files compress really well and, therefore, take up less disk space. The second reason is that it makes it more difficult for users to accidentally open a backup copy of the catalog (because now you have to unzip first).

**Figure 6.5** Each time the backup process runs, a new copy of the catalog is created in the backup folder.

## Restoring from a Backup

Should a situation arise in which you need to fall back on your most recent backup copy of the catalog, it helps to know what steps to take. The first thing you'll need to know is where your backup copies are stored, so make sure that you choose a place that is easy to find and easy to remember.

If your original working catalog is not opening (corrupted) or is lost (drive failure, human error, gremlins), then your last backup copy will step in to become your new working catalog. Here's how to do it:

1. Close Lightroom (if it should be open somehow).

2. Open your file browser, and navigate to the folder containing your working (or should I say previously working) catalog.

3. Move the bad catalog file (.lrcat) out of that folder to another location for safe keeping (the desktop is fine for now).

4. Open another instance of your file browser, and navigate to the folder containing your catalog backup copies.

5. Select the most recent backup copy (each backup copy is created in a folder named for the date it was made), and unzip the catalog from the compressed file (double-clicking the zip file should do it).

6. Move the catalog file (.lrcat) from the backup location to the folder where the original catalog was stored.

Each backup copy of the catalog has the same filename as the original catalog, so replacing the "bad" catalog with a copy of a "good" catalog is all you need to do to restore. Double-click the catalog file to open it into Lightroom and take it for a test-drive.

Only the catalog file itself is included in the backup process, so Lightroom will have to rebuild any cache files that may have been lost (as in the case of a drive failure) once the program launches. Don't be surprised if at first you see only gray boxes where the thumbnails used to be while Lightroom re-renders the previews. Any existing preview caches will be used automatically.

# How to Move a Catalog

Whether someone has bought a new, larger drive or just needs to move the catalog to a different location on the existing drive, a question I am asked fairly frequently is how to go about moving a Lightroom catalog to a new folder or even a new drive. Because Lightroom stores the absolute path for each photo being managed inside the catalog, you can move the catalog on your drive without losing contact with your photos (as long as the location of the photos does not change). Here's how to get it done:

1.  Open your file browser, and navigate to the folder containing the Lightroom catalog. If you don't remember where that is, you can always click the Show button in the General tab of the Catalog Settings to open a folder containing the Lightroom catalog in your file browser.

2.  Quit Lightroom.

3.  Use your file browser to *copy* the entire folder containing the Lightroom catalog (and its associated cache files) to the new destination. Copying is safer than moving, because if you lose power or make a mistake while moving, you can lose data. Copying leaves the original alone and makes a duplicate in the new location. (You'll go back and remove the original as the last step.)

4.  Once the copy operation is complete, double-click the catalog file (.lrcat) to open the catalog into Lightroom and verify all is well.

5.  Go to Preferences > General, and set that catalog in its new location as the Default catalog.

6.  After verifying that the catalog is working in the new location and all is well, you can use your file browser to go back and delete the original catalog folder to recover the space on that drive.

That's all there is to it. You should be all set with the catalog in the new location, set as the default, from there on out.

# How to Rename a Catalog

Why would you rename your catalog in the first place? Well, I occasionally hear from people who are using the most up-to-date version of Lightroom, but they have a catalog file named with an older version of Lightroom (from when they first started using Lightroom) and perhaps some other numbers in it, such as Lightroom 4 Catalog-2. They wonder if this is a problem, and they want to know how to rename the catalog.

First, it is not a problem at all. You can call your catalog file anything you want to call it. Lightroom doesn't care. If you want to rename it to something that makes more sense to you, however, here's how:

1. With Lightroom closed, go to the folder where the catalog resides using your file browser.

2. Use your file browser to rename the catalog file, but keep the file extension the same (.lrcat).

3. Rename any associated preview cache files in that folder the same way, keeping their respective file extensions (.lrdata).

For example, if your catalog and preview cache were named like this (**Figure 6.6**):

Lightroom 4 Catalog-2.lrcat

Lightroom 4 Catalog-2 Previews.lrdata

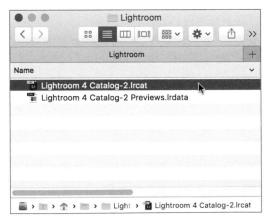

**Figure 6.6** A catalog created using Lightroom 4 but upgraded over time with each new version of Lightroom.

And you wanted to change it to simply "Lightroom Catalog," you would end up with (**Figure 6.7**):

Lightroom Catalog.lrcat

Lightroom Catalog Previews.lrdata

**Figure 6.7** The catalog and preview cache have been successfully renamed.

Once the renaming is done, double-click the catalog file to open it into Lightroom, and give it a quick test drive to make sure all is well. Assuming it is all working normally (and it should be), be sure to go to Preferences > General and update the default catalog to refer to this newly renamed catalog.

# How to Export a Catalog

Aside from the catalog backup process, Lightroom has the ability to export the data from one catalog into a new catalog. In Chapter 9 we're going to take a detailed look at how you can export catalogs in a larger workflow, use multiple catalogs, and even merge them back into one master catalog, but for now, we'll just focus on the basics of exporting a catalog, which can be useful to know when you are just troubleshooting a potential catalog problem. In some instances, I have seen this help people who experience some low-level quirk in their current catalog, and simply by exporting all the data from the quirky catalog into a new one they fix the problem (it just seems to leave the quirk behind). So just file this one away for now.

Let's say you were experiencing some odd quirky behavior in your catalog and you wanted to see if exporting all of the data to a new catalog made any difference in resolving that behavior; here's how you would do it:

1. Expand the Catalog panel and select All Photographs. That way, you ensure that all data about all photos is included in this catalog export (**Figure 6.8**).

**Figure 6.8** Selecting All Photographs in the Catalog panel calls up every file being managed by this catalog.

2. Go to File > Export as Catalog. This brings up the "Export as Catalog" dialog (**Figure 6.9**).

**Figure 6.9** The "Export as Catalog" dialog is where you can choose the options for the catalog you are going to export.

3. Confirm that the number of files being included in this catalog export matches the total in your catalog. For the example, I did not select all photos before launching this dialog, so I made sure "Export selected photos only" was unselected. I didn't want to include "negative files" (Lightroom lingo for copies of your source photos) at this time, but we'll look at how that is useful in Chapter 9. I would include available previews in this case just to avoid having to re-render them, but I wouldn't want to build new smart previews for every photo at this time.

4. Finally, choose where you want this exported catalog to be created (choose a place you will remember), and give it a meaningful name. Double-check your settings, and click the Export Catalog button to start the process.

Once the catalog is exported, use the File > Open Catalog menu to open that catalog and give it a test run. If that resolved the quirky issue you started with, then great. Make this your new working catalog using the steps I outlined earlier for recovering from a backup. Ideally few of you will ever need to export a catalog to stop quirky behavior, but knowing how to export a catalog is important for every Lightroom user.

In the end, it is my hope that understanding how critically important the catalog (and the data it contains) is to your workflow will motivate you to take care of it over time, keep it backed up in case of disaster, and allow you to stay focused on your photography with fewer interruptions and less software frustration.

**NOTE:** Publish Service connections, and unused keywords are not included in a catalog export.

# 7

# INCREASING LIGHTROOM EFFICIENCY

Simply using Lightroom can make our workflows more efficient; it's a one-stop solution that handles the majority of tasks from post-capture to output. As you become more comfortable using Lightroom, you can begin to use it more effectively, streamlining your workflows even more and completing tasks faster. Depending on the task, you can speed up your workflows by using presets, templates, and shortcuts—or a combination of these. Let's take a deeper dive into each type of speed-booster to learn how to get the most out of them.

## Presets and Templates

The words "presets" and "templates" get used fairly interchangeably in Lightroom lingo, but I think of *presets* as a way to capture a specific configuration of settings for easy reuse with a single click, whereas *templates* are a way to save all the parameters of a given layout for reuse. The bottom line is that anytime you think you'll reuse a given batch of settings or a layout, save it as a preset or template. For example, in the Develop module you can save a configuration of develop settings as a develop preset, while in the Print module you can save the parameters of a given print layout as a template. It doesn't really matter what you call them, but by thinking of them this way I hope you

will realize all of the places where these time-savers exist inside Lightroom. Here's a rundown of where you can find and use presets and templates:

▶ **Import dialog.** Has import presets to save different import settings, can access file-name templates for renaming, and can access metadata presets for applying to all imported photos.

▶ **Library module.** Can access develop presets via the Quick Develop panel, filename templates for bulk renaming, and metadata presets for bulk application of metadata.

▶ **Develop module.** Has develop presets via the Presets panel; Graduated Filter, Radial Filter, and Adjustment Brush tools share presets too (found under the Effect drop-down menu in each of those tools).

▶ **Book module.** Can create auto layout presets and text style presets and can access text templates for displaying text pulled from each photo's metadata.

▶ **Slideshow module.** Has slideshow templates for saving layouts and can access text templates for displaying text pulled from each photo's metadata.

▶ **Print module.** Has print templates for saving layouts and (with some layout styles) can access text templates for displaying text pulled from each photo's metadata.

▶ **Web module.** Has web templates for saving layouts and can access text templates for displaying text pulled from each photo's metadata.

▶ **Export dialog.** Has export presets for saving different export configuration settings for reuse. You can also access these presets from the File > Export with Preset menu to skip the Export dialog completely.

## Creating Different Types of Presets and Templates

**NOTE** Chapter 3 explained how to create filename templates, so I won't repeat that here.

As you delve into creating, editing, and deleting these presets and templates, you'll start to see that the names *preset* and *template* are used inconsistently within the program. This is not a big deal, but I will use the name found in Lightroom to match what you see. Here's where you can find them, how you can create them, and when you'll use them.

## Import Presets

For many of us, our import workflow is likely to be pretty consistent for each batch of photos we bring into Lightroom. Because most of the settings used in an import are "sticky," in that they remain in place from one import session to the next, there's rarely much need to change the settings. Over time, however, you may find occasional deviations from the norm (perhaps you switch from copying photos off a memory card to adding photos in a folder on your drive), and you may want to create different import presets for those situations. Also, having a preset for your standard workflow can help you return to your usual settings in a click if anything should appear out of order. I should mention that I have experienced some quirkiness with the way Lightroom remembers settings from session to session, so just a heads up in case you encounter it too.

That said, when creating your preset you can include the settings contained in the File Handling, File Renaming, Apply During Import panels, and even a specific Destination folder (when copying or moving), which can be very handy for quickly switching between destination folders and especially useful if Lightroom doesn't retain the desired destination folder between sessions. In all cases you want to be in control of selecting the source each time, which makes sense to me.

For example, most of the time I import from a memory card, and I use the following settings:

▶ Copy

▶ Previews set to 1:1

▶ Photos renamed using a custom filename template

▶ Custom metadata template applied

Everything else is set to the default settings. For those times when you want to change one or more of those parameters, an import preset comes in handy. Sometimes I want to convert to DNG as part of copying new photos to my chosen destination, and leave the photos with their original camera-generated filenames, so I have a preset that I can choose that changes the settings accordingly.

The Import Preset menu is located at the bottom of the Import dialog and is easy to miss (**Figure 7.1**). To create a preset, first configure all the settings you want to include in the preset; then click the Import Preset drop-down menu and choose Save Current Settings as New Preset from the bottom of the list.

**Figure 7.1** The Import Preset drop-down menu before and after it is clicked to open.

This will open the New Preset dialog, where you can give your preset a meaningful name (I use the key settings in the name itself) and then click Create (**Figure 7.2**).

**Figure 7.2** The more meaningful the name, the easier it is for you to choose the right preset later.

Now, when I open the Import screen, I can just check to see that the right preset is selected and know that all of my key settings are loaded up and ready to go. I can focus on making sure I have the right source and destination configured and spend less time on the Import screen.

## Export Presets

While you may have only a few different ways you configure the Import screen, you probably have lots of configurations for exporting copies via the Export dialog—I sure do. This is one place where a few good presets can really add up to a huge time savings over the lifetime of using Lightroom.

Chapter 8 looks at using the Export dialog in the context of a typical workflow, but for now, just know that exporting is the way that Lightroom creates copies of your photos with all of the Lightroom adjustments applied to them, plus any specific settings you dialed into the Export dialog itself (such as file type, folder location, color space, and so on). For example, do you need to create JPEG copies in sRGB color of a batch of photos to upload to an online gallery? If so, then the Export dialog is the way to go.

When it comes to creating export presets, you want to think about all the different ways that you export copies. If there are certain configurations of settings you use more than once, then those are prime candidates for saving as a preset. In my case, I have a preset for when I save out for uploading to Facebook, one for when uploading to my favorite stock website (Stocksy United), one for uploading to my portfolio, and so on. The act of export is usually driven by some specific set of parameters for a specific use case, so every time you encounter a new scenario that you are likely to repeat, save those settings as a preset too. You can create export presets only from the Export dialog, so select one (or more) photos and click the Export button to open it up (**Figure 7.3**).

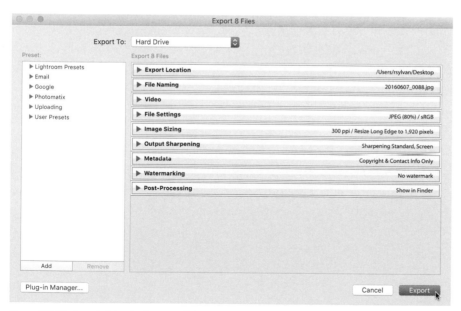

**Figure 7.3** The Export dialog is where you dial in all the settings you want to apply to the copies you are creating.

As you'll see, the act of creating a preset is consistent throughout Lightroom in that you start by configuring all the settings you want in your preset and then you click a button to save the preset itself. On the Export dialog, after you've dialed in your settings, you'll click the Add button that is always visible on the left side of the dialog. This opens the New Preset dialog (**Figure 7.4**).

**Figure 7.4** The New Preset dialog enables you to enter a name for the preset and choose a folder for organizational purposes.

Because you will likely have many different export presets for a variety of purposes, it can be helpful to create an organizational structure for your export presets to make them easier to find. I have an export preset folder named Uploading, and inside that folder I keep all the presets I use for places I upload photos to after exporting (**Figure 7.5**). You'll have folders based on whatever your needs dictate.

**Figure 7.5** Keeping your presets organized is a good idea.

From the New Preset dialog box you can select an existing folder, or you can choose New Folder from the drop-down menu and create the folder at that time. Once you've chosen the destination folder for your preset and given the preset a meaningful name, click the Create button to save it. Moving forward, you can configure the Export dialog with a single click of your preset or skip the Export dialog completely by choosing File > Export with Preset and selecting your preset from the list (**Figure 7.6**).

**Figure 7.6** The fastest way to export is to choose your preset from the menu.

## Develop Presets

Develop presets are probably the most well-known type of preset, and for good reason. We spend a lot of time in the Develop module, and if there is a particular combination of settings you like to apply to your photos, it makes sense to save them as a preset that you can reuse over and over again. Better still, you can also apply develop presets to batches of photos from the Quick Develop panel, and even from the Import screen. They are huge time-savers all around. Due to their importance, presets have their own panel on the left side of the Develop module (**Figure 7.7**).

**Figure 7.7** The Develop module's Presets panel is where you can create, organize, and access your develop presets.

It is a good idea to keep your presets organized into meaningful folders and, in my opinion, avoid using the User Presets folder completely. My problem with the User Presets folder is that it tends to become a dumping ground for presets and provides no useful organizational purpose. To go beyond that folder, simply right-click any existing folder and choose New Folder from the context menu. This opens the New Folder dialog, where you can enter a meaningful name. Because all the folders within the Presets panel sort alphanumerically, a good tip is to name your folders the way you want them to sort. As you can see in Figure 7.7, I have two folders at the top of my panel that I named with a leading number.

Lightroom comes loaded with a variety of presets (that can't easily be removed). If you find presets in those existing folders that you'd like to make easier to find, you can drag a preset from its existing folder and drop it into one of your new custom folders; Lightroom will duplicate it in that destination folder. I find this easier than trying to remember in which of the existing Lightroom folders it might be stored. And you can always drag and drop custom presets between custom folders to move them around.

To create new presets, first configure all the settings from the Develop module's panels that you want to include in the preset; then click the + sign at the top of the Presets panel (or go to Develop > New Preset) to open the New Develop Preset dialog (**Figure 7.8**).

From this dialog, select the names of the settings you want included in your preset. Some of my presets have only one setting included, while others have multiple settings. The only wrong answer is including more settings than you need. Note that it is possible to choose or create a destination folder for your preset right from this dialog (otherwise, it defaults to the User Presets folder). Don't forget the Check All and Check None buttons at the bottom to make your selections go faster. After entering a meaningful name, click the Create button to save your preset to the chosen folder.

**Figure 7.8**  The New Develop Preset dialog is where you choose which settings to include in your preset.

A popular way to obtain new presets is by downloading them from the web. Whether free or for a fee, presets are available from countless places online. Here's how to install presets you've gotten from others:

1. You may first need to unzip the downloaded preset by double-clicking the zip file it came in. If not, proceed to the next step.

2. Open Lightroom, and go to the Develop module.

3. Right-click the folder where you want your new preset to be stored, and choose Import from the context menu.

4. In the dialog that opens, navigate to the location of the preset, and click Import. Note that develop presets have an .lrtemplate file extension.

That will import the selected preset into the designated folder. You can just double-click a preset file to import it, but it ends up in the User Presets folder that way. I prefer to create a folder and import my new preset there directly.

## Print Templates

I love printing from Lightroom. It is so much easier to print multiple photos from Lightroom than it ever was from Photoshop, and you can get the same great results. One of the greatest strengths of the Print module is the ability to preserve your layouts as templates for reuse. You can find a number of pre-installed print templates in the aptly named Template Browser (**Figure 7.9**).

**Figure 7.9** The Template Browser is where you can access, organize, and create new print templates.

There are a lot of similarities between the workings of the Template Browser in the Print module and the Presets panel in the Develop module. The most significant similarity is that you can create an organizational structure for your templates within the panel by right-clicking an existing template folder and choosing New Folder from the context menu. Alternatively, you can go to the Print menu and choose New Template Folder.

Because there are three categories of layout styles in the Print module (see the Layout Style panel), my suggestion is to start by creating a folder for each layout style that you want to save as a template. The pre-installed Lightroom Template folder has templates from all three styles dumped in there, and this can be confusing because each layout style behaves a little differently.

For example, I right-clicked the Lightroom Templates folder, chose New Folder, and created a new folder named Single Image Contact Sheet (**Figure 7.10**). Any single image or contact sheet layouts I want to save as templates will go into that folder.

Just as in the Develop module, you can drag and drop any of the pre-installed templates into your custom folders to create a copy of the template in your folder. This might be a good way to get started. To determine what layout style is being used by a given template, just click the template and look in the Layout Style panel—whichever layout style is highlighted is the one being used.

To create a template, first configure all the panels on the left side the way you want them to be, then either click the + sign on the Template Browser or go to Print > New Template to open the New Template dialog and give your template a name (**Figure 7.11**). You can choose an existing template folder in this dialog, but you can't create one from here, so I like to make the folder first.

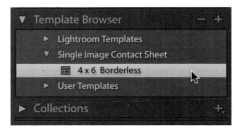

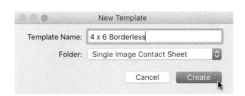

**Figure 7.10**  You can create folders for your templates that make the most sense to you and your workflow.

**Figure 7.11**  Always give your templates a meaningful name.

## Web and Slideshow Templates

The Web and Slideshow modules both have a Template Browser panel of their own, and they behave in the same way as the one in the Print module. Please refer to the previous section for an outline of how they work.

## Text Templates

If you've ever wanted to display text on photos during a slideshow, customize the title and caption content that appears with certain web galleries, or modify the text that can be displayed with some print layouts, then text templates are what you want to use. You can access, edit, and create these types of templates via any of the following:

▶ The ABC button in the toolbar of the Slideshow module (**Figure 7.12**).

**Figure 7.12** Click the ABC button on the Slideshow module toolbar to access the text template menu.

▶ The Image Info panel of the Web module (**Figure 7.13**).

▶ The Photo Info checkbox in the Page panel of the Print module when using the Single Image Contact Sheet layout style (**Figure 7.14**).

**Figure 7.13** Clicking either the Title or Caption drop-down menu in the Image Info panel takes you to the text template options.

**Figure 7.14** Once Photo Info is selected, you can access the text template options.

In each case you have access to all of the same text templates, and if you click the Edit option, it opens the Text Template editor (**Figure 7.15**).

**Figure 7.15**   The Text Template editor is where you can create or modify text templates.

The Text Template editor looks and behaves very much like the Filename Template editor in that it uses tokens to either pull existing information from each photo's metadata or enter in custom text. For example, let's modify the pre-installed Filename template. By default, this template is composed of just the Filename token. I'd like to customize that preset to begin with the name of the folder holding the image and include the filename extension at the end. Here's how to do that:

1. Select the Filename preset from the drop-down menu (if it's not already loaded).

2. Click the Filename token in the editor window once; then click again to see a pop-up menu of the other tokens contained in that set.

3. Click Folder Name to switch to that token (**Figure 7.16**).

**Figure 7.16** Clicking a token will access its other options.

Notice the Example field above the editor window; it shows a live preview of how the text will display. I don't want the folder and filename to run together, so I'll type a slash (/) and a space behind the Folder Name token right inside the edit window. You can hard-code text right into the template, which is great when you want to include specific text or characters in the template. There is also a Custom Text token, which inserts a placeholder in the template that you can customize with different text on a case-by-case basis at the time you are using that template.

4. At the top of the Image Name section, click the Insert button after the Filename drop-down to add Filename to the template. If you don't see Filename listed as the active token in the first item, click the drop-down menu and select it from the list.

**NOTE** If you add the wrong token or just want to start with a clean slate, select the unwanted tokens and press Delete to clear them.

5. Place your cursor behind the Filename token and type a period (.). Click the Filename drop-down arrow and choose Filename Extension. Your editor window should now look like this:

{Folder Name}/{Filename}.{Filename Extension}

Notice in the Preset menu that Filename now has *(edited)* at the end (**Figure 7.17**). This change occurs as soon as you make an edit to a preset. Click the Preset drop-down menu.

6. Choose either Update Preset "Filename" or Save Current Settings as New Preset. I just want to tweak the existing preset, so I choose Update Preset "Filename" and the *(edited)* part goes away.

7. If you decide that you want to keep the original preset and create a new one, choose Save Current Settings as New Preset, give your new preset a descriptive name in the New Preset dialog, and click Create.

**Figure 7.17** If you edit an existing template, you can choose to save it as a new one or just update the existing one.

There's no reason to keep templates you won't use, so I recommend tweaking the existing presets to your liking or deleting them before you make new ones. To remove a preset, select it and, before making any modifications, click the drop-down menu and choose Delete preset "[preset name]".

When you're finished working with the editor, click the Done button. Lightroom returns you to the module where you started, and your selected preset will be active.

## Metadata Presets

Metadata presets are a way to apply a lot of metadata information (copyright, contact, title, caption, location, and so on) to your photos at once. The most common use for metadata presets is to apply one during import so that all photos entering Lightroom have important information, like your contact and copyright info, applied to them from the start. Metadata presets can contain a lot more information than just that, though, and some photographers may create different presets for different locations they shoot at, for different models they work with, or maybe for different photographers if they hire second shooters. As with everything else in Lightroom, you get to decide how to best use these tools to suit your unique workflow.

You can access, edit, and apply metadata presets from a few different locations:

▶ The Metadata drop-down menu of the Apply During Import panel on the Import screen (**Figure 7.18**).

▶ The Metadata > Edit Metadata Presets menu of the Library module.

▶ The Metadata panel of the Library module (**Figure 7.19**).

**Figure 7.18** This is where you select a preset to be applied during import.

**Figure 7.19** If you forget to apply a preset during import, you can apply one right from the Metadata panel.

It may be easiest to simply start by going to Metadata > Edit Metadata Presets from the Library module to open the Edit Metadata Presets editor and create your first preset (**Figure 7.20**). I recommend that everyone have one that contains their copyright information at the very least, but I also like to include some contact info too.

**Figure 7.20** You can choose what information to include in your metadata preset.

The way the editor works is pretty straightforward in that you simply enter information in any field you want to include and leave the rest of the fields blank. In my case, I filled out the Creator, Creator State, Creator Country, Creator Phone, Creator E-Mail, Creator Website, and Creator Job Title fields, which is all information I apply at import.

One aspect of this preset that has tripped people up is that if you select the box next to a field and leave that field blank, it will erase that information from that field in any photos that are being imported. For example, some people mistakenly select the box next to the GPS field in the Camera Info section, which then wipes out existing GPS

information from each photo at import. Adobe's intention for this behavior was to provide the ability to clear fields if you wish; so be aware of what is selected when you save a preset, to avoid those good intentions backfiring. On that same note, make sure you include only information you *do* want applied to every photo. I have worked with people who have accidentally included a star rating or keyword in their presets and then spent a lot of time trying to figure out how that was being applied to all photos. In short, give every section a second look before clicking the Preset drop-down menu at the top to save your preset.

## Managing Presets and Templates Over Time

**NOTE** In Chapter 9, I will show you how to find where your presets and templates are stored on your drive, as well as how to migrate them to a new computer.

A couple of regular maintenance functions for presets and templates frequently cause confusion (at least judging by the questions I get on the topic), so I want to show you how to delete unwanted templates or presets, how to rename them, and how to update them with new settings. The functionality for doing these tasks within each editor or browser is similar yet different. I'll group the similar ones together, so as to not repeat the same steps each time.

For Import, Text, Metadata, and Filename presets, the behavior is the same. I'll demonstrate using the Metadata Preset editor. I already showed you how to create a preset, but the functions for renaming, deleting, and updating existing presets are all contained within the Preset drop-down menu at the top. So, for example, say you wanted to change or add a setting included in given preset. The steps are:

1. Open the appropriate editor, as shown earlier.

2. Click the Preset drop-down menu within the editor, and select the preset you want to change.

3. Make the changes to the preset.

4. Click the Preset drop-down menu, and choose either "Save Current Settings as a New Preset" (and then give the new preset a name) or Update Preset (to simply apply the changes to the existing preset) (**Figure 7.21**).

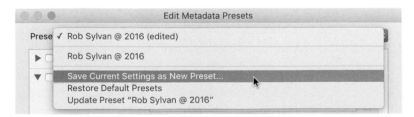

**Figure 7.21** Click the Preset drop-down menu after you've made your changes.

The really hidden features are the options to delete and rename a preset. For these, you need to first select the preset you want to delete or rename via the Preset drop-down menu and then click the Preset drop-down menu a second time and you will see the "Delete preset" and "Rename preset" options (**Figure 7.22**).

**Figure 7.22** The hidden functions are revealed the second time you click the Preset drop-down menu.

Updating, renaming, and deleting Export presets happen within the Export dialog itself. To delete a preset, simply select the preset and click the Remove button below the presets.

Updating an export preset is not as obvious. First you select the preset you want to update, which configures the Export dialog with those settings. From there you can make any changes you want to that preset, and when you are done, right-click the preset and choose "Update with Current Settings" from the context menu (**Figure 7.23**).

**Figure 7.23** Updating your preset is as easy as right-clicking.

Also within that context menu is the option to rename. To rename any preset, simply right-click it, choose Rename, and give the preset a new name.

The Presets panel in the Develop module and the Template Browser panels in the Print, Web, and Slideshow modules operate in a similar fashion to each other. You can't delete the pre-installed templates or presets in any of them. However, when one of your custom templates or presets is selected, you will notice that a – sign appears next to the + sign at the top of the panel (**Figure 7.24**). Click that – sign to delete the selected template or preset.

Alternatively, you can right-click any custom preset or template, and in the resulting context menu you will see the options Delete, Rename, and "Update with Current Settings" (**Figure 7.25**). This is my preferred method for doing any of those tasks.

**Figure 7.24** A minus sign appears when a custom preset or template is selected.

**Figure 7.25** The context menu puts all of your options at your fingertips.

Now that you know how template and presets can boost your productivity, and how to manage them over time, you should be well on your way to increased efficiency. The next step is to learn some keyboard shortcuts.

# Keyboard Shortcuts

No matter what software you are using, and Lightroom is no exception, there is probably no better way to increase your efficiency than to learn that program's keyboard shortcuts. That said, it can be overwhelming to try to memorize what seems like a series of random keystrokes when you are just trying to learn how to use the program itself. My advice is to start with the shortcuts for the commands you use most often,

and then, over time, start to add in others. Before you know it, your hands will automatically fly to the right keys without even thinking about it. How do you learn what the shortcuts actually are? There are actually quite a few ways to find them.

## Discovering Shortcuts

The most common way of discovering shortcuts is by finding them in the menu system. As new users, we tend to spend a lot of time going up to the menu bar, choosing a menu item, and then diving deeper into the menu system to find the command we want to use. Helpfully, right next to the menu command you will see the associated keyboard shortcut (if there is one). For example, a frequently used command is to send a photo to Photoshop for editing. If you choose Photo > Edit in > Edit in Adobe Photoshop, you will see the shortcut Ctrl+E (Windows) or Cmd+E (Mac) listed right there (**Figure 7.26**).

**Figure 7.26**  The shortcut for editing in Photoshop is shown right in the menu.

In addition to tripping over a shortcut in the menu system, a menu command will display the most important shortcuts for the module you happen to be in at the time. Go to the Help menu and choose [Module Name] Module Shortcuts, or press Ctrl+/ (Windows) or Cmd+/ (Mac), to see them displayed in an overlay (**Figure 7.27**). Just click the overlay to dismiss it.

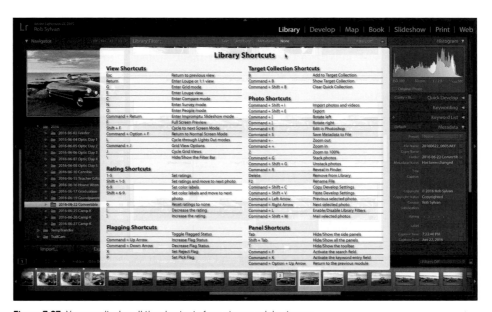

**Figure 7.27**   You can display all the shortcuts for a given module at once.

Finally, some shortcuts are displayed in a tool tip if you hover your cursor over the tool. For example, some of the tools in the toolbar display this tool tip, as do the tools in the toolstrip under the Histogram panel in the Develop module (**Figure 7.28**).

**Figure 7.28**   Some shortcuts are revealed in a tool tip.

## Starter Kit

To get you started on your shortcut journey, I'll share a few of the shortcuts that I think you will use most often and that will speed up your workflow:

▶ Press G to jump to the Grid view of the Library module from anywhere in Lightroom.

▶ Press E to jump to the Loupe view of the Library module from anywhere in Lightroom.

▶ Press D to jump to the Develop module from anywhere in Lightroom.

▶ Press F to show the selected photo in full screen.

▶ Press Shift+F to cycle through the screen modes.

▶ Press Ctrl+Z (Windows) or Cmd+Z (Mac) to undo your last action.

Obviously there are many, many more shortcuts to learn, but I use these on a daily basis, and I know you'll find them helpful. If you'd like to find a complete list of all shortcuts, which you can refer to or even print out, then head over to www.lightroomqueen.com/keyboard-shortcuts. Not only will you find the latest shortcuts for Mac and Windows, but that entire site is a wealth of useful information for all Lightroom users.

# Custom Default Settings

As you can now see, Lightroom can add efficiency to your workflow in many ways, but the cornerstone of that effort is the default settings you use as a starting point for all of your raw processing. Lightroom is programmed by Adobe with default settings for all raw photos—customizing those default settings to fit your style, taste, and workflow gets you started on the right foot every time.

When you shoot in raw mode, the photos are unprocessed by their very nature. What you see on the back of your LCD screen is a JPEG preview created by the camera, using the in-camera settings. As these photos are imported into Lightroom you will see that camera-generated JPEG being replaced by Lightroom's interpretation of the raw data, based on the default Lightroom/Camera Raw settings plus any develop preset settings you may have applied during import (applying a develop preset during import is optional, so you might not apply any). Out of the box, the Lightroom/Camera Raw default settings are responsible for controlling capture sharpening and noise reduction amounts, choosing a camera calibration profile, and leaving most other settings zeroed out. As starting points go, there is nothing inherently wrong with any of these settings.

However, if the first thing you do after every import is head to the Develop module and start changing various settings to get to a new baseline starting position, then you are a prime candidate for updating your default raw processing settings so that you can have all of your preferred settings applied automatically. For example, would you like to automatically enable lens profile corrections, start with a different camera profile, apply a different amount of noise reduction, or use a different tone curve? If you answered yes to any of that, then customizing the default settings to include these adjustments is the way to go.

## Defaults versus Presets

When you think about how you process your raw photos, try to separate the settings you tend to apply to all your photos all the time (these are your defaults) from the creative settings you apply to different photos based on specific output goals or visions (these might be good candidates for develop presets). A simple example might be that you want to choose a specific camera profile for all raw photos (custom default), but you also have a combination of settings that you like to use for creating contrast-y black-and-white photos (develop preset candidate). Once you have these settings separated in your mind, you can go forward with customizing your defaults and have a collection of develop presets that you can also apply during import when the mood or need strikes to take a given set of photos in a unique direction.

Let's go through the steps to customize the default settings to include two of the most common adjustments people ask me about: lens corrections and camera profiles. Feel free, however, to add any other settings you want.

**NOTE** The list of camera profiles varies with the camera model used to create the selected photo. Adobe supplies several style-matching profiles for most cameras, but you may see only Adobe Standard for some camera models. My example shows the profiles available for a Nikon D610. If you see Embedded only, then you don't have a raw photo selected.

1. Select a raw photo that has not been processed at all beyond the default settings, and press D to jump to the Develop module. Click the Reset button for good measure to ensure the photo has no other settings applied, because every adjustment (even set to 0) is included in the default settings.

2. Expand the Lens Corrections panel, click the Profile tab if it's not active already, and select the Enable Profile Corrections and Remove Chromatic Aberration checkboxes (**Figure 7.29**).

3. Expand the Camera Calibration Panel, click the Profile drop-down menu, and choose the camera profile you prefer to be the starting point (**Figure 7.30**).

**Figure 7.29**  Selecting these boxes includes them in your custom default.

**Figure 7.30**  The camera profiles for raw photos can have a big influence on the image.

4. Go to Develop > Set Default Settings to open the Set Default Develop Settings dialog (**Figure 7.31**). Default settings are specific to each camera model, so if you are using multiple camera models, you will need to update the defaults for each model separately.

**TIP**  You can also hold the Alt (Mac: Option) key, watch the Reset button change to Set Default, and click that button to open the Set Default Develop Settings dialog box.

**Figure 7.31**  Once all settings are dialed in, you can update your custom default.

5. Click "Update to Current Settings" to customize the default settings to include the changes you made.

While the Set Default Develop Settings dialog states that the changes are not undoable, this just means that you can't revert to the Adobe defaults via the Edit > Undo menu. However, you can always open this dialog and click Restore Adobe Default Settings if you want to revert to the out-of-the box settings, and you can always retrace these steps to further customize your default settings.

One heads-up about including profile corrections in your default settings is that the profile corrections are resource intensive. That means that Lightroom may be working pretty hard to apply those profile corrections to all photos from the start. If you find that performance is slowed down too much, you may want to re-do your custom defaults without the corrections included. I also have a develop preset that simply enables profile corrections and another preset that disables profile corrections. That way, I can toggle it on and off as needed if I am doing something else that is resource intensive, like removing spots with the Spot Removal tool.

## Synchronizing Previously Imported Photos

From this point forward, all newly imported photos will have your custom default settings applied to them automatically, and whenever you click the Reset button, these will be the settings the photo will reset back to using. However, this change will not affect any of your previously imported photos, because Lightroom doesn't want to unintentionally undo any work you have already done. You will need to manually apply these changes (if desired) to any previously imported photos that you have not yet adjusted. Here's a quick way to do that:

1. Select all photos you want to have these settings applied to, and press D to jump to the Develop module if you're not already there.

2. Go to the Settings menu and select Enable Auto Sync. Notice that when enabled, the Sync button at the bottom of the right panel group changes to Auto Sync. You can also enable Auto Sync by clicking the small switch next to Sync/Auto Sync to the up position.

3. Click the Reset button.

4. Disable Auto Sync by clicking the Auto Sync button or deselecting Enable Auto Sync under the Settings menu.

**WARNING** It is critically important that you disable Auto Sync when you are finished so that you do not inadvertently apply settings to the wrong photos.

## Advanced Settings

If you go to Preferences > Presets, you will see additional options to make the defaults specific to the camera serial number and to make defaults specific to the camera ISO setting (**Figure 7.32**).

**Figure 7.32**  You can customize your defaults by serial number and ISO.

If you have only a single camera body for each camera model you own or you want the same settings applied to all bodies of that camera model, then there is no need to tie the defaults to a serial number and you can leave that option unselected.

If you want to customize the amount of noise reduction and sharpening (or other settings) based on ISO setting, then you might want to experiment with selecting the ISO setting checkbox and repeat the steps to customize the defaults for each ISO setting. Remember that this is only a new starting point and you can always change any setting at any time in the future.

Once you are able to begin taking all that you have learned in this chapter into your workflow, you should be well on your way to making the most out of Lightroom's built-in efficiency-boosting tools.

# 8

# COMMON ORGANIZATIONAL WORKFLOWS

I completely understand the impulse to just start doing things before fully learning all there is to know about what you are doing (I am a guy, after all). There *is* a lot to be learned through experience (even if it is painful). Besides, the whole point of using Lightroom is to get stuff done, right? To that end, this chapter is all about doing things in Lightroom that make use of the panels, features, and tools I've covered in other chapters of this book. I'm not going to teach you about the ins and outs of those panels, features, and tools here, but I will refer you to the chapter where you can learn more if you need to dive deeper on any one topic. So, if you just opened the book to this chapter or if you've been reading steadily through chapter by chapter (gold star for you), you are covered either way. Let's get to it.

## Importing Photos

The one task everyone has to tackle in Lightroom is importing photos. Chapter 2 took a deep dive into understanding the import process and getting oriented to the Import screen, so please refer to that chapter if you want to learn more. You might also check out the section in Chapter 7 on creating an import preset. If you just want to get to work or try a way to work more efficiently, check out these workflows.

## Adding Photos on Your Hard Drive

I'm guessing that you already had photos on your hard drive before you started using Lightroom, so the most common scenario for adding the photos already on your drive is that first import. That said, there may be occasions when you get photos from some other source (email, download, FTP, and so on) and, after putting those photos in a folder of your choosing, you'd like to add them to your Lightroom catalog without moving or copying them to a new location. These steps work for any scenario in which the photos are where you want them and you just want Lightroom to take note and add them to the catalog.

1. Click the Import button to launch the Import screen.

2. Select the Add option at the top of the screen (**Figure 8.1**).

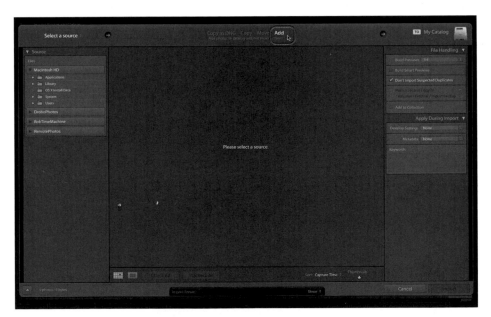

**Figure 8.1** The Import screen is set to Add.

**TIP** You can "dock" folders by double-clicking the parent folder to collapse the unwanted folders above it and just see the contents of the folder you are looking for, as shown in Figure 8.2.

3. Expand the Source panel, and choose the folder containing the photos you want to import (**Figure 8.2**). Select the Include Subfolders checkbox to include photos in any subfolders.

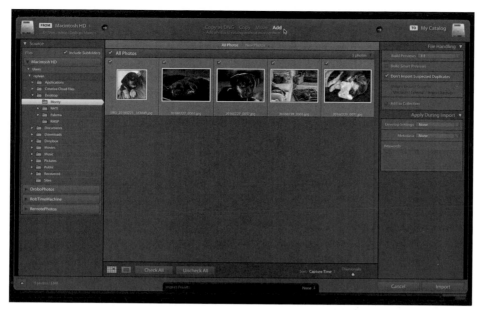

**Figure 8.2**  The source is the folder containing the photos you want to import.

## Quickly Find a Folder

A quick way to find common or recently used folders is to click the "Select a source" drop-down menu at the top, where you'll find these listed just a click away (**Figure 8.3**).

**Figure 8.3**  The "Select a source" drop-down menu is faster than drilling down through all folders.

4. Expand the File Handling panel, and configure your desired options for building previews, building smart previews, preventing the import of duplicates, and adding these photos to a collection (**Figure 8.4**).

5. Expand the Apply During Import panel, and configure your desired options for applying Develop settings, applying a metadata preset, and applying keywords (**Figure 8.5**). Keep in mind that anything you choose in this panel is applied to all photos imported at this time, and you can always do any of these tasks later too.

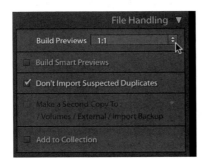

**Figure 8.4** Configure your file-handling settings to suit your needs.

**Figure 8.5** Applying things during import is intended to save you time down the road.

6. Double-check your settings, and click Import to start the process.

That's all there is to it. Now you will see those photos in the Library module, and the folder will appear in the Folders panel.

## Copying Photos from a Memory Card

Most of your Lightroom experience will involve bringing photos from your memory card to your primary storage location (internal, external, or network drive). Lightroom can assist in this process by copying the photos to a location of your choosing as part of the import process.

1. Click the Import button to launch the Import screen.

2. Select the Copy (or "Copy as DNG") option at the top of the screen (**Figure 8.6**).

> **NOTE** You can directly connect your camera to your computer and import photos that way, but I believe a memory card reader is a better option because it is usually faster, has fewer computer-driver–related issues, and doesn't drain your camera battery. Card readers are cheap too.

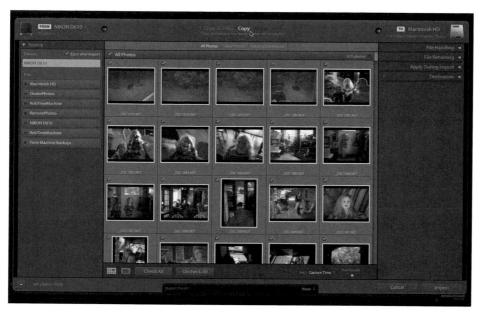

**Figure 8.6**  The Import screen is set to Copy.

3.  Expand the Source panel, and choose your memory card (**Figure 8.7**).

4.  Expand the File Handling panel, and configure your desired options for building previews, building smart previews, preventing the import of duplicates, making a second copy (backup) of your memory card, and adding these photos to a collection (**Figure 8.8**).

**TIP** You can invoke Solo mode on the right-side panels by right-clicking any of the panels on that side and choosing Solo Mode from the context menu.

**Figure 8.7**  Memory cards show up under Devices in the Source panel.

**Figure 8.8**  Configure your file-handling settings to suit your needs.

5.  Expand the File Renaming panel, and choose your desired renaming template (or leave Rename unselected to keep the camera-generated names). Alternatively, you can rename later.

6. Expand the Apply During Import panel, and configure your desired options for applying Develop settings, applying a metadata preset, and applying keywords.

7. Expand the Destination panel, select the folder you want these photos to be copied into, and (very important) configure the Organize option to suit your needs (**Figure 8.9**).

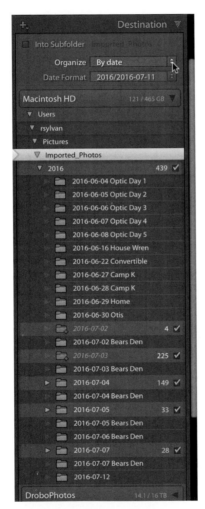

**Figure 8.9** I like to have the Organize option set to By Date so that Lightroom creates date-based folders within the selected parent folder.

8. Double-check your settings, and click Import to start the process.

At this point Lightroom begins copying the photos to the location chosen in the Destination panel and in accordance with the way you configured the Organize option. Lightroom only does what it is told, so make sure you know what you are telling it to do each time. If you chose the "Copy as DNG" option, you should know that the conversion to DNG doesn't start until all the photos have been copied to the destination, so give it some time.

A word about the Move option: You may have noticed that I don't devote much space to the Move option on the Import screen, and this is because I really don't think you should use it. Move is disabled for memory cards and is available only when your drive is the selected source. Moving photos involves copying them to a new location and then deleting them all in one action. The problem is that if anything goes wrong during that action (power goes out, drive gets disconnected, and so on), then you risk losing data. My recommendation is to stick to the Copy option as far as Lightroom is concerned, and once the copies are safely created in the new location you can always manually go back and delete the source. That said, if you were to use Move, the steps are essentially the same as for using the Copy option.

> **NOTE** Some people like to manually copy the photos from a memory card to a folder on their drive and then use the Add option to add those photos to the catalog. There's nothing wrong with that workflow, and if you want to try it, you can follow the steps in the "Adding Photos on Your Hard Drive" section.

## Compact Import Screen

If you ever open the Import screen and it looks unexpectedly smaller, you are seeing the compact view (**Figure 8.10**). Don't panic, just click the Show More Options arrow at the bottom to expand it to full size.

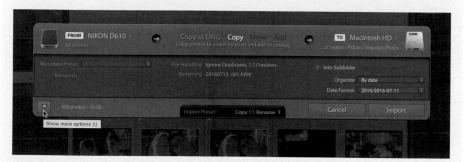

**Figure 8.10** Compact view is more streamlined, but I like seeing all the options.

# Evaluating Photos

**NOTE** Chimping is the habit of staring at the back of the camera in wonder immediately after taking each photo. Remember: Spend more time taking photos and less time staring at the camera.

We photographers spend a lot of time evaluating our photos, from "chimping" at the back of the camera to peeking at the Import screen once we get them inside of Lightroom. I can't help you break the chimping habit, but I will share some workflow tips for during and after import to help you separate the keepers from the clunkers.

## During Import

I don't recommend spending a lot of time going through photos on the Import screen. My workflow is to just bring them all in and then sort them out later. At times you might want to be more selective, however; or perhaps some obvious lens cap shots leap out at you that you'd rather not even copy off the card. Once the Import screen is open and your source is selected, you can control which photos enter the catalog. Here are some tips:

▶ If you have a large batch of photos but want to bring in only a few, start by deselecting all the images using the Uncheck All button on the bottom (**Figure 8.11**), and then just select the photos you want to include.

**Figure 8.11**  Click Uncheck All to make it easier to select only a few photos for import out of a large batch.

▶ You can select a contiguous group of photos by selecting the first photo and then holding the Shift key while selecting the last in line. Click the checkbox for any selected photo to select them all for import (**Figure 8.12**). You can also use this technique to deselect a group of photos.

▶ You can select a noncontiguous batch of photos by holding the Ctrl key (Mac: Command key) while you click each thumbnail. Click the checkbox for any selected photo to check them all for import (**Figure 8.13**). This tip works in reverse for deselecting photos too.

**Figure 8.12**  Hold the Shift key to select all photos between two photos.

**Figure 8.13**  Hold the Ctrl key (Mac: Command key) to select noncontiguous photos.

▶ Hover your cursor over a thumbnail to see the date it was taken appear in a tool tip.

▶ Double-click a thumbnail to see a larger version (if one is embedded in the source photo). Double-click again to jump back to the grid. There are also buttons below the thumbnails to jump between these views.

▶ Video files display a video camera icon on the thumbnail to help them stand out from the stills (**Figure 8.14**). Scan for these to more quickly select (or deselect) videos.

**Figure 8.14**  Video files display a video icon to make them more visible.

## After Import

The reason I like to wait to do major photo evaluations until after import is that then I have a lot more tools at my disposal to get the job done. Specifically, I can leverage rating stars, pick or reject flags, and even add color labels to help me identify my keepers, get rid of my clunkers, and begin organizing with colors.

I want to point out that you can apply ratings, flags, and color labels from their respective buttons on the Library module toolbar (**Figure 8.15**). If you don't see them on

your toolbar, click the disclosure triangle on the right end and select the ones you want to appear in the menu that appears. You can also find each of these grouped together under the Photo menu along with their keyboard shortcuts (**Figure 8.16**). That said, it is the keyboard shortcuts that we are really after, as those are the "keys" to making this workflow fly.

**NOTE** In a pinch, you can also find ratings, flags, and color labels nestled in the context menu when you right-click a photo or click the attribute on the thumbnail.

**Figure 8.15** Ratings, flags, and color labels can be applied by clicking the desired button on the toolbar.

| ary | Photo | Metadata | View | Window | Help | | | |
|---|---|---|---|---|---|---|---|---|
| | Remove from Target Collection | | | B | | | | |
| | Open in Loupe | | | ↵ | | | | |
| | Show in Finder | | | ⌘R | | | | |
| | Go to Folder in Library | | | | | | | |
| | Lock to Second Window | | | ⇧⌘↵ | | | | |
| | Edit In | | | ▶ | | | | |
| | Photo Merge | | | ▶ | | | | |
| | Stacking | | | ▶ | | | | |
| | People | | | ▶ | | | | |
| | Create Virtual Copy | | | ⌘' | | | | |
| | Set Copy as Master | | | | | | | |
| | Rotate Left (CCW) | | | ⌘[ | | | | |
| | Rotate Right (CW) | | | ⌘] | | | | |
| | Flip Horizontal | | | | | | | |
| | Flip Vertical | | | | | | | |
| | Set Flag | | | ▶ | | | | |
| | Set Rating | | | ▶ | | | | |
| | Set Color Label | | | ▶ | Red | 6 | | |
| | Auto Advance | | | | Yellow | 7 | | |
| | | | | | Green | 8 | | |
| | Set Keyword | | | ▶ | Blue | 9 | | |
| | Add Keywords... | | | ⌘K | Purple | | | |
| | Develop Settings | | | ▶ | None | | | |
| | Remove Photo... | | | ⌫ | | | | |
| | Remove Photo from Catalog | | | ⌥⌫ | | | | |
| | Delete Rejected Photos... | | | ⌘⌫ | | | | |

**Figure 8.16** The Photo menu also gives access to the ratings, flags, and color labels and their shortcuts.

The keyboard shortcuts for these are really easy to learn (well, maybe not color labels so much, but they are the least important of the three) because they are intuitive. For example, the 0 to 5 keys correspond to the 0- to 5-star ratings. Color labels start at the 6 key and go up to the 9 key (only purple has no shortcut). When it comes to flags, the P key corresponds to Pick, X corresponds to Reject, and U corresponds to Unflag. Commit those to memory, and I promise it will make your life easier.

As far as assigning meaning to each of the rating systems, well, that is entirely up to you. From movies to restaurants to hotel rooms, traditionally the higher the star rating the more the reviewer likes it. I prefer to keep things simple: I give an image 3 stars if I really like it and want to process it further as a way to make it stand out from the pack. I don't tend to use the other rating levels very much. When it comes to color labels, I've seen systems where people apply, say, a red label to all photos intended to be used as part of a panorama and a yellow label to all photos that were part of an HDR bracket, or a blue label for client favorites and a green label for personal favorites. The meaning you assign to them is really only important to you, so take some time to experiment and come up with a system that you can apply consistently over time.

Let's dive into the workflow. In the previous sections on importing you may have noticed that I consistently have the Build Previews setting on 1:1. The reason for this is that I want Lightroom to get right on rendering out those 1:1 previews so that when I sit down to review my photos I can zoom in to 1:1 (100%) without any delay. So, with your 1:1 previews rendered and your keyboard shortcuts memorized, here's how to go through a shoot in no time:

1. Press G to jump to Grid view, and select the first photo in the batch.

2. Go to the Photo menu, and select Auto Advance.

3. Press Shift+Tab to hide all panels and give maximum room to your photos (**Figure 8.17**). Start with a focus on flags with the goal of applying a Pick flag to all keepers and a Reject flag to all the ones you want to delete.

4. Press and hold the Z key to zoom to 1:1 view to check focus; then release the Z key to return to Grid view. If you keep the Z key down, you can still drag in the photo to pan around while zoomed in.

5. Press the P key to mark the photo as a keeper, press the X key to mark it as rejected, and if you really can't decide at that moment, press the U key to keep it marked as unflagged and still trigger Auto Advance to move on to the next photo.

**TIP** If you didn't render 1:1 previews on import, select the photos and go to Library > Previews > Build 1:1 Previews.

**NOTE** When Auto Advance is enabled, as soon as you apply a star rating, flag, or color label, Lightroom will automatically advance focus to the next photo. This lets you focus on applying your metadata without delay.

**NOTE** If you just tap the Z key, it will toggle you into 1:1 view. Tap again to toggle back to Grid view.

**Figure 8.17** Auto Advance is enabled, my panels are hidden, and I'm ready to go.

6. Repeat steps 4 and 5 until you get to the last photo in the shoot.

7. When you get to the last photo in the shoot, click the Attribute button on the Library Filter bar (more on the Library Filter later in this chapter). When the Attribute options appear, right-click the flag icons and choose Unflagged Photos Only (**Figure 8.18**). This tells Lightroom to hide all photos marked with a Pick or Reject flag and show only the unflagged photos. Now you have to fish or cut bait and decide on each remaining photo if you want to keep it or mark it for deletion. By turning on this filter, as soon as you flag a photo it will be hidden from view.

**TIP** Holding the Shift key temporarily disables Auto Advance, which can be helpful if you want to apply a star rating or color label in addition to a flag before moving on to the next photo. So hold Shift, apply the flag, release Shift, and apply a rating, and then Lightroom auto-advances to the next photo.

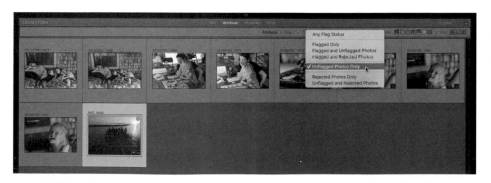

**Figure 8.18** The Attribute filter is set to show only unflagged photos.

8. Repeat steps 4 and 5 until there are no photos left in view.

9. Press Ctrl+L (Mac: Command+L) to disable the filter and return all photos to being visible. They will all have a flag and possibly even a rating or label (depending on what you decided), and every photo will have been evaluated.

This last step is optional. If you are prepared to delete the photos you marked as rejected, Lightroom makes it easy. Go to Photo > Delete Rejected Photos, and Lightroom will gather up all photos marked as rejected and give you the prompt for carrying out the deletion (**Figure 8.19**). If you've come this far, then my suggestion is to choose "Delete from Disk" to get rid of them completely. Choosing Remove removes them only from the Lightroom catalog and leaves them on the drive.

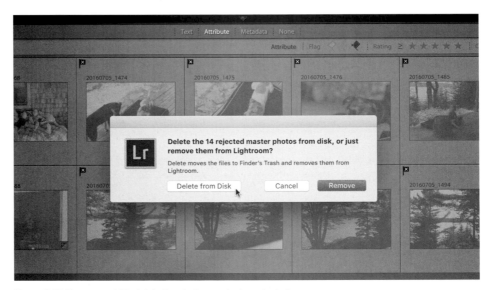

**Figure 8.19**  You can quickly delete the photos marked as rejected.

Now you can move on through your workflow with just your keepers.

## Applying Keywords

There are actually a lot of different ways you can apply keywords to your photos, and which route you take is largely a matter of personal preference. I've touched on some already in this chapter (such as the Apply During Import panel of the Import screen) and on others in the keywording section of Chapter 5. In this section, I want to show you a couple of alternative workflows you can add to your repertoire.

# Using the Keyword List Panel

Chapter 5 covered many aspects of the Keyword List panel, but the one part I left out was how you can use it to apply keywords to and remove keywords from your photos. The key to using this technique is to already have a keyword list in place (which you learned how to create in Chapter 5).

## Applying Keywords

This is how I usually end up applying keywords to my photos:

1. Select the folder or collection containing the photos you want to keyword, and press G to jump to Grid view (if not there already).

2. Select the photo(s) you want to tag with keywords.

3. Expand the Keyword List panel.

4. Locate the keyword you want to apply in the Keyword List panel. If you have a large keyword list (like me), type the first few letters of the keyword into the Filter Keywords field at the top of the panel to filter the list to just the keywords that match what you've entered (**Figure 8.20**). In my case, I'm looking for swim-related words.

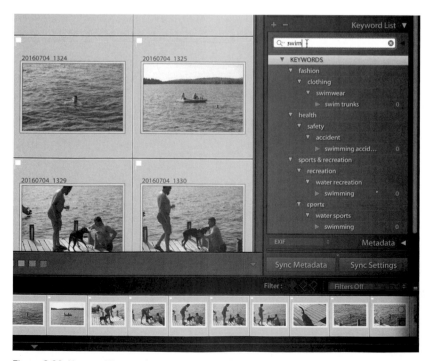

**Figure 8.20** You can filter your keyword list to just the word you are looking for.

5. Once your keyword is visible, you can drag the selected photos to the keyword or drag the keyword to the photos (**Figure 8.21**).

Alternatively, you can just select the box to the left of the keyword to apply it.

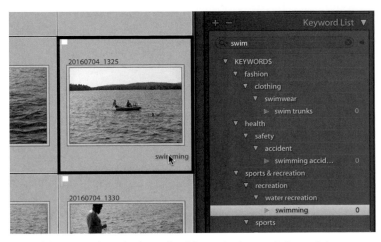

**Figure 8.21** Keywords can be dragged and dropped onto your photos, and vice versa.

**NOTE** Thumbnail badges appear only if they are enabled in the Library View Options > Cell Icons section.

Notice that once a keyword is applied to a photo, you get visual confirmation in the form of a tag badge appearing on the thumbnail(s), as well as, in the Keyword List panel, a checkmark appearing to the left of the keyword and a photo count appearing to its right (**Figure 8.22**).

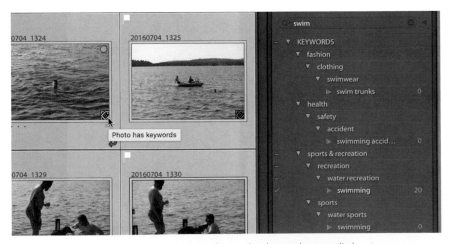

**Figure 8.22** Lightroom provides important visual cues when keywords are applied.

6. Repeat steps 4 and 5 until all desired keywords are applied to the selected photos, then move on to the next batch of photos.

OK, so you may be wondering why I prefer this method as opposed to just typing in the Keywording field, or any other method. With my large keyword list, I like being able to see the keyword hierarchy so that I know which meaning of the word I am applying, and I like all of the visual confirmations that appear after it is done. It is a very hands-on method, and that just suits my style.

## Removing Keywords

You can use basically the same steps to remove a keyword from a photo. This is helpful anytime you've accidentally applied the wrong keyword or you need to clean up your keyword list.

1. Select the folder or collection containing the photos you want to remove the keyword from, and press G to jump to Grid view (if not there already).

2. Select the photo(s) you want to remove the keyword from.

3. Expand the Keyword List panel.

4. Locate the keyword you want to remove in the Keyword List panel. Use the Keyword Filter if needed.

5. Once your keyword is visible, just click the checkmark to the left of the keyword to remove it from the selected photo(s).

6. Repeat steps 4 and 5 until all keywords are removed.

The following technique can be especially useful when cleaning up a messy keyword list. I've encountered people who end up having multiple forms of a word in their keyword list, with different photos applied to each form of the word. They don't want to lose the work they've done, but they want to unify under a single form of the word. For example, let's say in my haste I created a keyword with a typo, misspelling "water" as "watre" (hey, I was in a hurry), and I applied that bad version to some photos. I had previously applied the correctly spelled "water" to other photos. Realizing my mistake, I want all of the photos to be tagged with the correct spelling and then delete the typo. Here's what you'd do in this situation:

1. Locate the keyword you want to remove in the Keyword List panel.

2. Hover your cursor over the keyword and you'll see an arrow appear to the right of the word; click that arrow to bring up all photos with that tag in Grid view (**Figure 8.23**).

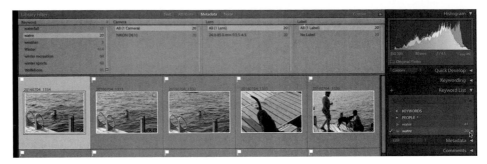

**Figure 8.23** The arrow to the right of a keyword will call up all photos with that tag.

3. Select all photos (Edit > Select All).

4. Locate the keyword you want to keep in the Keyword List panel.

5. Select the box to the left of the correct keyword to apply it to the selected photos.

6. Remove the checkmark from the bad version of the keyword to remove it from the selected photos.

7. With the bad keyword selected, click the – sign at the top of the Keyword List panel to delete it.

## Painting Your Photos with Information

The often-overlooked Painter tool can be a real time-saver when working with large groups of photos in Grid view in the Library module. I always find myself forgetting about the Painter tool. Then I come up against a project where I need to work through hundreds of photos for some reason—such as assigning a new keyword—and then I remember the Painter tool! Do you see that little spraypaint icon in the Grid view tool-bar (**Figure 8.24**)?

**Figure 8.24** The Painter tool is visible only in Grid view.

Here's how to use it:

1. Select the Painter tool from the toolbar to enable it (or go to Metadata > Enable Painting).

2. Click the Painter tool drop-down menu, and choose Keywords from the list (**Figure 8.25**).

Figure 8.25 The Painter tool can be loaded with keywords and other things.

3. Click into the Keyword field and enter a keyword. If you have a keyword list, Lightroom will auto-complete as you type.

   Alternatively, hold the Shift key to open a pop-up dialog containing your keyword sets, choose a set from the drop-down menu, and click any keywords from that set that you want to apply (**Figure 8.26**).

Figure 8.26 You can access your keyword sets to choose those words quickly.

4. With the Painter tool now loaded with keywords, drag over the photos you want to assign those keywords to. You'll notice that the cursor has changed to the Painter icon when you place it over a photo, and as you drag, the can animates to appear as if it is spraying. A message will also appear to verify that you have assigned the keyword to that photo.

   If you "overspray" and hit a photo you didn't want to add to that collection, you can hold the Alt (Mac: Option) key to change the painter to an eraser and drag over those photos to remove them from the target collection. A message will appear to verify that you have removed the keyword from the photo.

**NOTE** You can also load it with a color label, flag state, star rating, metadata template, develop preset, rotation setting, or even a collection. It's like a Swiss Army knife!

5.  When you have finished with the Painter tool, you can click the Done button in the toolbar, put the Painter cursor back into its docking circle, or press the Escape key to exit the Painter tool.

The basic process works the same with whatever item you have loaded in the Painter tool. However, if you are painting with a metadata preset, rotation, or develop preset, you can't erase the overspray with the Painter tool, but Ctrl+Z (Mac: Command+Z) does undo it if you catch it right away.

# Finding Photos

With all your keywords, ratings, flags, tagged faces, and other metadata in place, now you can put that database to work to help you filter and find the photos you need when you need them. You've had a few peeks at the Library Filter bar so far, but let's dive a little deeper into how it can be used. I'll wrap up this section with a useful way you can employ smart collections.

## Using the Library Filter

**NOTE** The Library
Filter bar is accessible
only when you are
in Grid view. If you
don't see the Filter
bar, press the \ key
to toggle its visibility
back on (the same
key will also toggle its
visibility off to get it
out of the way).

The Library Filter bar appears above the thumbnails in Grid view (**Figure 8.27**), and its purpose is to help you find and focus on just the photos you want to see by harnessing the data contained the Lightroom catalog.

**Figure 8.27**  The Library Filter bar lives above the thumbnails in Grid view.

The three types of filters—Text, Attribute, and Metadata—can be used independently or in combination to help you drill down into your catalog. The Text filter searches any of the indexed metadata fields, such as keywords and filenames, as well as some of the IPTC and EXIF metadata. The Attribute filter allows you to filter your photos based on flag state, rating, color label, and copy status. The Metadata filter displays customizable columns of metadata pulled from the catalog, based on the currently visible grouping of photos.

Each of these filters provides a slightly different means to home in on a desired grouping of photos, and they can be incredibly powerful when used together. Let's walk through a basic example of how to find all photos in a catalog that match a specific keyword, star rating, and capture date to see how this works.

1. Expand the Catalog panel, and select All Photographs.

   The Filter bar works on the pool of photos you make available. If you want to search your entire catalog, then start here. However, you can select any folder or collection and filter from there in the same way.

2. Click the Text label on the filter to activate the input field, and set it to Keywords.

3. Start typing the desired keyword (**Figure 8.28**).

   I wanted to find all photos tagged with "bear." As soon as I start entering the first letters of the keyword, the filter kicks into action and displays only photos tagged with words that match what I have typed.

**Figure 8.28** All the photos showing contain the keyword "bear."

4. Hold the Shift key and click the Attribute label. This expands the Attribute section of the Filter bar.

5. Click the number of stars you want to filter by (**Figure 8.29**).

   I chose 3 stars or higher by clicking the third star and leaving the rating set to "greater than or equal to." You can choose as many attributes as you want to refine your filter.

**Figure 8.29**  Now only photos with the keyword "bear" and a 3-star rating or higher are shown.

6. Hold the Shift key and click the Metadata label to expand that section of the Filter bar.

   If you don't see a Date column at first, click the drop-down menu on the top left of any visible column and choose Date from the list (**Figure 8.30**).

**Figure 8.30**  There are many metadata options to choose from.

7. In the Date column, click the desired capture date (**Figure 8.31**).

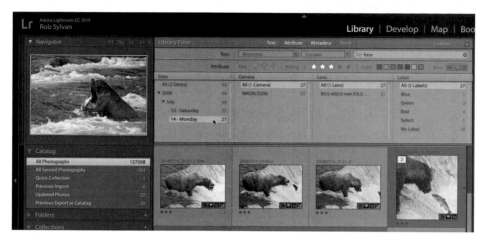

**Figure 8.31** Dates based on the photos in the current filter will be shown.

You can, of course, click any piece of metadata to drill down to just the photos that match the criteria you require.

In my example, I wanted to find all my bear photos that were rated 3 stars or higher and were shot on July 14, 2008, which required a combination of all filters, but as you can see, there are a lot of ways to drill down into your photo catalog to home in on just the photos you want to find. When you are done, press Ctrl+L (Mac: Command+L), or click the None button, to turn off all filters.

Now that you know the basics, give the Filter bar a test-drive and don't be afraid to experiment to get a feel for what it can do.

**NOTE** You can customize the Metadata filter by adding up to eight columns or reducing down to one by clicking the drop-down menu on the top right of any visible column.

## Creating Smart Collections

You learned the basics of smart collections in Chapter 4, so here I want to focus on some methods for leveraging the power of smart collections to help you in your workflow and to help you manage your photos. One way I've found smart collections to be useful is to create a collection set of them using various parameters that provide a level of insight into what I have in my catalog. I call this my catalog dashboard. For example, within my so-called dashboard I have a collection set named File Type, and then within that I have a series of smart collections that are based on file type parameters (**Figure 8.32**). This gives me an at-a-glance view of the contents of my catalog based on file type.

**Figure 8.32** This is my custom-made "dashboard" collection set.

**NOTE** Collection sets are not required, but they help you keep your collections structured and organized.

**NOTE** You can always drag and drop collections into collection sets later too.

These collection sets are simple to create:

1. Click the drop-down menu in the Collection panel header, and choose Create Collection Set. Give that collection set a name, and click Create.

2. Click that same drop-down menu, and choose Create Smart Collection.

   Give the collection a meaningful name, select the box to have it put inside a collection set, and then click the associated drop-down menu and select the collection set you just created.

3. Create your first rule by clicking the drop-down menu next to the first criterion. Choose File Name/Type > File Type (**Figure 8.33**) and then configure the type of file you want this smart collection to gather (for example, JPEG, TIFF, PSD, and so on).

4. Click Save to save this smart collection and put it to work.

**Figure 8.33** Choose File Type as your criterion.

I repeated that process to create a smart collection for each of the supported file types and then also added one for 32-bit TIFF files (they can take up a lot of disk space), files that have smart previews rendered, and files that have been converted to black and white in Lightroom. What you find useful may vary.

As soon as you click Save and the Edit dialog closes, Lightroom begins to automatically populate the smart collection based on that set of criteria. Remember that the only way to remove files from a smart collection is to either change the rules so the files no longer match or change the files so they no longer match the rules.

# Exporting Copies for Output

Typically, the main goal of getting photos into Lightroom is to, eventually, get processed versions out of Lightroom to share with the world. Maybe you are creating copies to send to clients or friends, or perhaps you want to upload photos to your blog, social media, or an online print service. In all of these cases, whenever you want to create copies of your photos, it is time to export. Exporting is the moment where all the work you've done in Lightroom is applied to copies of your source photos (because Lightroom never changes the pixels of your source photos).

The Export dialog box is where you can configure all of the particulars about a given set of copies, such as where you want it save to, what file type, any resizing specifications, and so on (**Figure 8.34**).

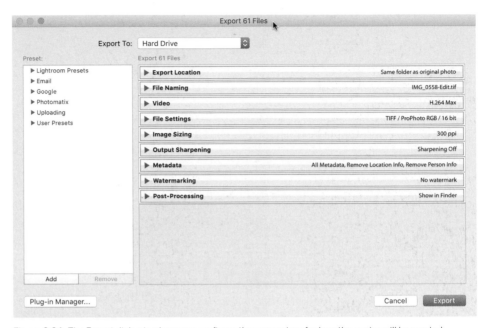

**Figure 8.34** The Export dialog is where you configure the parameters for how the copies will be created.

**NOTE** It is good to glance at the top of the Export dialog to verify that the number shown matches how many photos you wanted to export.

**NOTE** I generally don't add exported copies back to my catalog, but it is an option for those who need to use it.

For any export, you need to know the purpose for creating the copies before you start. Let's go through the steps for exporting copies of processed photos to be delivered as JPEGs to a client.

1. Select the photo(s) you want to export. You can select any number of photos at a time for export.

2. Click the Export button to open the Export dialog.

3. Set the Export To drop-down to Hard Drive.

4. Expand the Export Location panel, and choose where you want these copies to be saved on your drive (**Figure 8.35**).

   I chose my Desktop, and I selected the "Put in Subfolder" checkbox to create a new subfolder at that location with a name of my choosing.

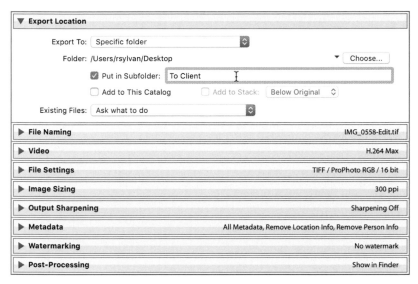

**Figure 8.35** Choose where you want these copies to go.

5. Expand the File Naming panel, and choose how you want these copies to be named (**Figure 8.36**).

Leave Rename To unselected if you want the copies to have the same names as the source photos.

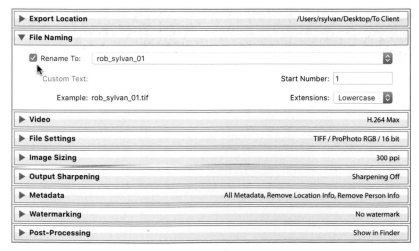

**Figure 8.36** Renaming is optional, but you are in control.

**NOTE** Only the H.264 video format will include the edits you made in Lightroom in your video clips.

6. (Optional) If you selected video files for export, select the Include Video Files checkbox. I didn't have any video, so I deselected that option (**Figure 8.37**).

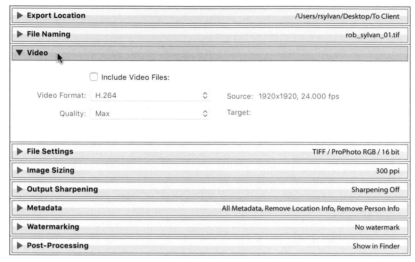

**Figure 8.37** Decide whether you want to include video.

7. Expand the File Settings panel, and configure the desired file type settings (**Figure 8.38**).

I needed JPEG files, so that was my choice for Image Format. The Quality slider appears only for JPEG files, and it controls how much compression is applied. When you are not sure of the needed color space, it is always safest to go with sRGB.

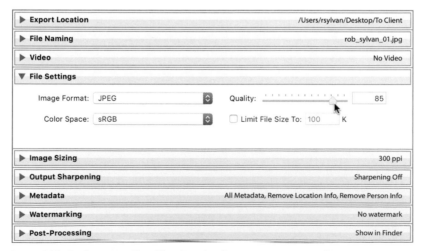

**Figure 8.38** Configure your file settings based on the reason you are exporting.

8. Expand the Image Sizing panel, and configure how you want Lightroom to resize the copies. This is where you can choose to have Lightroom resize the pixel dimensions of the copies smaller for web use, to resize to a specific print size for uploading to a print service, or to leave the pixel dimensions the same as the source files (by leaving Resize to Fit unselected).

I wanted to resize all copies so that the long edge of each photo was no more than 3000 pixels. The Resolution field really only matters when sending to a printer, but I left it at 300 pixels per inch because that makes people happy (**Figure 8.39**).

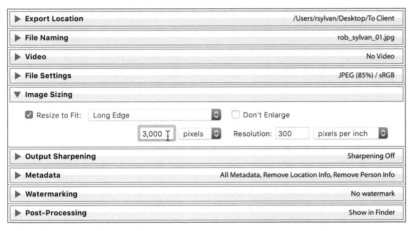

**Figure 8.39** Image sizing considerations are extremely important, so give this one some thought based on your output needs.

9. (Optional) Expand the Output Sharpening panel, and configure what type of output sharpening, and its amount, that you want applied to your copies. I left it unselected (**Figure 8.40**).

| ▶ Export Location | /Users/rsylvan/Desktop/To Client |
| ▶ File Naming | rob_sylvan_01.jpg |
| ▶ Video | No Video |
| ▶ File Settings | JPEG (85%) / sRGB |
| ▶ Image Sizing | 300 ppi / Resize Long Edge to 3,000 pixels |
| ▼ Output Sharpening | |
| ☐ Sharpen For: Screen ◇    Amount: Standard ◇ | |
| ▶ Metadata | All Metadata, Remove Location Info, Remove Person Info |
| ▶ Watermarking | No watermark |
| ▶ Post-Processing | Show in Finder |

**Figure 8.40** Output sharpening is optional.

The need for output sharpening is largely driven by your taste and the destination. This option mostly serves the needs of people sending photos to an online print service and lets them apply a sharpening algorithm based on the media surface they are printing to (glossy or matte) and its amount. It does work for screen display too, but in any case you should test each setting to see which results you personally prefer.

10. Expand the Metadata panel, and configure the metadata you want saved to your exported copies (**Figure 8.41**).

   Like all other settings here, this is driven by your reason for export. If I need to keep all original metadata with the copies, I choose All Metadata, but if I don't need it all, then I might choose All Except Camera & Camera Raw Info, which retains custom metadata I added (like keywords, titles, and captions) but strips the camera-generated EXIF metadata and the Develop module processing instructions.

   As a rule for myself, I keep the Remove Person Info and Remove Location Info checkboxes selected. The first option removes any people tags I've applied to photos to protect privacy, and the section option removes any GPS coordinates.

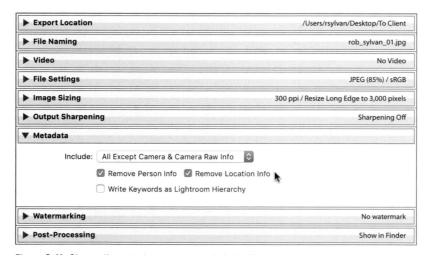

**Figure 8.41** Choose the metadata you want included with your copies.

11. (Optional) Expand the Watermarking panel and configure your choice for applying a watermark to each exported copy. I opted to skip the watermark (**Figure 8.42**).

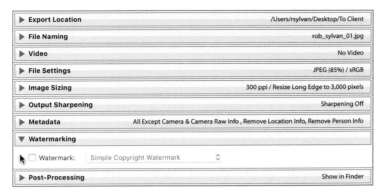

**Figure 8.42** You have the option to apply a watermark to each exported copy.

12. (Optional) Expand the Post-Processing panel, and configure any action you want Lightroom to take once the export is complete (**Figure 8.43**).

I find it very useful to set this panel to "Show in Explorer" (Mac: Show in Finder) so that once the export is done a new Explorer (or Finder) window opens right to those exported copies. That way, I can verify that the job was done and that the right number of files is present. Plus, moving those files to wherever they are headed next is easier.

**Figure 8.43** Give Lightroom one last job to do once the copies are made.

13. Give the dialog once last double-check, and click the Export button to start creating the copies to your specifications.

You can save any combination of these settings as a custom preset to make reusing the same settings a snap! Refer to Chapter 7 for details on creating presets. As long as you always let your export needs dictate your settings, the Export dialog is pretty straightforward. In the next chapter, we move on to some less frequently used, yet still important, workflows.

# 9

# ADVANCED WORKFLOWS

Now that you have a much firmer foundation in routine Lightroom operations and in how to work most efficiently, let's dive into some more advanced situations you might encounter. A few of these situations arise infrequently, but others are inevitable. Maybe you don't need to use multiple computers, merge multiple catalogs into one, or transfer your catalog to a new computer today, but a time may come when you do. So take note of the techniques you'll need and file them away for the future—you'll be glad you did.

## Using Lightroom with Multiple Computers

As the number of devices we use on a daily basis increases, it is only logical that more and more people are looking for a way to use Lightroom on multiple computers. I divide my time between my laptop, desktop computer, and smartphone. Perhaps you use a tablet and a desktop system or maybe a smartphone and laptop. Whatever the combination, wouldn't it be great to be able to access the same set of photos and the same catalog from your multiple computers and mobile devices? I have to be honest: At the time of this writing, there is not an easy way to do that—yet.

Yes, there is Lightroom Mobile, which is a fantastic step in the right direction of solving this problem. It still has a way to go to being the complete solution we need, however, because it doesn't allow access to the same catalog on multiple computers. Lightroom Mobile does extend many aspects of a single catalog to multiple iOS- and Android-based mobile devices, which is very useful (for details, see "Lightroom Mobile" in Chapter 10), but we want more than that. We want that access on our computers too.

One of the biggest obstacles to solving this problem is that a Lightroom catalog cannot be opened from a network drive. That's right, you can open a catalog stored on a locally connected hard drive only (internal drive or external drive). This is by design to avoid the risk of catalog corruption, which increases from operating a catalog over a network. Many a Lightroom user has requested that this functionality be added in a future version, so perhaps in time it will be possible, but for now we have to work around that limitation.

## Word of Warning

Before going any further, I want to say that using Lightroom with multiple computers is not for everyone. Unless you absolutely need to access your entire catalog and all of your photos from multiple computers, you are better off making one computer your designated Lightroom computer. As a side benefit, you'll gain free time and avoid having to deal with the myriad of small and (potentially) large problems that come with the territory of using a product outside of the ways it was originally designed. At the very least, make frequent backups and research alternative options, as new software and new ways of doing things emerge all the time.

## One Drive to Rule Them All

In all the years I've been providing Lightroom support, I've seen many attempts to hack the catalog or trick Lightroom into treating a network drive as a locally connected drive. If those solutions are appealing to you and you are savvy enough to deal with the risks to your catalog, then more power to you. I wish you all the best.

I prefer a much simpler solution: Simply keep your catalog and all of your photos on an external drive (**Figure 9.1**). You can then plug that drive into any computer running Lightroom and open the catalog right where you left off the last time you used it, and with all of your photos ready to go.

In my experience, there is no perfect solution to being able to seamlessly access one catalog and its photos from any computer, but this method is the simplest and safest method I've come across to date. It is also the one I use myself.

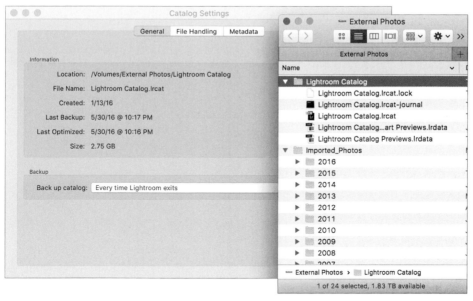

**Figure 9.1** My catalog and my photos are all on one portable external drive.

# Keeping It Simple

The reason I use this system is that it relies on old technology that is reasonably inexpensive, which means it is simple and accessible to even the least technologically savvy among us Lightroom users. In addition to the ease of use, low cost, and familiarity of the external drive, this simple method does not require an Internet connection or the time and hassle of keeping files synchronized across two or more locations.

Are there downsides? Sure, but the workarounds are pretty straightforward. First, you need to get an external drive with enough capacity to house all of your files. Second, depending on the external drive you get, you may also have to contend with an external power source for that drive. Third, because you are keeping all of your photos and your catalog on a single external drive, you need to be incredibly regimented in your backup process (that whole proverbial "keeping all your eggs in one basket" thing). I don't feel that any of those obstacles are insurmountable, but you have to weigh your need for being able to make the Lightroom catalog portable with your ability to work around the roadblocks.

Are there variations on the external drive theme? Why yes, there are! Although Lightroom is unable to open a catalog file stored on a network drive, it can work with *photos* stored on a network drive. As you recall from Chapter 1, Lightroom stores the path to each imported photo in the catalog. So if your photos are stored on a network drive and

all your computers are part of that network, then the path to each photo should be the same from each computer, and in this case you could just keep the catalog itself on the external drive and swap that between computers. This lets you use a much smaller drive and spread your eggs into a few baskets.

Are there even more possible variations for solving this problem? Sure, and I encourage anyone with the desire and computer savvy to keep pushing the boundaries of what is possible and discovering what works (and what doesn't). For the rest of us, keep it simple and back up frequently.

## Cross-Platform Issues

If you use a mix of Mac and Windows computers, then the external and network drive approaches become a little more difficult. Although the Lightroom catalog file (and its associated preview caches) are cross-platform compatible, large external drives are usually formatted for one operating system or the other, and this can be a problem in a mixed-OS environment. For example, my Mac laptop can read from a drive formatted NTFS for Windows, but it cannot write to it. On the flip side, my Windows 10 desktop machine may not even be able to read from a drive formatted HFS+ for Mac.

Like all technology problems, this one has more than one solution. In my case, I chose a solution that involved installing an inexpensive application (paragon-software.com) on my Mac to give it the ability to read and write to NTFS drives. With that application installed on my Mac and my external drive formatted NTFS, I can safely swap the drive between my Mac and Windows machines and keep on working. I have not had any problems with this workflow in the many years I've been using it.

Alternatively, you can install a similar application on a Windows computer to give it the ability to read and write to HFS+ formatted drives. In my experience, however, these don't seem to work as well as the route I have taken, and I urge you to do your research and use caution if you decide to take that path.

Likewise, be aware that using a network drive for your photos may not work if you have a mixture of Mac and Windows machines on your network, because of the different ways each operating system records the path to the network drive. Meaning that if you store your photos on a network drive, the path to the photos on that network drive is written differently on each OS, which makes it a problem for one OS or the other.

# Making It Happen

If you are starting from scratch, using an external drive for your catalog is simple. Just create the catalog on an external drive, and as you begin importing new photos, choose to have them copied to that same external drive. There's nothing more you need to do to make that system portable.

If you've already been using an external drive for your photos, then you are halfway there. To complete the process, you need to transfer your catalog (and its preview caches) to the same drive. To do this, copy the folder containing the Lightroom catalog to the external drive (I'd keep it in a separate folder from your photos). Once the copy operation is complete, double-click the catalog to open it into Lightroom and make sure all is working normally. If it is, go to Preferences > General, and update the Default Catalog setting to point to this catalog on the external drive as the new default. When you are satisfied that all is well (and backed up), you can go back and delete the original folder containing the catalog. (If you use Lightroom Mobile, read the "Note for Lightroom Mobile Users" sidebar before you delete that folder.)

If you've never used an external drive at all but would like to, then you can use the "Export as Catalog" feature in Lightroom to export a copy of your catalog along with copies of all imported photos to an external drive. To do so, follow the steps in Chapter 6 for exporting an entire catalog, but be sure to check the box to include negative files (so copies of your photos are made as well as the catalog). When this process is done, you'll have an exact copy of your catalog and of all imported photos in the location you chose on the external drive. You'll want to configure this catalog as your new default catalog, and once you've verified that all is working correctly and that all files have been safely copied to the external drive, you can remove the originals to recover that disk space.

# Take Your Presets and Templates Too

When you move your catalog to an external drive, don't forget to bring along your presets and templates. To help you, there is a setting in the preferences made for just this type of use. Head over to Preferences > Presets, and take note of the Location section of that screen (**Figure 9.2**). If you are interested in using Lightroom on multiple computers, then select the section's "Store presets with this catalog" box.

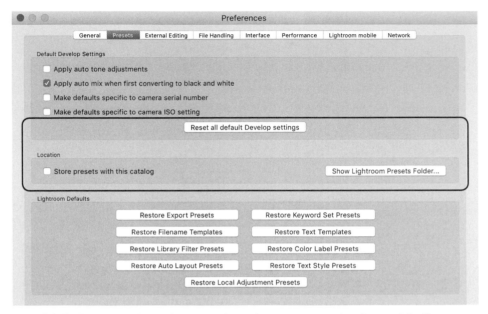

**Figure 9.2** The Presets tab of the preferences can be used to store your presets with your catalog file.

When you do, Lightroom creates a folder called Lightroom Settings right alongside your catalog and subsequently refers only to this folder for your presets and templates. Lightroom will populate that Lightroom Settings folder with only the default presets, leaving any custom presets you created in their original, default central location. You'll have to manually copy any custom presets from the central location to the new Lightroom Settings folder. Here's how:

1. With "Store presets with this catalog" *unselected*, click the Show Lightroom Presets Folder button to open your file browser to the Lightroom folder containing all presets.

2. Return to Lightroom, go back to the Presets tab, and now select the "Store presets with this catalog" box to create the Lightroom Settings folder next to your catalog.

3. Click the Show Lightroom Presets Folder button a second time, and now it will open your file browser to the new Lightroom Settings folder.

4. Copy all of your custom presets from their respective folders within the default Lightroom folder to their respective folders within the Lightroom Settings folder.

## Note for Lightroom Mobile Users

If you are a Lightroom Mobile user and have synced photos captured on your mobile device, then you most likely have a special .lrdata file, named *Mobile Downloads.lrdata*, alongside your catalog in the default location of the Pictures folder. When a photo is captured on your mobile device and synced through Lightroom Mobile, the actual full-size copy of that photo is stored in that .lrdata cache folder, and this shows up in the Folders panel under a volume browser named for your device (**Figure 9.3**).

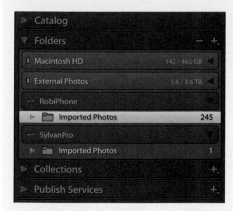

**Figure 9.3** Photos synced from my iPad and iPhone are accessible under the volume browser for each in the Folders panel.

Don't delete that Mobile Downloads file until you have moved those photos to a new location. Here's how to move them to a new location:

1. Expand the Folders panel; then expand the volume browser representing your mobile device.

2. Expand the volume browser for the drive you want to use for storing those mobile photos. Just as Chapter 3 discussed, you will use Lightroom to move the photos from one folder to another.

3. While in Grid view, select the photos you want to move, and drag and drop them onto the desired destination folder. Lightroom will move the photos to the destination and keep the catalog up to date.

4. Once the original folder is empty, you can remove it from the Folders panel by right-clicking the folder and choosing Remove (**Figure 9.4**). Removing that folder will also remove the parent volume browser from the Folders panel.

*continues on next page*

## Note for Lightroom Mobile Users (*continued*)

**Figure 9.4** You can remove the empty folder from the Folders panel.

To take control of the location in which Lightroom stores photos from your mobile devices in the future, you can configure that location in the preferences. Go to Preferences > Lightroom Mobile, and look in the Location section (**Figure 9.5**).

**Figure 9.5** Choose where you want mobile photos to be stored.

Here you can click the Choose button and select an alternative location that works better on your system. In my case, I pointed it to the same external drive as the rest of my photos. If you wish, you can even have Lightroom create date-based folders for new photos as they are synced. Prior to this setting being added, I always manually moved my mobile photos into my existing date-based folder structure, so I find this a welcome addition. We'll dive much deeper into Lightroom Mobile in Chapter 10.

# Catalog for the Road

At times you may need to create a smaller version of your main working catalog to take on a trip and continue working, or perhaps to show to a client on location, and then be able to merge that catalog back into your master catalog. The same process can be helpful for anyone who may have created multiple catalogs for other reasons and now wishes to merge the data contained within them into a single catalog. All these operations are possible thanks to Lightroom's catalog export and import functionality.

## Exporting a Smaller Catalog

Even though my main catalog is pretty portable, when I travel sometimes I don't want to lug my big external drive with me. I simply want to take a subset of images with me on my laptop, be able to import new photos I create while away, and then be able to bring it all back into my main catalog when I return. Here's how I do it (and you can too):

1. Create a new collection in the main catalog, and name it something that makes sense for your purpose (you might include the name of the place you are going, the date, client name, and so on).

2. Add all of the photos you want to bring with you to that collection.

3. Right-click the collection and choose "Export this collection as a catalog."

This is why I find it easiest to put the photos in a collection first. It is not required to create a collection before exporting a catalog, as you can simply select any number of photos and go to the File > Export as Catalog menu to export a catalog. However, by creating a collection it gives you a way to thoughtfully gather up the photos you want to bring no matter where they reside on your drives.

After choosing the "Export this collection as a catalog" option, you will see the Export as Catalog dialog (**Figure 9.6**), where you have some choices to make. Let's go through the options.

First, give your new catalog a meaningful name so that you know what it contains when you see it later. For this example, I'm heading to New York for a week, so I named this catalog *New York*. Next, choose where on your system you want this catalog to be created. You can choose an internal drive for now and copy it to another drive later, or you can simply choose a location on an external drive that you can connect to your laptop and bring with you. In my case, I chose a smaller external drive that I use for travel.

Now you need to decide what you want to be able to do with the photos in this catalog while you travel. Do you want the ability to export copies, send a copy to an external

**TIP** When creating the new collection, select the Target Collection box, as this will make it super easy to add photos to the collection: simply select the photo and press the B key.

editor for additional processing, use Lightroom's Photo Merge options, be able to zoom to 100% in the Develop module, or print? If so, then you should select the "Export negative files" box, which tells Lightroom to include copies of all source photos in a folder alongside the exported catalog.

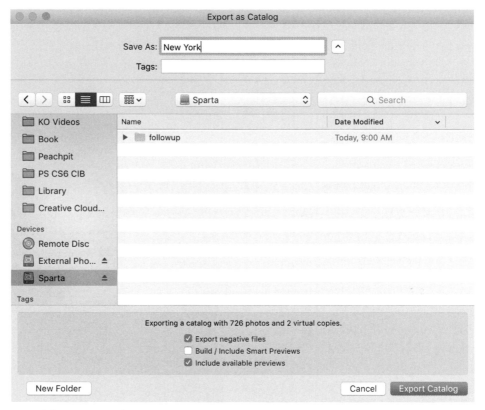

**Figure 9.6** The Export as Catalog dialog is where you configure the options for exporting a catalog.

However, if you don't need those types of output possibilities or to zoom to 100% in the Develop module, then you can save some disk space by deselecting "Export negative files" and selecting the Build/Include Smart Previews option instead. This tells Lightroom to only include Smart Previews for each source photo included in this catalog export. Smart Previews allow you to still use the Develop module (albeit with a potentially smaller version of the source photo) even though the catalog can't access the original source photos. You can, of course, use all of the other functions for adding and editing metadata (keywords, flags, ratings, titles, captions, and so on) with Smart Previews too.

If you don't plan to do any work in the Develop module at all, and maybe you just want to add keywords, captions, titles, and other metadata, then you can leave

"Export negative files" and Build/Include Smart Previews unselected and select "Include available previews." Lightroom can still work with metadata while the photos are offline. You'll just want the previews so that you can see which photo is which.

In my case, I want the ability to send to an external editor, so I chose to include negative files but skipped Smart Previews. Including available previews is a good way to avoid having to re-render them later. Once the dialog is configured to your liking, click Save (or Export Catalog on a Mac) to start the process of creating the new catalog.

## Working with the Exported Catalog

If you exported the catalog to an external drive, you can connect that drive to your laptop (or any other computer running Lightroom) and open the exported catalog into Lightroom via the File > Open Catalog menu. All of the work you do in that catalog while you're away—from adding metadata to processing in the Develop module—is stored in that catalog. You can seamlessly transfer it back to your main catalog later.

The catalog (.lrcat), the preview cache (.lrdata), and the photos (if you opted to include negative files) are all stored in a folder with the same name you gave the catalog in the Export as Catalog dialog (**Figure 9.7**). You can move that folder to any other drive as needed to make it work for you. While on my trip I will import any new photos I take into that same folder to keep things organized and easy for my return. You don't need to add new photos to the collection you created earlier, because when you get back, you're going to transfer all the data back to the main catalog.

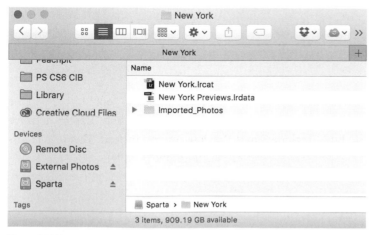

**Figure 9.7** My exported catalog and the photos (negative files) I included are all stored together in my chosen destination.

# Bringing It All Home

Now, imagine that you've returned from your trip and you want to bring all the changes you made to the original group of photos back into your original catalog, as well as copy all the new photos you took while traveling to your primary storage location. Here are the steps:

1. Connect the travel drive containing the exported catalog to the computer you use with your original working catalog.

2. Open your main working catalog into Lightroom.

3. Go to File > Import from another catalog, navigate to the drive containing your travel catalog, select the previously exported catalog file, and click Choose.

4. In the Import from Catalog dialog, you can decide what to do with any new photos as well as how to handle existing photos that changed since exporting the catalog (**Figure 9.8**).

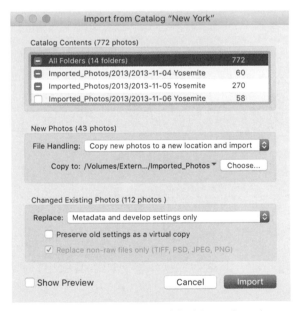

**Figure 9.8** The Import from Catalog dialog lets you choose how to deal with existing photos that may have changed as well as with new photos that you've imported.

If you imported new photos into this catalog, they will show up under the New Photos section. In the File Handling drop-down menu, you can choose to add the new photos without moving them (helpful if you want to keep the photos in their current location

and add them to the catalog), choose to copy new photos to a new location and import them (the most likely choice), or choose not to import them at all (unlikely). In the example, I chose to copy them to a new location and import them so that they can be stored with my other photos (**Figure 9.9**).

If you made any edits to the existing photos while you were away, you have some additional choices to make in the Changed Existing Photos section (**Figure 9.10**). You could choose to do nothing, but that seems unlikely if you went through the trouble to make the changes. The other two options are to replace only the metadata and Develop settings or to replace the metadata, Develop settings, and negative files. If you chose the option to replace negative files, an additional option is enabled below to limit the replacement to non-raw files, which is really the only reason you'd need to replace negative files (such as making pixel-based changes to a PSD file in Photoshop while away).

I opted to replace only the metadata and Develop settings. When you do this, you also have the option to preserve old settings as a virtual copy via the checkbox below the Replace menu. This is really helpful if you are not sure your new edits are better than what was there before (or if you can't remember and want to play it safe), but if you know the new work was intended to replace the existing settings, then leave that option unselected and avoid creating unwanted virtual copies.

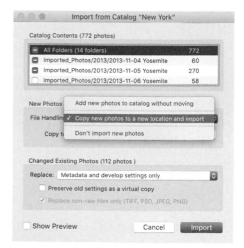

**Figure 9.9** I want to copy any new photos from this temporary storage to my primary storage.

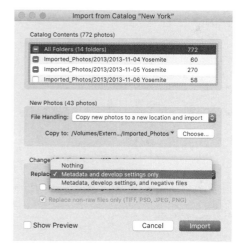

**Figure 9.10** You can update the original catalog with changes you made in the travel catalog to existing photos.

## Clean Up

Once all the data has been imported into your main catalog and the new photos safely copied to a new destination (and backed up), you can go back and delete the exported catalog from the external drive (and any associated files) using your file browser. That catalog was intended to serve a temporary purpose. Now that the job is done and you are home, you don't want to waste space with those files or stumble on it later and not remember what it was for. Better to clean up now and be ready for your next adventure with a clean slate (drive).

# Import Multiple Catalogs into One

Now that you see how easy it is to export data from a catalog and then turn around and import new and changed data back into the original catalog, you can employ that same process to essentially merge multiple catalogs into one master catalog. Why would you do this? I regularly encounter people who, for one reason or another, have created multiple catalogs in their time learning Lightroom and would like to have all of that work contained in a single catalog. Here's the advice I give them (along with the steps shown in the "Bringing It All Home" section).

Make sure you have a good backup before you start, and then be methodical in your approach. Most of the people I've encountered in this situation are in the midst of trying to clean up their systems and may have a lot of files to sort through. You don't want to throw the baby out with the bathwater. Take a deep breath and move forward with purpose, taking little scoops of bathwater at a time. Break out a good old pen and paper to take notes so that you have something to refer to as you work.

Outside of Lightroom, you may not know what any one catalog file contains. The catalog filenames often leave a lot to be desired, and may all even seem to be the same. I suggest opening each catalog into Lightroom and making some notes about its contents, its filename, and where it is located on your system. You can open a catalog by double-clicking the .lrcat file or via the File > Open Catalog menu. As you do this, you may discover an old catalog (or two) that you created by accident or by experiment that can safely be deleted outright. Ideally, you will come through this process with a good handle on the catalogs that contain the data you want to keep while having gotten rid of the rest.

## Choose the Master

After you have inspected each catalog file that you want to merge together and have written useful notes about each catalog's contents, you need to choose one to be the new master catalog that will contain all the data. It doesn't matter which catalog this is, and if it helps, you can use the File > New Catalog menu to create a clean slate. Open this master catalog into Lightroom so that you can import the other catalogs into it. Go to Preferences > General, and configure this catalog to be the default catalog.

Here's where those notes you took earlier will come in handy again; go to File > Import from another catalog, and choose the first catalog on your list. You can import only one catalog at a time, so start at the top of your notes and methodically work your way down until you have gone through the process with each catalog file. With each catalog, you need to choose what to do with the new photos (either copy to a new location or leave them where they are) and how to handle any changes to existing photos (it is possible you may encounter situations where two catalogs have been managing the same photos, so be ready to use that "Preserve old settings as a virtual copy" option if you are not sure which are the latest settings).

Once all the data from all the catalogs has been imported into the one master catalog, you have confirmed all is working well, and everything is backed up, you can go ahead and get rid of any catalogs (and associated files) you no longer need. Just be sure you know which catalog is the master catalog and that you've configured it to be the new default. Refer to Chapter 6 if you also want to rename this master catalog. Now you can enjoy the simplicity of a single catalog and hopefully have cleaned up all the old clutter.

# Migrating to a New Computer

Whether you can't wait for it or can't imagine it, there will come a time when you get a new computer and want to transfer your Lightroom catalog and photos to that new machine. It happens to all of us, and from a Lightroom perspective at least, the transition is easy. You will want to transfer three essential components from your old computer to the new machine:

▶ Your photos

▶ All custom presets, templates, and third-party plug-ins

▶ The Lightroom catalog (and possibly its associated preview cache files)

**NOTE** If you already have Lightroom set up to work on multiple computers, as I described earlier in the chapter, then you can skip this section because you are done. This transfer process is for people who just need to move to a new computer and stay there.

Although there are more than a few ways to successfully migrate this stuff to a new computer, I am going to highlight one method that will get all your data safely copied to a new computer, keep you in the driver's seat every step of the way, work with both operating systems, and ensure that you know where all your files are when the job is done. You are free to use any other method that gets the job done.

## Before You Start

Although you can transfer files over a network connection, I don't recommend it. Instead, use a large-capacity external drive (or multiple external drives if needed, depending on the number of photos you have); it will make this process much simpler and faster. Also, do yourself a favor and make sure you have a good solid backup in place before you begin!

## Preparing the New Computer

The main thing to do on the new computer is to install the latest version of Lightroom. You can skip the original installation disc and simply download the installer for the latest version you own.

If you are a Creative Cloud subscriber, you can just log in to Creative Cloud on the new computer and install Lightroom that way. Lightroom's End User License Agreement allows you to install a second copy of the software for your own exclusive use on another computer (provided that Lightroom is not used on both computers at the same time). This is also true for Creative Cloud subscriptions. Lightroom is truly cross-platform, so even if you are changing operating systems (Windows to Mac or Mac to Windows), you can use the same serial number for both installations, and there is no activation software involved. Don't bother launching Lightroom yet on the new computer; just install the software and go back to the old computer so you can gather up all the pieces to bring over.

## Migrating Your Photos

As you know, stored within your Lightroom catalog is the complete path to each imported photo, from the volume name (Windows: drive letter) to the filename, and every folder in between. If something in that path changes outside of Lightroom, then the path stored within the catalog becomes out of sync with the actual locations of your photos. In the process of migrating from one computer to another, it is very likely that something in that path will change. This is not a big deal, and the process to update the

catalog at the folder level is very straightforward (we'll go over that when we get to the new computer). The moral of the story is that if all your photos are stored within a single parent folder (no matter how many subfolders are within it), then once you get to the new computer you only need to update a single folder to get every subfolder and photo up to date. I realize that there is no single right way to store photos, and your photographic situation may be slightly more complicated; in that case, you may need to update more than one folder.

For example, on every drive I use to store photos, I maintain a structure that starts with a single parent folder containing multiple levels of subfolders for all the actual photos. This keeps things very simple for portability and backup. This parent folder is at the top of the tree in the Folders panel (**Figure 9.11**).

If I open a file browser window to that same location, you can see that the same folder structure is shown there too (**Figure 9.12**).

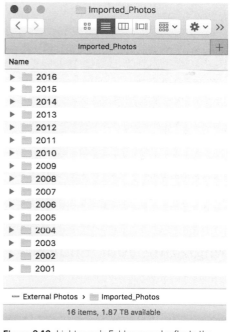

**Figure 9.11** Keeping all photo subfolders within a single parent folder makes your life simpler.

**Figure 9.12** Lightroom's Folders panel reflects the actual folder structure on the drive for the photos that have been imported.

OK, so what if you keep all your photos in a single folder but the top-level folder is not showing in the Folders panel? Just right-click the top-most folder and choose Show Parent Folder from the context menu to bring that parent folder into the Folders panel. On the flip side, if you have too many levels of parent folders showing in the Folders panel, you can hide unnecessary folders by right-clicking the top-most folder and choosing Hide This Parent. Typically, it works best to have just one level of parent folder above the folders containing your actual photos.

If your photos are already on an external drive that you are moving to the new computer, then there is no need to copy your photos to yet another drive. Just be prepared to connect that drive to the new computer, and skip ahead to the next section, "Presets and Plug-Ins."

If you need to migrate your photos to an external drive, then here's what to do. With Lightroom closed, *copy* (don't move) the parent folder containing your photos (and its contents as-is) to the external drive you are using to transfer the data. Remember: don't change the existing structure; just copy it to the external drive.

## Presets and Plug-Ins

NOTE Windows can hide the AppData folder. On Windows 7, open Explorer, go to Tools > Folder Options > View, and select "Show hidden files, folders, and drives." On Windows 10, open Explorer, click the View tab, and then select "Hidden items." Macs do a similar thing with the Library folder. Open a new Finder window, click Go in the Menu bar, and hold the Option key to make Library appear in the list of places to go; choose Library, and then follow the rest of the path above.

Time to gather up all your custom presets, plug-ins, and templates! If you've never created custom presets or templates and you've never installed a third-party plug-in or web gallery, then you can skip this part of the process and I'll see you in the "Copying the Catalog" section. When you install Lightroom on your new computer, you will get all the default presets and templates, so right now you are just concerned with all the custom bits you've added.

In my experience, most people leave their presets and templates in the default central location. The simplest way to access this location is to go to Preferences > Presets and click the Show Lightroom Presets Folder button. This will open the folder, named Lightroom, containing all of your presets into your file browser. That folder is located here:

Mac: Users/[username]/Library/Application Support/Adobe/Lightroom

Windows: Users/[username]/AppData/Roaming/Adobe/Lightroom

On the Preferences > Presets tab, if you already had "Store presets with catalog" selected, then I assume you know where all your presets are, and you can skip ahead to the "Copying the Catalog" section. If you don't have "Store presets with catalog" selected, then don't select it now! Doing so will simply create a new folder (named Lightroom Settings) alongside your catalog with only the default presets, which won't help you with your custom presets.

Within this Lightroom folder are all your presets, templates, and third-party web galleries (if installed), within their respective subfolders; it also contains the most common location for third-party plug-ins (the Modules folder). Your task is to place a copy of all your custom files on the external drive destined for the new computer, and the easiest way to do that is to copy the entire Lightroom folder to the external drive. That said, the Lightroom preference file is also stored within the Lightroom folder in a folder named Preferences. I don't recommend bringing a copy of this file to the new computer, as I think it's wiser to start with a fresh preference file on the new computer. So leave the Preferences folder behind.

As for third-party plug-ins, I've always found it simplest to place a copy of the .lrplugin file within the Modules folder so that the Plug-in Manager will automatically add and enable the plug-in. However, you may have chosen to store your plug-ins in a different location and manually add them via the Plug-in Manager. There's no wrong answer, but I'll leave it to you to know where your plug-ins are stored if not in the Modules folder. Lightroom plug-ins (.lrplugin file extension) are typically cross-platform, but some may have special requirements for each operating system, so be sure to check the website of the plug-in's author for all compatibility concerns. If you have installed plug-ins that are more like external editors—such as the ones from Nik Software or ON1 that you access via the Photo > Edit In menu—then you will want to go to the developer's website, download the installers for those plug-ins to the new computer, and install them like new software at the end of the transfer process. Now that you have all your photos, presets, and plug-ins copied to your external drive, let's turn our attention to the Lightroom catalog.

**TIP** While you have Lightroom open, take note of your preference settings so that you can re-configure them on the new computer.

## Copying the Catalog

When it comes to migrating the actual Lightroom catalog, I advocate creating a copy of your working catalog to transfer to the new computer. This is because there is no other way to transfer the Publish Services connections you previously set up, as they are not included in a catalog export. In addition, a catalog export includes only the keywords that are applied to exported photos, which may leave out parts of your entire keyword hierarchy that have not yet been applied to photos (though it is possible to export a keyword list and import it into a new catalog).

To find your catalog, go to Catalog Settings > General, and click the Show button to reveal its location. The default location of the catalog is in the Pictures folder, but the Lightroom catalog can exist at another location of your choosing.

Within the folder containing the catalog are other important files, the catalog itself (with the .lrcat file extension), and the associated preview caches (with the .lrdata file extension). If you see .lock or .journal files, then close Lightroom and they will go away, as they are temporary files that assist the catalog. If you created Smart Previews at some point, you will also see a Smart Previews.lrdata file (remember back to Chapter 1). If you've never changed the default location of the catalog backups, then you might see a Backups folder as well. With Lightroom closed, *copy* (not move) the .lrcat and .lrdata files to a folder on the external drive. If you can fit them on the same drive holding your photos, then go for it. If you need to use a separate drive, that's fine too.

You should now have a copy of your photos, your presets, and your catalog on the external drive. Safely disconnect the external drive from the old computer, and connect it to the new computer.

## Transferring to the New Computer

Launch your file browser on the new computer, and view the contents of the external drive.

First, copy the folder containing the Lightroom catalog (and preview cache) to a location of your choosing on the new computer. Then, copy your photos' folder structure to a new location of your choosing (or leave the photos on the external drive if that is your plan). Once those copy operations are complete, navigate to the catalog in its new home and double-click the .lrcat file to open it into Lightroom.

Don't panic if you see question marks on your folders and photos—you just need to update the catalog to point to their new location. This is when having a single parent folder showing in the Folders panel comes in handy. (If you don't see question marks, then you can skip this part.) The steps are:

1. Right-click the top-level parent folder, and choose Find Missing Folder.

2. Navigate to and select that exact folder in its new location, and click OK (click Choose on the Mac).

Lightroom will then go through the process of updating the catalog to reference that folder (and everything inside it) at this new location. Repeat the process for any folders not contained within that parent folder (if you have any).

Next, go to Preferences and re-configure your settings. I suggest that you configure the Default Catalog on the General tab to reference this catalog specifically instead of loading the most recent catalog. Once it's configured, go to the Presets tab and click the Show Lightroom Presets Folder button to open it in your file browser. Copy all your custom presets, templates, plug-ins, and web galleries from the external drive to their respective folders on the new computer. Restart Lightroom when the copy operation is complete to see your custom bits inside of Lightroom.

Go to File > Plug-in Manager, and make sure all your plug-ins are installed and running. If you haven't already, this is a good time to make sure you are running the latest version of each one. You will need to re-register any third-party plug-ins you had running on the old computer.

## A Word about Publish Services Connections

Connections that were set up on the old computer to online sources such as SmugMug or Flickr should still work, but give them a test-drive to make sure. However, existing hard drive connections will display any photos they contain but may no longer function due to the change in drives. The export location of an existing connection cannot be changed after the connection is created, and it will have to be rebuilt by making a new hard drive connection on the new computer. Once you create the new hard drive connection, you can repopulate its contents to match the old connection and you'll be back in business.

## Walk It Through

Give your catalog a thorough walkthrough to make sure there are no lingering question marks on any files, that all your presets are accounted for, and that everything is functioning as it should. If you are satisfied that all is well, you can close Lightroom and install any additional third-party plug-ins (such as the kind from Nik, ON1, and so on) if you have them. Congratulations on the successful migration!

# 10

# INTEGRATING WITH LIGHTROOM MOBILE

Adobe knows that we spend a lot of time on our mobile devices creating content, managing content, and consuming content. In 2014 the company released the first version of Lightroom Mobile, an app designed to extend your Lightroom experience beyond the desktop to your mobile devices. While the first iteration of Lightroom Mobile was available only for the iPad, Adobe has since expanded its support to iPhones and Android devices. Lightroom Mobile has evolved rapidly since its release, and I look forward to seeing how much functionality will be added to our mobile devices in the future. For now, I want to introduce you to what is currently possible so that you can start exploring this app on your own and using it to your advantage.

# What Is Lightroom Mobile?

**NOTE** You'll hear references to a "desktop catalog" a lot in the context of Lightroom Mobile, and the term is meant to differentiate what happens in Lightroom on your computer (whether it's a laptop or desktop computer) from what happens on your mobile devices.

Lightroom Mobile is an app for your iOS or Android device that enables you to extend your desktop Lightroom catalog to your mobile devices through the use of regular collections that you manually create and maintain (**Figure 10.1**).

**Figure 10.1** Lightroom Mobile is all about making your photos accessible wherever you are.

Within the Lightroom Mobile app you can:

▶ View/display photos in the synced collections from your desktop catalog.

▶ Import photos on your mobile device into the app and have them automatically transferred to your desktop catalog.

▶ Apply star ratings and flags to photos, which sync back to your desktop catalog.

▶ Process photos using (a subset of the) Develop module tools and have that work sync back to your desktop catalog.

▶ Export copies of photos to other apps on your mobile device or share photos directly on social media.

Understanding an application's boundaries is equally important when trying to get the most out of it, so let me also clarify what Lightroom Mobile is not intended to do (at the time of this writing anyway). For instance, you cannot tether your camera to your mobile device using Lightroom Mobile. You cannot apply keywords, color labels, captions, or titles to your photos in the app. Most significantly, although Lightroom Mobile is free and you can use its editing capabilities without a Creative Cloud subscription, you do need to be a Creative Cloud subscriber (or using the free trial) in order to sync Lightroom Mobile with your desktop catalog.

With that said, it is important to remember that this is a fluid environment where upgrades and new features are released on a rolling basis. The Lightroom Mobile app we have today is not the Lightroom Mobile that we'll have a year from now. I expect that by the time you are reading this there may already be new features or upgrades to existing features.

A few key capabilities have been fairly consistent throughout the versions and will remain so. These are also the aspects that will be the most help to you in your efforts to tame your photo library: connecting the mobile app to your desktop catalog, creating the collections that will serve as the conduit between the app and the desktop catalog, and applying ratings and flags to your photos while on the go. Let's take a closer look at each of these.

**NOTE** The processing of photos using Lightroom Mobile's editing tools is beyond the scope of this book, but to get up to speed with the latest editing capabilities of Lightroom Mobile, head over to bit.ly/LRmobileEdit.

## Smart Previews

In Chapter 1 you learned about smart previews, which are essentially lossy DNG versions of your imported photos. This allows you to continue to use the Develop module even when the original source photos are offline. Adobe has leveraged this smart preview technology in Lightroom Mobile as a way to facilitate the synchronization of develop settings between the app and your main catalog, as well as to overcome the bandwidth and storage limitations that currently exist in the mobile arena. So when you select a photo in your desktop catalog to sync to Lightroom Mobile, it is a smart preview version of that photo that is uploaded to the cloud and accessed from your mobile device. You need to have an Internet connection to make this work.

# Syncing Your Desktop Catalog and Mobile Device

Suppose you are a Creative Cloud subscriber and are signed in with your Adobe ID in the desktop version of Lightroom CC. If you want to use Lightroom Mobile, you next need to download the Lightroom Mobile app to your mobile device from the App Store (iOS) or Google Play (Android) and sign in to it using those same Adobe ID credentials. At this point you are ready to start syncing collections in this catalog with Lightroom Mobile.

## Lightroom on the Desktop

**NOTE** You can sync only one desktop catalog with Lightroom Mobile at a time.

In your desktop copy of Lightroom (which I'll call Lightroom Desktop in this chapter), click the app's identity plate; it acts as the gateway to starting the Lightroom Mobile experience on your desktop (**Figure 10.2**). Click the Start option to begin.

**Figure 10.2**  Click the identity plate in Lightroom Desktop to start the connection.

**NOTE** Only regular collections can by synced at this time, but there is hope that the ability to sync smart collections will come in the future.

Now you're ready to start choosing what collections you want to sync with Lightroom Mobile. Here's how:

1. Expand the Collections panel, and find the collection you want to sync.

2. Click the box to the left of the collection name to enable synchronization (**Figure 10.3**).

Just as the initial importing of photos into your Lightroom catalog requires a bit of patience, you'll need to call on that patience as Lightroom begins the process of uploading this data into the cloud before it can then download it onto your mobile device. Synchronization is automatic, but it is not instantaneous. You will see collections start to appear in the app (once you are logged in to it), and that is when the mobile part of the process begins.

**Figure 10.3** Choose which collections you want to sync.

# Lightroom on Mobile

While your data is on its up- and downloading journey, take a look at some important info under the app's hood. After logging in to the app, notice the Lr logo in the upper-left corner. Give that a tap to access some additional settings, such as Sync Only Over WiFi (enabling this one will help protect your mobile data plan's monthly allotment), as well as Auto Add Photos and Auto Add Video (the latter is on iOS devices only at the time of this writing). Another helpful tidbit in there is a link to a demo of all the gesture shortcuts available in the app (**Figure 10.4**). I highly recommend checking out the gesture shortcuts and learning how they work in each view.

Looking to the rest of the app interface (**Figure 10.5**), you'll see your collections appear as columns of square thumbnails running down the screen. Above the synced collections is an automatically created collection named Lightroom Photos, which puts all your photos a tap away.

**Figure 10.4**   You can configure key Lightroom Mobile settings.

**Figure 10.5**   The Lightroom Mobile interface displays your synced collections.

# Working with Collections on Your Mobile Device

OK, you've started syncing collections from your desktop catalog and installed the app on your mobile device (or even multiple mobile devices if you have them). Now, let's look at how to create collections on your mobile device and start adding photos to those collections so that they sync back to your desktop.

## Adding Photos

The bulk of your photos will come from your desktop catalog, but at times you may want to bring the photos created on your mobile device into the app as well. To create a new collection in the app and import photos from your device's camera roll, tap the plus sign (+) in the upper-right corner of the app. Alternatively, you can add photos from existing collections. Here's how to create a new collection and import photos on your device:

1. Tap the plus sign to open the Create Collection dialog, give the collection a name, and tap OK (**Figure 10.6**).

**Figure 10.6** Create a new collection, and give it a meaningful name.

2. Tap the new collection's icon to open the collection, and tap Add Photos at the bottom of the screen to choose where you want the photos to come from (**Figure 10.7**).

**Figure 10.7** You can choose to add photos from your camera roll or from the existing pool of synced photos via Lightroom Photos.

3. Tap Camera Roll, then select individual photos by tapping each thumbnail (**Figure 10.8**), or tap and hold on any thumbnail to access a pop-up menu that provides the options for selecting all or a range of photos.

**Figure 10.8** After selecting the photos you want to add, tap the Add [number] Photos button to complete the process.

4. Tap the Add [number] Photos button at the bottom of the screen to add the selected photos to the collection, which will then be synced back to your desktop catalog automatically. Any photos that have already been added will display the Lr logo in the upper corner.

Speaking of automatic, you can also enable an auto import of your camera roll into any of your collections in the app. First, make sure Enable Auto Add is selected under the app's preferences; then find the three dots to the right of each collection's thumbnail (**Figure 10.9**).

**Figure 10.9**  Tapping the dots next to any collection reveals a context menu of options for that collection.

Tap the three-dot icon to access the collection's context menu, which allows for enabling auto import, manually adding new photos from the camera roll, enabling offline editing, renaming and removing the collection, as well as some sharing options. Offline editing is useful for those times when you know you are going off the grid but still want to be able to edit your photos. Once you are back online, those edits will automatically be synced.

## Viewing Photos

To view all of the photos in a collection, simply tap the collection's thumbnail and the display will switch to a grid of all photos in that collection. A single tap of any thumbnail takes you to a Loupe view of that photo (**Figure 10.10**). From there you can swipe left or right to move through the collection. Tap the left-facing arrow at the top of the screen to return to the Grid view (and one more tap of that arrow returns you to the main screen). You'll use that Loupe view for accessing the editing tools as well as for applying ratings and flags (more on that later).

**Figure 10.10**  Tapping a thumbnail opens that photo into the larger Loupe view.

## Segmented View

One of the ways I use Lightroom Mobile is to manage all the photos I take with my iPhone. I have a special collection just for iPhone photos, which is set to automatically import new photos from my phone's camera roll, and as a result that collection has photos from many different years. The Segmented view gives me the ability to view the contents of a collection by grouping the photos by date. To access this view, you first need to open a collection and then tap on the name of the collection at the top of the screen to open the menu for filtering the way it is viewed (**Figure 10.11**).

Here you'll see the default view option, named Flat, and the other view option, Segmented. When you choose Segmented, the photos are automatically grouped by date (**Figure 10.12**). You can long-tap any date heading to see a list of alternative date groupings (year, month, day, and hour).

**Figure 10.11** You can modify how photos are grouped and sorted within each collection.

**Figure 10.12** Segmented view is useful for quickly changing how your photos are grouped within a collection.

## Presentation Mode

Another useful display option is called Presentation mode. There are probably times when you hand off your mobile device to another person to let them scroll through a set of photos. To avoid the inadvertent changing of flags, ratings, or develop adjustments, you might want to consider switching the collection into Presentation mode before handing it over. Start by opening the collection you want to show, tap the Share icon in the upper-right corner, and choose Present at the bottom of the menu (**Figure 10.13**).

**Figure 10.13** Presentation mode is great for running a slideshow.

In Presentation mode you can manually scroll left and right through the photos, or tap the Play icon in the upper-right corner to launch an automated slideshow. When your friend hands your phone back, you can exit Presentation mode by tapping the X in the upper-left corner. (If the slideshow is running, just tap the screen once to reveal the application bar to exit.)

# Exporting Photos

You can export copies (based on that smart-preview-sized image, unless it was a photo imported from your device, which should be full size) right from the app by tapping the arrow icon in the upper-right corner of the interface and then choosing Share (**Figure 10.14**).

**Figure 10.14**  Choose Share to access the output destination of your choice.

The app can output directly to any of the core apps you have configured in the device's settings (such as Mail, Twitter, Facebook, and so on). You can also save the photo back to the camera roll and choose from other options that are device dependent (**Figure 10.15**).

**Figure 10.15**  Choose where you want the exported copy to go.

In addition, Adobe has been developing other mobile editing apps, and one in particular, Photoshop Fix, has a bit of integration with Lightroom Mobile. If you tap the Edit In option, you'll see the options Liquify in Photoshop Fix and Healing in Photoshop Fix (**Figure 10.16**), which enable you to access some of the retouching power of Photoshop in a mobile app. To learn more about Photoshop Fix, head over to www.adobe.com/products/fix.html.

**Figure 10.16**  Photoshop Fix has a level of integration with Lightroom Mobile to bring edited versions back to your catalog.

## Lightroom Web

A final way that you can view and share your synced collections on the web is by logging in to Lightroom Web View, at https://lightroom.adobe.com/. Once logged in, you'll be able to get to your synced collections and add photos through the web, and you'll have access to news, tutorials, and more (**Figure 10.17**).

**Figure 10.17**  Lightroom Web provides access to your synced collections and a whole lot more.

To share a collection, either privately or publicly, click the Photos tab at the top and then click the collection you want to share (**Figure 10.18**).

**Figure 10.18**  Share a collection via the web privately or publicly.

Once you click into a collection, you'll see a Share button along the top (refer to Figure 10.18) that facilitates the process of serving up a link with options that you can share on your social networks or copy to your clipboard (**Figure 10.19**).

**Figure 10.19**  You can configure the options for publicly sharing your collection.

You can also share a collection from within Lightroom Desktop by clicking the Make Public button at the top of the synced collection (**Figure 10.20**) or from within the mobile app via the Share menu by choosing Share Collection (**Figure 10.21**). You get those additional options only on Lightroom Web itself, however.

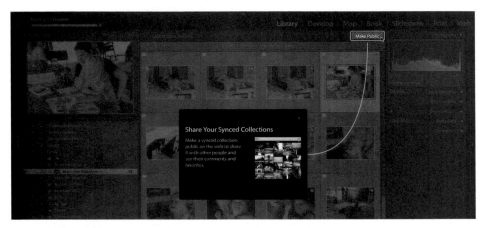

**Figure 10.20**  Synced collections can be shared from your desktop catalog.

**Figure 10.21**  You also can share collections from your mobile device.

Once you make a collection public, you can send a link to another person for viewing via his or her web browser, which is great. However, if that person logs in with an Adobe ID, he or she then has the ability to leave comments and "like" the photos. Any comments and likes are then synced back to the app and Lightroom Desktop, where you can view them and even reply. Back in Lightroom Desktop, you'll see that there is a special badge for when comments are left on a photo. You can view and reply to the comments themselves via the Comments panel.

## Applying Ratings and Flags on the Go

When it comes to helping you tame your Lightroom library, the main functionality inside Lightroom Mobile you can leverage is the ability to apply flags and star ratings to your photos and have that information automatically sync back to your desktop catalog. How you use this is entirely up to you, but the general philosophy behind Lightroom Mobile is for a more on-the-go, relaxed, kicked-back-on-your-couch type of workflow. So the real-world scenario might look like importing a shoot from a memory card into your desktop catalog, adding those photos to a synced collection, and then later grabbing a tablet or phone and reviewing the photos with your feet up somewhere. All the work you do in Lightroom Mobile is then automatically synced back to your desktop catalog, and you can pick up where you left off with the next step in your process.

Here's how it works after the photos have synced with your mobile device:

1. Choose the collection on your device; then tap the first photo to enter Loupe view.

2. If you see the Crop, Presets, and Edit options below the photo, tap the three vertical dots at the bottom left to switch to the flag and rating options (**Figure 10.22**).

**Figure 10.22** The options for flagging and rating appear along the bottom of Loupe view.

3. To apply a flag, simply tap the desired flag state. To apply a star rating, tap the desired star level (**Figure 10.23**)

**Figure 10.23**   This photo has a pick flag and 3-star rating applied.

A faster way to work is to enable Speed Flagging, Speed Rating, or Speed Review Combined, depending on which attributes you want to apply. To do this, tap and hold on the photo in Loupe view to bring up the context menu (**Figure 10.24**).

In my case, I enabled Speed Review Combined, which allows me to apply a flag or star rating simply by swiping up and down on the photo. Swipe up or down on the left side of the photo to change the flag state, or do the same on the right side to change the star rating (**Figure 10.25**).

Chapter 5 talked about how powerful Lightroom can be when you start adding metadata (flags, ratings, keywords, and so on) to your photos, and Lightroom Mobile extends that functionality to wherever you are at the time. So whether you are applying flags to a new shoot to determine which photos to keep or delete or applying star ratings to determine which photos you want to prioritize for post-processing, this aspect of Lightroom Mobile is yours to leverage for your own needs.

The mobile editing space is clearly a high priority for Adobe, and I think developers have only begun to scratch the surface of what is possible in this environment. If you are a Creative Cloud subscriber, I highly recommend taking the time to get to know the Lightroom Mobile app.

**Figure 10.24** You can enable Speed Flagging, Speed Rating, or Speed Review Combined.

**Figure 10.25** Using Speed Review Combined I changed the flag state and rating by swiping on the photo.

# Appendix

## TROUBLESHOOTING 101

If you've made it through the chapters in this book, you should be well on your way to avoiding the most common (self-inflicted) Lightroom pitfalls, but sometimes things still go wrong even when you are doing everything right. If that should ever happen to you, turn to this appendix for help.

## Time for a Do-Over

Lightroom is a very robust program that, at times, needs a lot of computer resources. Many people, myself included, often have multiple programs running at the same time as Lightroom (Photoshop, email, web browser, and so on), and that can sometimes cause our machines (especially older ones) to freeze up, choke, run slowly, or crash. On top of that, regular software updates and operating system updates may cause unexpected conflicts or affect performance.

When things go wrong, it is usually a good idea to take a break, reduce the number of variables, and start over. The first thing I do when I experience an odd performance problem (or crash) with Lightroom is restart the program. We can all benefit from the occasional reset. This is easy to do, and you'll quickly discover whether it solves the problem or not.

If the problem persists, take things to the next level by closing all open programs, shutting down the computer, and rebooting. (Refresh yourself too: Take a short break and get a coffee refill.) Once the machine is up and running again, restart only Lightroom and see if things have improved. This can cure a wide variety of quirks and gremlin-like behaviors. If this hasn't resulted in a cure, however, then it is time to escalate to the next level.

# Resetting the Preference File

If Lightroom does crash, especially repeatedly, it can be a sign of a problem with its preference file. The way to fix that is to force Lightroom to throw away the old preferences and create a brand new preference file. Starting with Lightroom CC 2015/Lightroom 6, Adobe has finally added an easy way to replace the Lightroom preference file with a keyboard shortcut. Before we get to that, I would advise you to first open the preference file and take note of any places where you customized the settings. Back in Chapter 1, I showed you how to find the preferences and suggested some places you might consider changing the defaults. When Lightroom creates a new preference file, all of those settings will revert to what they were before you made any changes, so you'll need to go back and customize them again.

Thankfully, Adobe also separated your startup preferences into a separate file that is not affected by this replacement operation, which means that Lightroom will still open the correct catalog when you launch it.

Once you are ready to replace (sometimes referred to as "trash") the preferences, you'll need to quit Lightroom. Once it's closed, on Windows, hold down the Shift and Alt keys (Mac: the Shift and Option keys) while launching Lightroom. You will see a prompt asking, "Reset Lightroom preferences?" (**Figure A.1**). Click Reset Preferences to throw out the old and start fresh with the new, or click Start Normally if you were just trying out the keyboard shortcut and didn't really want to do it at this time.

**Figure A.1** Click Reset Preferences to create a new default preference file.

After you click the Reset Preferences button, Lightroom will launch, and you'll notice that things like the helpful module tips have returned or that panels you previously resized are back to their default sizes. Go through Lightroom and see if you can replicate the problem that brought you to this point, and if all is working well, open the preferences and customize any default settings you had changed. I've seen this reset trick solve all kinds of weird and unexplainable quirks, so hopefully that does the trick. If not, it is worth trying the next option.

# Creating a New Catalog

Back in Chapter 6, I walked you through the steps for exporting a catalog from your existing catalog as a way to see if you could export the good data from a catalog and leave behind whatever problem you may have been having. That is a great tip to keep on file and potentially use. Depending on the size of your catalog, however, that method can take some time to complete. An easier interim method to try is to simply create a new (empty) catalog, import a few test photos into it, and then see if you can replicate whatever problem you were having originally. That way, you can do a quick test to see if having a new catalog solves the problem. To do this, go to File > New Catalog, and then in the resulting dialog (**Figure A.2**) give this test catalog a meaningful name and choose a location on your computer that is easy for you to find (like your desktop). This may end up being a short test, and you may want to be able to discard this catalog easily later.

**Figure A.2**  Give this catalog a meaningful name to avoid confusion with your existing catalog.

After the new catalog opens and you've imported a few test photos, you can evaluate whether it made any difference with the problem you were having. If the problem is gone, well, then that may suggest the problem is related to your original catalog, but if the problem persists, we'll have to look at other options (more on that in the sections that follow).

If the problem is gone in the new catalog, here are the options I suggest you consider, in the order I'd try until your catalog is working again:

▶ Restore from the most recent backup copy of your catalog (refer to Chapter 6).

▶ Export a catalog from the problem catalog (refer to Chapter 6).

▶ Create a new catalog and try importing the data from the problem catalog into the new catalog (refer to Chapter 9). This is sort of the reverse of exporting from your catalog; it's just nice to have options in case one option doesn't work.

Hopefully you've found a solution to whatever problem was troubling you to bring you this far, but if you haven't, it is time for more extreme measures.

## Uninstalling and Reinstalling Lightroom

In my experience, reinstalling Lightroom rarely fixes anything, but as a last resort, it is worth a shot and causes no harm. In all the years I've been using Lightroom, helping people on the Help Desk by trying to replicate problems, running Beta versions of Lightroom, and even testing for Adobe, I couldn't possibly count how many times I've uninstalled and reinstalled Lightroom. It is super easy to do, and it doesn't even touch any of your existing Lightroom catalogs or even the Lightroom preference file. All it does is uninstall the program and then reinstall the program, which may be why it doesn't usually result in any change in behavior. That said, here's how to do it.

If you are a Creative Cloud subscriber, you can uninstall Lightroom from the Adobe Application Manager (**Figure A.3**). The process is the same on both Mac and Windows. Just click the icon for the Application Manager to open it, select the Apps tab, and then hover your cursor over the Lightroom CC app to reveal the gear icon that houses the Uninstall option. Click Uninstall to start the process.

**Figure A.3** You can uninstall and reinstall applications from the Adobe Application Manager.

Once Lightroom is uninstalled, open the Application Manager again and reinstall. That's all there is to it.

If you have the perpetual license for Lightroom 6, then you would uninstall the program on Windows the same way you uninstall any other program (System > Apps & Features; then select the program and choose Uninstall). Lightroom is no different in this regard, and Windows users are used to uninstalling this way. For Mac users, Lightroom is a little different in that, as of Lightroom 6, you shouldn't just drag the application to the Trash (like we usually do to uninstall programs). Instead, open the Applications folder, and under the Adobe Lightroom app there will be an alias named Uninstall Adobe Lightroom. Double-click the Uninstall link to remove the program. Once it's removed, you can just reinstall if you still have the installer handy, or you may need to download the installer from Adobe.

**NOTE** For more help with installing Lightroom 6, go here: helpx.adobe.com /creative-cloud /help/download -install-single-app -Lightroom-6.html.

Once it's reinstalled, launch Lightroom and see if that resolved your issue. I suspect not, but you've at least ruled that out of the equation. It may be time to seek outside help.

# Finding Outside Help

One of the real benefits of using Lightroom is that there is a huge base of other Lightroom users, and it is extremely likely that you are not the first person to have encountered whatever bit of trouble that has brought you to this point.

The most obvious resource to reach out to is Adobe's own support team. This is especially true if your issue has anything to do with something related to your account or subscription or if your issue something only Adobe can resolve. To reach out to these fine folks, head over to helpx.adobe.com/support.html.

You may find that you are provided with a link to try the Adobe User Forums (forums .adobe.com/community/lightroom) or the community-powered support for the Photoshop family of applications (feedback.photoshop.com/photoshop_family). These are both excellent resources to consider, and if you search through the existing conversations, you may quickly find a solution for your problem (or at least other people to commiserate with). One important point to keep in mind is that although Adobe staff may participate in some of the conversations going on there, most of the people you will encounter are just regular Lightroom users, like yourself, who are simply sharing their expertise with the larger community. I can appreciate how frustrating some situations with Lightroom can be, but it always pays to be kind to the people trying to help.

There are also a couple of non-Adobe user-driven resources I've had excellent experiences with. The first is Lightroom Forums (www.lightroomforums.net), which has been around for a really long time and is populated by incredibly knowledgeable Lightroom users. The other is the Lightroom Help Group on Facebook (facebook.com /groups/lightroomhelpgroup). It is a closed group, but anyone can join, and as long as you follow the posted rules, I think you'll find it to be a very valuable resource for solving problems and learning about Lightroom.

For a more personal touch, you might look into a local camera club or professional photographer organization; they will very likely have a large number of Lightroom users who may be able to assist you.

Last but not least, if you are a KelbyOne subscriber (kelbyone.com), you gain access to unlimited Lightroom, Photoshop, and even gear help through its Advice Desk. I handle all of the Lightroom questions that come through, so it is like having me on speed dial. I also have a blog (lightroomers.com), where I post only Lightroom-specific info, and I contribute to Photofocus.com (where I host a free monthly Lightroom hangout and take live questions).

I hope that this is the least-read section of the book for you, but if you should ever be in dire straits, the solutions and resources I've compiled here should get you on your way again. I wish you all the best with your Lightroom journey!

# Index

1:1 previews, 12–13, 178

## A

ABC button, 150
Adobe Application Manager, 244, 245
Adobe Lightroom. *See* Lightroom
Adobe Photoshop, 18
Adobe User Forums, 246
Apply During Import panel, 47, 154, 170, 172
Attribute filter, 179, 186, 187
Auto Advance option, 178, 179
Auto Hide setting, 35
auto-complete feature, 100, 106, 116–117

## B

Back Up Catalog dialog, 129, 130
backups
    catalog, 127, 128–130
    photo, 45–46
Book module presets/templates, 140
Build Previews setting, 178

## C

cache files
    deleting, 13
    management of, 11–13
    types of, 9–10
Camera Raw cache settings, 19
cameras
    importing from, 170
    profiles for, 162
captions, 99
Catalog panel, 78–79, 136
Catalog Settings dialog, 12, 128, 129
catalogs, 1, 127–137
    backing up, 127, 128–130
    collections exported as, 207–209
    creating new, 243–244
    default location for, 9
    explanation of, 2–4
    exporting, 135–137, 203, 207–209
    external drive for, 200–201, 203
    finding location of, 217
    importing, 210–211, 212–213
    integrity test for, 130
    managing backups of, 131–132
    merging multiple, 212–213
    migrating to new computers, 213–219
    moving to a new location, 133
    multiple computer use and, 200–204
    opening individual, 212
    optimize function for, 131
    presets stored with, 203–204
    renaming, 134–135
    restoring from a backup, 132–133
    settings dashboard for, 128
    single vs. multiple, 11
    startup setting for, 15
    syncing with mobile devices, 224–226
    working with exported, 209
chimping, 174
Choose or Create New Folder dialog, 55
collapsing panels, 35–36, 37
collection sets, 77, 80–81, 89, 190
collections, 75–92
    Catalog panel, 78–79
    deleting, 91, 92
    explained, 75–76
    exporting as catalogs, 207–209
    Lightroom Mobile, 224–225, 227–239
    maintaining, 89–92
    Quick, 89–90
    regular, 77, 81–83
    removing photos from, 89
    renaming, 91–92
    sets of, 77, 80–81, 190

collections (*continued*)

   sharing, 235–236

   smart, 77, 83–88

   sort order for, 92

   syncing, 224–225

   target, 89–91

   types of, 77–78

Collections panel, 76, 77, 91

color labels, 176–178

Colored Red smart collection, 83, 84

compact view, Import screen, 173

Compare view, 31–32

computers

   disk maintenance functions on, 6

   freeing up startup drive space on, 5–6

   migrating Lightroom to new, 213–219

   using Lightroom on multiple, 199–206

   *See also* Mac systems; Windows systems

configuration settings

   Mac system access to, 14

   Windows system access to, 13

   *See also* preferences

controlledvocabulary.com website, 109

copying

   files to new computers, 213–219

   photos from memory cards, 40–42, 170–173

Create Collection dialog, 81–82, 227

Create Collection Set dialog, 80–81

Create Folder dialog, 56–57

Create Keyword Tag dialog, 110

Create Smart Collection dialog, 85, 87

cross-platform issues, 202

custom filename templates, 65–68

**D**

date

   organizing folders by, 7, 8, 43–44

   syncing GPS and camera, 124, 125

Date Format menu, 43

date/time stamp, 124, 125

default settings, 161–166

customizing, 162–164, 165

explained, 161–162

presets versus, 162

synchronizing new, 164

deleting

   collections, 91, 92

   keywords from lists, 113–114

   photos in Lightroom, 58–60, 70

   presets, 157

   rejected photos, 60, 180

   templates, 158

   *See also* removing

desktop catalog

   definition of term, 222

   syncing with mobile device, 224–226

destination options, 42–44

Destination panel, 43, 172

Develop settings

   applying during import, 47

   customizing default, 16

   presets for, 140, 145–148

disk maintenance functions, 6

DNG file format, 42

dragging-and-dropping

   photos between folders, 61

   photos into collections, 83

drives. *See* external drives; hard drives

**E**

Edit Keyword Set dialog, 108

Edit Keyword Tag dialog, 113

Edit menu, 25

Edit Metadata Presets editor, 155

Edit Smart Collection dialog, 84, 86

editing

   existing keywords, 113

   preferences for external, 17–18

evaluating photos, 174–180

   after import, 176–180

   during import, 174–176

EXIF metadata, 96–97, 98

Export as Catalog dialog, 136, 207–208
Export dialog, 140, 143, 192
Export Location panel, 192–193
exported catalogs, 207–212
  collections created for, 207–209
  deleting temporary, 212
  importing into main catalog, 210–211
  info on working with, 209
exporting
  catalogs, 135–137, 203, 207–209
  collections as a catalog, 207–209
  copies for output, 191–197
  keywords, 109, 111–112
  photos from Lightroom Mobile, 233–234
  presets for, 143–145
external drives
  cross-platform issues with, 202
  multiple computer use and, 200–201,
    202, 203–204
  reconnecting offline, 68–70
  Smart Previews and, 10
  *See also* hard drives
External Editing panel, 17–18
external editors, 17–18

**F**

faces
  assigning names to, 115–117, 119
  drawing regions around, 117–118
  finding in People view, 114–115
  tips for working with, 119–120
File Handling panel
  import process and, 45–46, 170, 171
  managing the preview cache in, 11–13
  setting preferences in, 19
File Name field, Metadata panel, 64, 65
File Naming panel, 64, 193
File Renaming panel, 46, 64
File Settings panel, 194
Filename Template Editor, 65–68
Fill settings, 30

Filmstrip, 26–27, 36
finding photos, 53–54, 186–191
  geolocation data for, 121–122
  Library Filter bar for, 186–189
  People view for, 114–115
  smart collections for, 189–191
Fit setting, 30
Five Stars smart collection, 83
flags, 60, 176–180, 237–239
folders
  collections from, 82
  creating new, 54–57
  date-based structure for, 7, 8, 43–44
  displayed in Folders panel, 49–50
  exported catalog, 209
  finding photos and, 53–54, 169
  moving photos and, 61–63
  organizing for photos, 6, 7–8, 44
  reconnecting missing, 70–73
  removing empty, 58
  renaming, 57
  showing/hiding parent, 52–53
  storage structure for, 215–216
  subfolders nested under, 50, 56–57
  tip on docking, 168
Folders panel, 49–54
  explanation of, 49–50
  finding folders in, 53–54
  folder structure displayed in, 215
  showing/hiding parent folders in, 52–53
  volume browsers in, 50, 51–52
formatting memory cards, 45
Full Screen mode, 35

**G**

General preferences, 14–15
geolocation data, 121–125
  finding photos with, 121–122
  manually adding to photos, 122–124
  reverse geocoding for, 123–124
  tracklogs for adding, 124–125

gesture shortcuts, 225
Google Maps, 122
GPS coordinates. *See* geolocation data
graphics processor (GPU), 20–21
Grid view, 28–29
    applying metadata in, 101–102
    deleting photos using, 59–60
    Library Filter bar in, 186
    Painter tool visible in, 184
    rating photos in, 178

## H

H.264 video format, 194
hard drives
    adding photos from, 41, 42, 168–170
    disk maintenance for, 6
    moving photos between, 5, 63
    photo storage on, 8
    *See also* external drives
hiding
    panels, 37–38
    parent folders, 53
hierarchy of keywords, 105, 110, 112

## I

identity plate, 25, 224
Image Info panel, 150
Image Sizing panel, 195
Import button, 39, 47
Import dialog, 39, 140
Import from Catalog dialog, 210
Import Keywords menu, 109
Import Preset menu, 142
Import screen, 4, 39–40, 168, 173
importing catalogs, 210–211, 212–213
importing keywords, 109
importing photos, 39–47, 167–173
    adding from hard drive, 41, 42, 168–170
    Apply During Import options for, 47
    copying from memory card, 170–173
    destination options for, 42–44

evaluating photos while, 174–176
file handling options for, 45–46
Import screen overview, 39–40
presets for, 141–142
renaming photos while, 46
source location options for, 40–42
workflows for, 167–173
installing Lightroom, 8, 214
interface
    components, 24–27
    customizing, 34–38
Into Subfolder checkbox, 44
IPTC metadata, 97, 98

## J

JPEG files, 15, 192, 194

## K

KelbyOne Advice Desk, 246
keyboard shortcuts, 158–161
    discovering, 36, 159–160
    rating photos using, 178
    starter kit for, 161
Keyword List panel, 109–114
    applying keywords in, 181–183
    creating keywords in, 110–112
    deleting keywords from, 113–114
    editing keywords in, 113
    explanatory overview of, 109–110
    importing keywords into, 109
    ordering lists in, 113
    removing keywords from photos in, 183
    replacing bad keywords in, 183–184
keyword sets, 107–108
Keyword Suggestions feature, 107
Keyword Tags drop-down menu, 106, 107
Keywording panel, 104–108
    explanation of, 104
    keyword hierarchy and, 105
    tools for working in, 107
    views available in, 106–107

keywords, 103–114
  applying, 47, 180–186
  creating new, 110–112
  deleting from list, 113–114
  editing existing, 113
  explanation on using, 103
  exporting, 109, 111–112
  filtering, 181
  hierarchy of, 105, 110, 112
  importing lists of, 109
  Keyword List panel for, 109–114, 181–184
  Keywording panel for, 104–108
  lists of existing, 105–106, 109–114
  Painter tool for, 184–186
  parent and child, 105, 110, 112
  person, 115–117
  removing from photos, 183
  replacing bad, 183–184
  sets of, 107–108
  speeding up application of, 107
  structuring lists of, 113
  viewing entered, 106–107

## L

library card catalogs, 2–3
Library Filter bar, 27
  Attribute options, 179
  finding photos using, 186–189
  toggling visibility of, 186
Library menu, 81
Library module, 23–38
  Compare view, 31–32
  customizing, 34–38
  Filmstrip, 26–27
  Grid view, 28–29
  Lights Out mode, 38
  Loupe view, 30–31
  main workspace, 27
  menu bar, 24–25
  panels, 26, 35–38
  People view, 34

  presets, 140
  screen modes, 35
  Survey view, 33–34
  toolbar, 27, 176–177
  view options, 28–34
Library View Options dialog, 29
Lightroom
  installation, 8, 214
  instructional video, xv
  migration process, 213–219
  multiple computer use, 199–206
  preparing to use, 5–8
  troubleshooting, 241–246
Lightroom Catalog.lrcat.lock file, 10
Lightroom Catalog.lrcat-journal file, 10
Lightroom Catalog Previews.lrdata file, 9
Lightroom Catalog Smart Previews.lrdata
    file, 10
Lightroom Forums, 246
Lightroom Help Group, 246
Lightroom Keyword List Project, 109
Lightroom menu, 25
Lightroom Mobile, 221–239
  adding photos to collections in, 227–229
  app interface and settings, 225–226
  creating collections in, 227
  exporting photos from, 233–234
  functional overview of, 222–223
  info on editing capabilities of, 223
  Lightroom Web and, 234–236
  photo storage location for, 205–206
  Photoshop Fix and, 234
  Presentation mode in, 232
  ratings and flags applied in, 237–239
  Segmented view in, 230–231
  smart previews used in, 223
  syncing desktop catalog with, 224–226
  viewing photos in, 229–232
  volume browsers for, 52
  *See also* multiple computer use
Lightroom Settings folder, 204
Lightroom Templates folder, 149

Lightroom Web, 234–236
lightroomers.com blog, 246
Lights Out mode, 38
location data, 121–125
    finding photos with, 121–122
    manually adding to photos, 122–124
    reverse geocoding for, 123–124
    tracklogs for adding, 124–125
Location Filter bar, 122
Loupe view, 30–31
    deleting photos in, 60
    Lightroom Mobile, 229–230, 237
.lrcat file, 9, 134, 209, 218
.lrdata file, 9, 13, 134, 205, 209, 218
.lrplugin file, 217

### M

Mac systems
    configuration settings on, 14
    disk maintenance functions on, 6
    Lightroom on Windows vs., 8
    menu bar on, 25
Make a Second Copy To checkbox, 45–46
Map module, 121–125
    finding geotagged photos in, 121–122
    GPS tracklogs used in, 124–125
    manually mapping photos in, 122–124
master catalog, 213
memory cards
    copying photos from, 170–173
    importing photos from, 40–42, 45–46,
        170–173
menu bar, 24–25
merging multiple catalogs, 212–213
metadata, 95–125
    applying to multiple photos, 101–102
    auto-complete feature, 100
    captions applied as, 99
    definition of, 95
    EXIF and IPTC, 96–97, 98
    exporting with photos, 196

geolocation data as, 121–125
    importing photos and applying, 47
    keywords applied as, 103–114
    person keywords as, 115–117
    presets for, 154–156
    syncing across photos, 102
    tips for entering, 100–101
    titles applied as, 99
Metadata filter, 186, 188–189
Metadata panel, 96–102
    Default view, 98
    Export dialog and, 196
    File Name field, 64, 65
    Title and Caption fields, 98–100
    views available in, 96–98
migrating to new computers, 213–219
    copying the catalog for, 217–218
    essential components for, 213
    folder structure and, 214–216
    preparing the new computer for, 214
    presets and plug-ins for, 216–217
    Publish Services connections and, 217, 219
    transferring files for, 218–219
    walkthrough following, 219
missing folders/photos, 70–73
    computer migration and, 218
    disconnected drives and, 68–70
    moved outside Lightroom, 70–73
    renamed outside Lightroom, 73
&lt;mixed&gt; metadata warning, 101
Mobile Downloads.lrdata file, 10, 205
mobile version of Lightroom. *See* Lightroom
    Mobile
Module Picker, 25
moving
    catalogs to new locations, 133
    caution on importing by, 173
    folders into other folders, 62
    large groups of photos, 63
    photos between folders, 61–62
    shortcut feature for, 63

multiple computer use, 199–206
   cross-platform issues and, 202
   external drives for, 200–201, 202, 203–204
   network drives and, 200, 201–202
   presets and templates for, 203–204
   word of warning about, 200
   *See also* Lightroom Mobile

## N

naming. *See* renaming
Navigator panel, 30–31
negative files, 137, 208–209
network drives, 200, 201–202
New Develop Preset dialog, 146–147
New Preset dialog, 142, 144
New Template dialog, 149
Nik Collection, 18

## O

offline hard drives, 68–70
ON1 Photo 10 application, 18
Organize drop-down menu, 43, 172
organizing
   folders for photos, 6, 7–8, 44
   imported photos, 43–44
Output Sharpening panel, 195–196

## P

Painter tool, 184–186
panels
   collapsing, 35–36, 37
   hiding, 37–38
   left/right groups of, 26
   Solo mode for, 37, 171
   *See also specific panels*
parent and child keywords, 105, 110, 112
Past Month smart collection, 84
People view, 34, 114–120
   assigning names to faces in, 115–117
   drawing face regions in, 117–118

   finding faces in, 114–115
   tips for using, 119–120
Performance panel, 20–21
person keywords, 115–117
Photo Info checkbox, 150
Photo menu, 177
Photofocus.com website, 246
photos
   deleting, 58–60, 70
   evaluating, 174–180
   exporting for output, 191–197
   face tagging, 114–120
   finding, 53–54, 186–191
   geolocation data for, 121–125
   importing into Lightroom, 39–47, 167–173
   keywords added to, 103–114
   metadata for, 95–125
   moving folders and, 61–63
   organizing folders for, 6, 7–8
   preparing for Lightroom, 6–8
   rating, 176–178, 237–239
   reconnecting missing, 68–73
   renaming, 64–68
   storage location of, 4
Photoshop, Adobe, 18
Photoshop Fix app, 234
Pick flag, 178
plug-ins, 217, 219
Post-Processing panel, 197
preferences, 13–21
   External Editing, 17–18
   File Handling, 19
   General, 14–15
   Mac access to, 14
   Performance, 20–21
   Presets, 16–17
   resetting, 242–243
   Windows access to, 13
Preferences dialog, 15, 16, 17
Presentation mode, 232

presets
    defaults vs., 162
    deleting, 157, 158
    develop, 145–148
    export, 143–145
    external editor, 18
    filename template, 67
    import, 141–142
    installing downloaded, 147
    metadata, 154–156
    overview of, 139–140
    renaming, 157, 158
    setting preferences for, 16–17
    storing with catalog, 203–204
    transferring to new computer, 216–217
    updating, 156, 157
    *See also* templates
Presets panel, 16–17
previews
    1:1 ratio, 12–13, 178
    cache files for, 9–10, 13
    creating on import, 45
    size/quality settings, 11–13
    Smart, 10, 208, 223
print templates, 140, 148–149
profiles, camera, 162
Publish Services connections, 217, 219
Purge Unused Keywords option, 114

**Q**

quality setting for previews, 12
Quality slider, 194
Quick Collections, 89–90

**R**

rating photos, 176–178, 237–239
Recently Modified smart collection, 84
reconnecting folders/photos, 68–73
    on disconnected drives, 68–70
    moved outside Lightroom, 70–73
    renamed outside Lightroom, 73

regular collections, 77, 81–83
reinstalling Lightroom, 244–245
Reject flag, 178, 180
Remove Photo option, 60
removing
    folders from Lightroom, 58
    keywords from photos, 183–184
    photos from smart collections, 88
    *See also* deleting
Rename Photos menu, 64
renaming
    catalogs, 134–135
    collections, 91–92
    folders, 57
    import-based, 46
    individual photos, 64–65
    Lightroom options for, 64
    multiple photos, 65–68
    presets, 157, 158
resizing copies for output, 195
restarting Lightroom, 241–242
restoring the catalog, 132–133
reverse geocoding, 123–124
rules for smart collections, 85–86

**S**

screen modes, 35
Segmented view, 230–231
Select a source drop-down menu, 169
sequence numbers, 67
Set Default Develop Settings dialog, 163–164
Set Metadata on Multiple Photos warning,
    102
sharing collections, 235–236
sharpening, output, 195–196
shortcuts. *See* keyboard shortcuts
slideshow templates, 140, 150
smart collections, 77, 83–88
    creating new, 85–86, 189–191
    dashboard view using, 189–191
    example of creating, 86–88

preinstalled, 83–84
 removing photos from, 88
 setting rules for, 85–86
Smart Previews, 10
 cache file for, 10
 exported catalogs and, 208
 Lightroom Mobile use of, 223
Smart Previews.lrdata file, 218
Snapseed app, 18
Solo mode, 37, 171
source files, 40–42
Source panel, 41, 171
Speed Review Combined option, 238
star ratings, 176–178, 237–239
startup drive space, 5–6
Startup preferences file, 14
"sticky" settings, 141
structuring keyword lists, 113
subfolders, 50, 56–57
Survey view, 33–34
Synchronize Metadata dialog, 102
synchronizing
 metadata, 102
 with mobile devices, 224–226
 new defaults, 164
system setup, 5–6

**T**

Tab key navigation, 100
tagging faces, 115–117
target collections, 89–91
Template Browser, 148–149
templates
 custom filename, 65–68
 deleting, 158
 management of, 156–158
 overview of, 139–140
 print, 148–149
 text, 150–153
 web and slideshow, 150
 *See also* presets

temporary collections, 79
Text filter, 186, 187
Text Template editor, 151–153
text templates, 150–153
thumbnails
 enabling badges for, 182
 moving photos using, 61
time/date stamp, 124, 125
titles, 99
tokens, 67
toolbar, 27, 176–177
tooltips, 160
tracklog files, 124–125
transferring files. *See* migrating to
 new computers
troubleshooting Lightroom, 241–246
 creating a new catalog, 243–244
 finding outside help for, 245–246
 resetting the preference file, 242–243
 restarting the program, 241–242
 uninstalling/reinstalling Lightroom, 244–245

**U**

Uncheck All button, 174
uninstalling Lightroom, 244–245
Update Folder Location command, 63
updating presets, 156, 157
User Presets folder, 146

**V**

video files
 exporting copies of, 194
 icon indicating, 176
Video Files smart collection, 84
video tutorial on Lightroom, xv
view options, 28–34
 Compare view, 31–32
 Grid view, 28–29
 Loupe view, 30–31
 People view, 34
 Survey view, 33–34

views
compact Import screen, 173
Lightroom Mobile, 229–232
Metadata panel, 96–98
virtual copies, 82
volume browsers, 50
info provided by, 51
Lightroom Mobile and, 52
offline drives shown in, 69

## W

Watermarking panel, 196–197
web templates, 140, 150
Windows systems
configuration settings on, 13
disk maintenance functions on, 6
Lightroom on Mac vs., 8
menu bar on, 25

Without Keywords smart collection, 84
workflows
for applying keywords, 180–186
for evaluating photos, 174–180
for exporting copies of photos, 191–197
for exporting smaller catalogs, 207–209
for finding photos, 186–191
for importing catalogs, 210–212
for importing photos, 167–173
for merging multiple catalogs, 212–213
for migrating to new computers, 213–219
for multiple computer use, 199–206
workspace in Lightroom, 27

## Z

zoom level setting, 30